Graphis is committed to presenting exceptional work in international Design, Advertising, Illustration & Photography. This year, we proudly introduce our new Platinum, Gold & Silver Awards for excellence in the visual arts. Every student included in this year's Annual has earned a Gold Award, and four instructors, whose inspiration consistently produced outstanding work, have earned the Platinum Award for their contributions to the industry and academic community.

Published by **Graphis** I CEO&Creative Director: B. Martin Pedersen I Publishers: B. Martin Pedersen, Danielle Baker
Editor: Anna Carnick I Designer: Yon Joo Choi I Production Manager: Eno Park I Support Staff: Rita Jones, Carla
Miller I Interns: Malia Ferguson, Mi Young Kim, Gi Young Lee, Nikeisha Antonette Nelson, Ryan Quigley, Corey Sharp

Remarks: We extend our heartfelt thanks
to contributors throughout the world who
have made it possible to publish a wide and
international spectrum of the best work in
this field. Entry instructions for all Graphis
Books may be requested from: Graphis
Inc., 307 Fifth Avenue, Tenth Floor, New
York, New York 10016, or visit our web site
at www.graphis.com.

Anmerkungen: Unser Dank gilt den Einsend-
ern aus aller Welt, die es uns ermöglicht ha-
ben, ein breites, internationales. Spektrum
der besten Arbeiten zu veröffentlichen. Teil-
nahmebedingungen für die Graphis-Bücher
sind erhältlich bei: Graphis, Inc., 307 Fifth
Avenue, Tenth Floor, New York, New York
10016.Besuchen Sie uns im World Wide
Web, www.graphis.com.

Remerciements: Nous remercions les par-
ticipants du monde entier qui ont rendu
possible la publication de cet ouvrage
offrant un panorama complet des meil-
leurs travaux. Les modalités d'inscription
peuvent être obtenues auprès de: Graphis,
Inc., 307 Fifth Avenue, Tenth Floor, New
York, New York 10016. Rendez-nous visite
sur notre site web: www.graphis.com.

Contents

Commentary 6

Advertising 23
AmusementPark 24
Automotive 26
Beverage 32
Billboard 34
Broadcast 38
Camera 40
Computer 41
DeliveryService 42
Environment 44
Events 52
Fashion 56
Food 59
Products 64
ProfessionalService 86
PublicService 92
Retail 98
SocialCommentary 104

Design 105
Books 106
Branding 118
Brochures 128
Calendars 130
CreativeExploration 132
Currency 139
DVDs 140
Editorial 142
Exhibitions 158
Games 159
Illustrations 160
Letterhead 166
Logos 168
MusicCDs 174
Packaging 180
Posters 194
Products 214
Promotion 220
ShoppingBags 222
Stamps 226
Typography 228

Photography 235
Advertising 244
Digital 237, 243
Landscape 236
Portraits 238, 239, 241, 242
StillLife 240

Credits&Index 245

InMemoriam: Silas H. Rhodes Dies at 91; Built School of Visual Arts

Silas H. Rhodes, co-founder of a trade school for Cartoonists and Illustrators in Manhattan that he built into the School of Visual Arts, one of the nation's most important colleges for Art and Design, died on Wednesday (June 27, 2007) at his home in Katonah, N.Y. He was 91.

Mr. Rhodes, who remained active as chairman of the school's board, died in his sleep after spending a full day at his office, said his son David, who is the school's president.

Mr. Rhodes and the Illustrator Burne Hogarth, who is perhaps best known for drawing the "Tarzan of the Apes" comic strip for many years, founded the Cartoonists and Illustrators School in 1947, primarily to serve returning veterans, most of whom worked during the day and took courses at night to compete for better jobs in the Advertising and publishing worlds.

The school began with a faculty of three, a student body of 35 and a budget largely supplied by the G.I. Bill. Mr. Rhodes, who had earned a doctorate in English literature from Columbia University before serving as a pilot during World War II, insisted early on that humanities and liberal arts education take a prominent role alongside studio courses.

In 1955 he changed the name of the institution to the School of Visual Arts to reflect its broader mission.

Just as the school was beginning, it ran into trouble that threatened its existence. In 1956 Mr. Rhodes and Mr. Hogarth were called before a Senate investigations subcommittee and asked whether they were members of the Communist Party. The committee was trying to determine whether Communist influence had tainted vocational schools that were supported largely by federal money. Both men said they had not been members since founding their school but they invoked the Fifth Amendment when asked about prior involvement. Their refusal to testify provoked Senator Joseph R. McCarthy, who was quoted in an article in *The New York Times* saying that it proved the men were Communists.

Mr. Rhodes shouted back: "I'll match my record against yours any day in the service. That's a horrible thing to say." The senator responded, "I don't doubt a bit you are a full-fledged Communist."

David Rhodes said his father had been a Communist but left the party in 1936; he said his father told him that the Veterans Administration later audited the school and contested some of the money that had been provided to it through students who were veterans. The dispute between the school and the government was later settled, he said.

Silas Harvey Rhodes was born on September 15, 1915, in the Bronx. His father worked for many years as a postal clerk, and his mother ran a wholesale egg business that failed (Both his parents later worked in longtime administrative roles at the School of Visual Arts).

Besides his son David, of Manhattan, he is survived by two other sons, Stephen, of Goshen, N.Y.; and Anthony, of Katonah; and by six grandchildren. His wife, Beatrice, died in 2002.

Mr. Rhodes, who was raised in the Bronx, received a bachelor's degree from Long Island University and master's and doctorate degrees from Columbia. He wrote a dissertation on the poet Robert Burns and intended to become an English teacher.

But he enlisted after Pearl Harbor and flew missions with the Army's elite First Air Commando Group in Burma, India and China. When he returned, he worked for the Veterans Administration and, with Mr. Hogarth, came up with a plan approved by the administration to create an art school to help veterans.

Mr. Rhodes was a longtime humanities teacher at the school and was its president for six years. In the 1970s he negotiated successfully with the New York State Board of Regents to allow the school to confer bachelor's degrees in fine arts, an authorization not typically given to proprietary schools like his.

During his term as president, the school grew to become the largest independent college of art in the United States, with 2,700 students; it now enrolls more than 3,000 undergraduates and graduate students.

Some of the more illustrious teachers and students over the years have included the Graphic Artists Milton Glaser and Paul Davis, and the Artists Joseph Kosuth and Keith Haring. In addition to pursuing his administrative and teaching duties, Mr. Rhodes was also Creative Director for one of the school's signature public projects, the visually adventurous posters that the faculty has produced for the New York subway for more than 50 years to promote the institution and recruit students.

Mr. Rhodes, who was given to quoting Socrates, ultimately saw the school and its students as promulgators of much more than just good Art, Advertising and Design.

"Education is a moral affair," he wrote in a 1963 essay, "and the ultimate concern of the school is with moral values, while society is concerned with such matters indirectly and only occasionally."

Article by Randy Kennedy / Silas H. Rhodes photographed by Amy Stein, 2006

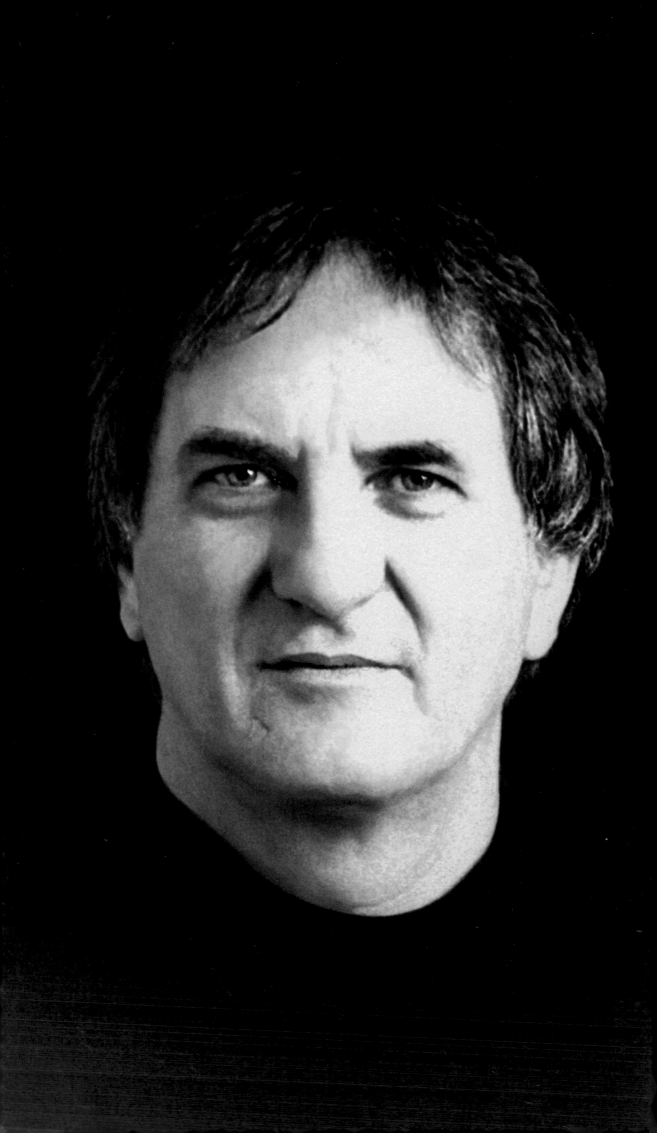

Q&A with Richard Wilde: Chair of SVA's Advertising and Graphic Design Department

SVA Mission Statement: School of Visual Arts is a college of Art and Design whose mission is to educate students who aspire to become professional artists or to work in arts' many related fields. The college's mission is realized by: the employment of working professional artists, critics and scholars in all the disciplines taught at the School of Visual Arts, and whose credentials and experience qualify them to teach at the college level; a commitment of resources to meet the educational and co-curricular needs of students studying at all degree levels, as well as to provide for an enriching campus life experience; a concerted effort to capitalize upon the extremely large number and quality of cultural institutions located in New York City; a system of institutional and learning outcomes assessment designed to facilitate institutional planning and institutional renewal; and a sound financial position sufficient to ensure the college's ability to meet the diverse and dynamic educational needs of the college community, to provide for opportunities for innovation and experimentation and to ensure the maintenance of quality in all areas of the institution's operations.

You have been chairman of the Advertising and Graphic Design Department at SVA for over 35 years. How has the department changed during this time?

The department has reinvented itself over the years to meet the needs and demands of both the student body and an ever-changing social climate. This is carefully reflected in the curriculum. In addition to having a core staple of required Design and Advertising courses, there are several courses added annually to augment the program. Some of these new offerings are: Toy and Game Design, Sustainable Design, Advertising for Social Change, Filmmaking for the Graphic Designer, Music Video, Guerilla Advertising and Entertainment Design. The department has metamorphosed into one that now offers four distinct majors: Advertising, 3D Design, Graphic Design (with all its diverse career options), and Motion Graphics (the next dimension of Graphic Design).

Even though the department is continually changing and adapting, we have always created an environment that nurtures inventiveness, spontaneity, experimentation and love of process, which enables students to develop a sense of identity and purpose in their work.

What do you think is unique about studying Graphic Design and Advertising at SVA?

The unique aspects of the department are defined largely by the conceptual approach it takes in teaching visual communications. It is a program that draws together passionately committed instructors, a dynamic student body, a rigorous curriculum and state-of-the-art technology. In an environment of robust experimentation and a general spirit of openness and exchange, the program is also defined by the ways in which the faculty and students embody a philosophy of nurturing enthusiasm, of stressing the love of process, and most importantly, of emphasizing the art of questioning.

Over the years, it has been said that my department is lacking a unifying style. For me, this 'criticism' is a source of pride, because style by its very definition limits the range of possibilities. Yet, what does exist is a common thread that runs throughout the department — one that manifests itself only upon close inspection. This thread is expressed by students having their own voice. Whether the work is conceptually driven or highly personal, whether it encompasses a sense of wit, a love of craft, a sense of exploration, or a fascination with color, the aggregate result is a kaleidoscope of expression; it is a body of work that signals originality.

What is your philosophy of Design and how does this inform the curriculum?

My central philosophy is that everyone is creative. This can be verified by studying children's art. Unfortunately through early education and social constraints, this innate quality gets buried. The teacher's role is to help rediscover this creativity, this unique quality which lies in the realm of one's own spontaneity by creating conditions that foster a personal investigation to find one's own signature and to nourish this uniqueness that we all have, but have so much difficulty touching. Unlike the more traditional approaches toward Design education, putting students into the realm of the unknown forces them back on their heels

where they have to grapple directly with themselves to develop concepts relative to their level of understanding. It's my belief that the best you can do as an educator is to create conditions where students can flourish. Keep the teachers challenged and the students stimulated — not so they can just go out and get an entry-level job, but to be able to embark on a career for the next 50 years. My educational belief is that in life, and certainly in college, you should learn how to do one thing well, which becomes the measure of doing everything well. It's not about a technique, but about a sense of wonder, a personal vision that can sustain one for a lifetime.

How would you describe the Advertising and Graphic Design faculty? What do you look for when hiring a faculty member?

SVA was founded on the principle that all faculty members should be practicing professionals, and it has held true to this standard throughout its 60 years. The department has over 100 faculty members, which reads like a Who's Who of the industry — some of these luminaries include Paula Scher, Bob Giraldi, Tony Palladino, Ed Benguiat, Carin Goldberg, Louise Fili, Jeffrey Metzner, Jack Mariucci, Chris Austopchuk, Richard Poulin and Seymour Chwast, to name a few. The common denominator among the faculty is their ability to push students past predictable solutions into uncharted territories. This is achieved through an atmosphere of extreme rigor, where commitment evolves into passion. Teaching is always a challenging endeavor. I look for teachers who are passionate about their calling, who inspire their students to create original work. I rely on inspirational teaching much more than on a curriculum. A teacher is someone students want to aspire to be like. Most of the Design greats were teachers at one time or another. Teaching leads to a sense of connectedness, openness. And it leads to growth.

How is the department evolving and what are the plans for the next five years?

Admittedly, I do not have a preset notion, nor do I have a well orchestrated plan; instead I intuit, sense, try to be open to what is needed to not only sustain, but to challenge both students and faculty so as to continually be relevant. Perhaps the best way to understand this is to use the prizefighter Sugar Ray Robinson's technique of counter punching. His plan of action was predicated on the dictates of his opponent. He would not initiate action, but rather, respond.

Why do you think it is important for SVA students to take part in Graphis New Talent?

What has become the overarching issue for many Design schools today is the question of assessment. In short, how does one evaluate student work? For me, there is no better outside assessment criteria than the Graphis New Talent Annual, which is considered the definitive competition within the industry. Using the New Talent Annual as an outside assessor functions as a barometer of where schools rank both nationally and internationally. When a student's work is selected, it's an honor and an empowering experience. I am extremely proud that SVA students have been well represented in this publication over the years. It is a validation, not only for them, but for me as well.

Richard Wilde portrait by Keith Trumbo

Visual Literacy: a beginning class for all Advertising and Graphic Design majors

One of the required classes in SVA's Advertising and Graphic Design program is Visual Literacy, taught by department chairman Richard Wilde. This rigorous course sets the stage for what will be required of the students in the coming years and embodies the theoretical approach of the department. Having more than 100 students each semester in this studio/lecture class makes for a unique dynamic where discoveries can arise. By working on weekly projects that have no limitations on color or medium, which require multiple solutions, greatly increases the chances of pushing their work past predictable solutions. Selecting from approximately 2000 solutions each week, the best work is scanned into a presentation, which sets the tone for the parameters of excellence. The following four projects are examples of what this course produces. While some examples are shown in their entirety, most are single solutions.

Zen (and the creation of images)

In an attempt to touch one's inner self, be present to where ideas arise and to develop a more intuitive and insightful creative process which enhances one's capabilities for problem solving, students were asked to experiment using a grid composed of dots to create images without thinking. This is an activity to bypass habitual thought, where playing in the spirit of a child becomes paramount. They were encouraged to enter a way of working where one visual form dictated the next in a spontaneous and unpremeditated way.

Visual Diary

This project entailed creating a month long personal "visual diary." At the end of each day, students visually recorded the day as a whole, or the most important aspect of that day, or the most memorable part, or a single event, or anything they felt was pertinent. Their solutions could either be literal or abstract, conceptual or formalistic, tightly rendered or spontaneously designed and they allowed their concepts to dictate the appropriate medium. Also, underneath each solution, an explanation of intent was included.

Sound Problem

The task was to graphically represent the sounds of various given topics. It was essential to consider the character of the sound in terms of its tempo, volume, duration, context and color. It was pointed out in this project that although literal problem solving has its place in Design, a graphic vocabulary must be expanded beyond a narrative voice. Hence, the use of metaphor, symbolism, and abstraction was stressed.

Map Problem

The map of the United States and the World are so familiar and commonplace that they lack visual impact. The assignment was to use the map as a point of departure in revitalizing it by working conceptually, creating political or social comments, or altering the map by experimenting with a formalistic approach, or by using abstraction to make a personal statement.

Approaching Communication Design education in the form of experimental projects (as shown in the Zen, Visual Diary, Sound and Map assignments) serves as the precursor for work that meets the standards for inclusion in the New Talent Design Annual.

"Remember the ability to come up with new ideas is already there. It's your birthright. It doesn't have to be invented. It has to be rediscovered." Richard Wilde, Chair

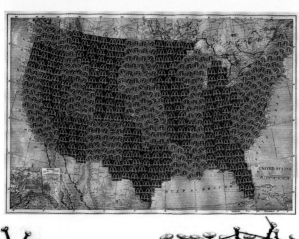

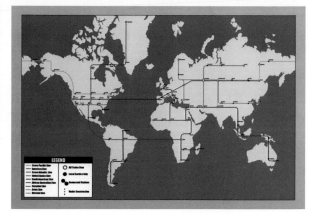

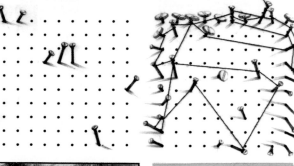

DID HOMEWORK
ALL DAY

I hate my
insomnia

DID MY LAUNDRY

COOKED
BEEF

feel dizzy

DEVASTATED

Today I feel like a big
ugly green nonsensical
yellow teeth. Ugh.

OPENING A BOTTLE OR CAN OF BEER

ELEVATOR MUSIC

WHISTLING TEA KETTLE

CONVERSATION BETWEEN A PICCOLO
AND AN UPRIGHT BASS

Map Problem | Zen | Visual Literacy | Sound Problem

SVA Information

School Address:
209 East 23 Street, New York, NY 10010
Website: www.sva.edu
Admissions Department:
Tel 212.592.2100 / *email* admissions@sva.edu
Number of Enrolled Students: 3715
Number of Faculty: 830
Pupil-Teacher ratio: 4 to 1
Average Class Size: 15 (undergraduate), 12 (graduate)
Internship and Job Placement Assistance:
Outstanding Career Development office with online job listings, counseling and assistance
Pre-College Program:
SVA's Pre-College Program is designed for high school students who want to enhance their creative skills, learn more about a particular field of art, develop a portfolio, and/or experience the challenges and triumphs that exist at one of the most dynamic colleges. In courses taught by the same faculty of leading art professionals who teach in the undergraduate degree program of the college, students will explore the fundamentals of Art & Design at a level not readily available in high school.
Continuing Education:
SVA offers over 400 continuing education classes per semester, with a broad curriculum that encompasses Communications, Design, Entertainment and Fine Arts. The faculty is made up of distinguished professionals and established artists who help make SVA one of the most respected colleges of the arts.

Tuition Cost:
$11,760 per semester (undergraduate)
$13,060 per semester (graduate)
Scholarship Opportunities:
SVA awards partial tuition scholarships to new students entering the fall semester through the Silas H. Rhodes Scholarship program based on academic and creative merit.
SVA Alumni Association:
The Office of Alumni Affairs is dedicated to advancing the cultural and educational best interests of its members. Through programs, publications, special events and promotions, the office maintains an active relationship with the alumni and encourages them to support the college's mission to educate students who will be prepared to enter the professional world of art.
Notable SVA Alumni:
Deborah Adler, *Designer*
Matthew Ammirati, *Principal, Ammirati*
Sam Bayer, *Director*
Paul Davis, *Designer and Illustrator*
Sal DeVito, *Principal, DeVito/Verdi*
Genevieve Gorder, *Producer, Director and Actor*
Drew Hodges, *Principal, SpotCo*
Joseph Kosuth, *Conceptual Artist*
Sol LeWitt, *Minimalist Installation Artist*
Kevin O'Callaghan, *3D Designer*
Bill Plympton, Director, *Animator*
Kenny Scharf, *Painter*
Todd Seisser, *Creative Director*

"We think of SVA as the quintessential American art college. By that we mean that SVA is animated by a principle which is America's unique contribution to philosophy — pragmatism. Pragmatism entails experimentation. Experimentation necessarily entails success and failure. We keep what is successful and discard what is not. Our pragmatic approach permits us a faculty with incompatible views bound only by a commitment to excellence. In this way we are able to keep the curriculum current and fresh. We are not tied to an ideology or theory which purports to be timeless but whose time has long passed. Under the inspired direction of Richard Wilde, SVA's Advertising and Graphic Design Program is a uniquely successful expression of this philosophy." David Rhodes, *President*

This page: SVA amphitheater, opposite page: SVA main building, all photographed by David Corio

Oct. 24 – Dec. 2, 2006

Visual Arts Museum

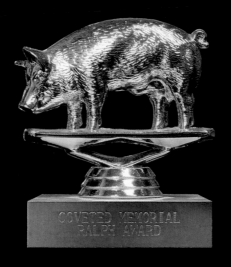

COVETED MEMORIAL
RALPH AWARD

The Creative Summit at Texas State University in San Marcos: An Ecosystem

Imagine a stage filled with world-class creative people like Kit Hinrichs, Anita Kuntz, Gene Hoffman, Dana Arnett, B. Martin Pedersen, Jennifer Morla, Lana Rigsby, McRay Magleby, C. F. Payne, Stefan Sagmeister, Greg and Pat Samata, Forrest and Valerie Richardson, Michael Vanderbyl, Francois Robert, and Jack Unruh. They are all applauding and looking out to the audience with big smiles. Shyly, a nineteen-year-old student stands up and makes her way to the stage to accept an award and cash prize for her package design, which is projected twenty feet high above everyone's head. It is a moment that this young lady will not soon forget. Now imagine that scene is acted out every year with more world-class talent and more nineteen-year-olds. Who or what could bring scores and scores of big names to the hot and sleepy little town of San Marcos, Texas? The who is Chris Hill, and the what is the Creative Summit.

It is hard to talk about the different sides of Chris Hill — an "A list" Designer and recent AIGA Fellow; his solid Houston firm, HILL; or the Creative Summit, the perennially successful Design conference for students he founded in 1984 while teaching on the weekends — as separate items. In many ways they are the same animal. This is a piece mostly about the Creative Summit aspect.

In the twenty-three years that Chris has grown the brand, the Creative Summit has become an energizing force in the Design world, creating a heightened education experience for students from all over the South. To date, Chris has raised over $200,000 in scholarships. Branders know that a great brand is essentially a great experience. Chris has designed an experience that shows no sign of age, no wear or tear. The Summit works on many levels that deepen its identity as an annual regional Design event. Here is the ecosystem of the Creative Summit.

From September to May, the student competition, the Summit's ignition system, is in the back of the minds of every Graphic Design student and teacher within 800 miles of San Marcos. Student competitions are useful, but this one has the bonus of encouraging wide-ranging intramural competition. Not just the students, but the schools themselves, engage in the competition. The results of every project undertaken throughout the year are measured with a steely eye: "Is it good enough to enter the Creative Summit?" Each time the bar gets raised.

As the Summit rolls into production, many of the student entrants help organize the event. (My guess, however, is that the dear and dedicated HILL office still does the heavy lifting of providing logistics, funding, and thousands of hours of time.) The student volunteers gain insight into the process of creating a gathering — a good thing by itself — and volunteers get clipboards and lists of tasks, which require them to run around — also very good. They see every piece that is entered into the competition, an even better thing, and they hang around with nationally recognized visiting pros who have relaxed into the bosom of Texas hospitality and who engage the students at close range, which is a powerful thing. The student volunteers get to talk Design and see how the pros judge Design. They get a glimpse into how big and how small the process is. And they grow.

The Summit's Design education experience is not only for the students. In earlier days, the judges/speakers bunked in a moldering yet perfect little "resort," Aquarena Springs, which in still earlier days headlined an aquatic act featuring "Ralph the Diving Pig." No, really. Back then, Aquarena Springs was as big on bugs as it was small on formality.

Chris made sure you enjoyed yourself. You quickly understood you were with family, of the best kind. (Chris kept the rumor of Ralph's eminent comeback afloat for years, until the Summit eventually moved to less memorable lodgings. The trophy for the Summit still is a gold pig, cheaply crafted in Ralph's honor. I am proud to say my wife, Karin Hibma, and I possess four Ralphs; one wears a tiny Hawaiian shirt, though how he acquired the shirt or how I qualified to receive the dapper Ralph eludes me.) The experience of such casual and boundless good humor, inspired by Chris's personality, is a tonic to all the visitors he invites. Everyone becomes, to a greater or lesser degree, a part of the family. The pros feel privileged to be in each other's company, and they take away a renewed sense of the passion of being a Designer or Photographer or Illustrator or whatever. And they grow as well.

The experience continues with the exhibition and talks. The pros, after judging, hanging out, and doing a lot of laughing and sharing with individual students and one another, usually deliver their best talks, speaking more from the heart than they might do somewhere else. And at the very end of the event, awards are presented. This, too, falls into the heightened experience category. Each winner gets a kind of group acknowledgment from the judges (here is where the scene described in the first paragraph comes in): hands are shaken and backs are patted for an effect like a baptism of "attaboys" that gives the winners their first big taste of recognition, a feeling they will want to chase for years.

The Summit experience continues as the students make their way into the world of Design as interns and assistants for the very pros, speakers, and judges they met and hung out with in San Marcos. The pros become apostles for the Summit. They encourage others, both old pros and new pros, to go to Texas if Hill invites them. The cycle continues.

As other conferences wither and morph, the Creative Summit gets stronger. The why in the equation is Chris Hill himself. Long ago Chris understood that Design is essentially a way to think about and do everything. For him and his team, making the Creative Summit work year after year is not a struggle; it is yet another opportunity to feel the passion of being a Designer.

Article by Michael Cronan, July 9, 2007
Cronan Design, 3090 Buena Vista Way, Berkley, CA 94708 2020 / www.cronan.com
Creative Summit, San Marcos, Texas / www.creativesummit.com
Creative Summit is hosted by Chris Hill of HILL, 3512 Lake Street, Houston, TX 77098 / www.hillonline.com
Image credits: previous spread & top left – Chris Hill portrait by Terry Vine Photography, top right – Michael Cronan portrait by Terry Lorant, opposite page – Summit Books photograph by Ralph Smith Photography

Past Creative Summit Speakers:

Gail Anderson	Bill Carson	Brian Gibb	Phil Hollenbeck	Ed Lindlof	Everett Peck	Stefan Sagmeister	Laura Smith
Jim Anderson	Roger Christian	Gary Gibson	Nigel Holmes	Michael Mabry	B. Martin Pedersen	Greg Samata	Jennifer Sterling
Andre Andreev	Jim Couch	John Giordani	Jim Jacobs	Eric Madsen	Victor John Penner	Pat Samata	Dugald Stermer
Marshall Arisman	G. Dan Covert	Abby Godee	Chuck Jennings	McRay Magleby	Rex Peteet	Sandro	DJ Stout
Dana Arnett	Michael Cronan	Keith Gold	Paul Jerde	Bob Marberry	Bryan Peterson	Mike Schneps	Ron Sullivan
Lawrence Azerrad	Jose Cruz	Bill Grigsby	Bryan Jesse	Jeff McKay	Charles Phoenix	Jason Schulte	Jack Summerford
Eric Baker	Hillman Curtis	Melissa Grimes	Doug Johnson	Phillip Meggs	Steve Pietzsch	Ellen Schuster	Rick Tharp
Gary Baseman	Dan Daues	Eric Heiman	Ron Jones	Arthur Meyerson	Raphaele	Michael Schwab	Jack Unruh
Peter Bell	Michael Doret	Christian Helms	David Kampa	Duane Michals	Myers Raymer	Mark Searcy	John Van Dyke
John Bielenberg	Regan Dunnick	Jerry Herring	Robb Kendrick	Clement Mok	Forrest Richardson	Ken Shafer	Michael Vanderbyl
Kim Blanchette	Pat Epstein	Karin Hibma	Jeffrey Keyton	Jennifer Morla	Valerie Richardson	Jim Sherraden	James Victore
Linda Bleck	Gary Faye	Mike Hicks	Charlie Kifer	Sarah Nelson	Lana Rigsby	Don Sibley	Terry Vine
Steve Brady	Louis Fishauf	Chris Hill	Anita Kunz	Rosanne Olson	Kim Roberson	J. Otto Siebold	Don Weller
Braldt Bralds	Craig Frazier	Kit Hinrichs	Paul Kwong	Gary Panter	Francois Robert	Rich Silverstein	Kent Whitten
J.W. Burkey	Steve Frykholm	Gene Hoffman	David Lerch	Francis Pavy	Jean Robert	Jim Sims	Fred Woodward
George Campbell	Mark Geer	Brad Holland	Lance Letscher	C.F. Payne	Chris Rovillo	Rad Sinyak	Sam Yeates

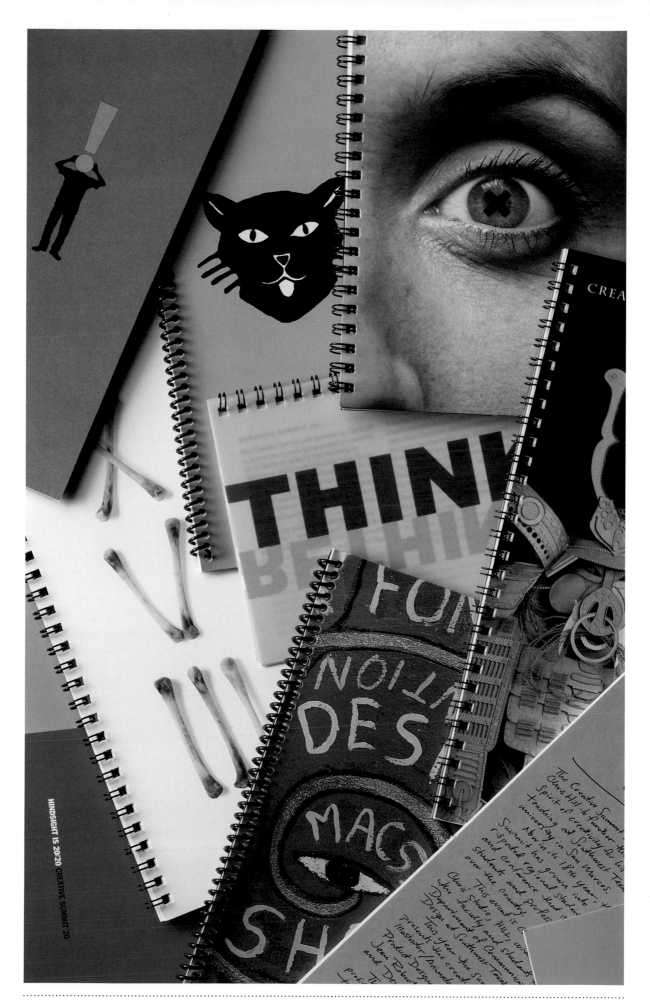

Creative Summit Facts: *Started in 1985 by Chris Hill while teaching on weekends at Texas State University. The Creative Summit is a 501c3 non-profit organization and is not affiliated with any organization or university.*
Location: Texas State University, San Marcos (30 min South of Austin)
Attendees: 500 students, professors, professionals and past speakers
Students: From 20 universities of 6 different states
Auction: Speaker & past speaker silent auction of art, photographs, posters, books, etc.
Presentations: 12 guest speakers

Creative Summit Student Show
Entries: over 250 portfolios with a total of over 2,000 entered each year
The Judging: 12 to 20 speakers and past speakers jury the show
Show: Approximately 110 entries are selected into the show
Best in Show awards: 25 coveted Memorial Ralph Awards
Student Cash Scholarships: All entries selected for the show receive a cash award as well the Best in Show awards up to $3,000
Historical: Over the last 4 years cash prizes have totaled $100,000

A Cara Bailey, Texas State University
"Roxanne Sides, Sandra Munoz, Gaby Hoey"
Instructor: Holly Shields

Mkuki Bgoya, Texas A&M University – Commerce
"Things Fall Apart - Chinua Achebe"
Instructor: David Lloyd Beck

J.Emerick Carlson III, Texas State University – San Marcos
"Casting Call"
Instructor: William "Bill" Meek

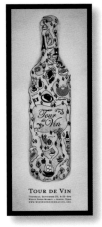

Lauri Combest, Texas State University – San Marcos
"Tour De Vin Poster"
Instructor: Tom Berno

Colin Decker, Texas State University – San Marcos
"Allen Lafuente, John Livingston, Ashley Ross, David Kelly"
Instructor: Holly Shields

Chad Ehlingerm, Texas State University
"Paper system for Ministry of Tourism"
Instructor: Jeff Davis

Jessica Gassen, Texas State University
"Public Service Announcement Poster"
Instructor: William Meek

David Irias, Art Institute of Houston
"The Motorcycle Diaries film poster DVD/CD soundtrack"
Instructor: Michele Damato

Lupe Mendoza, Texas State University – San Marcos
"Final Portfolio"
Instructor: Eric Weller

Miguel A. Martinez, The Art Institute of Houston
"Oink"
Instructor: Arden de Brun

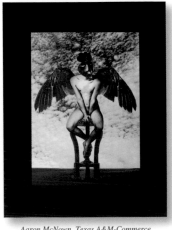

Aaron McNown, Texas A&M-Commerce
"Baros, Photo Collage Book Illustration"
Instructor: David Beck

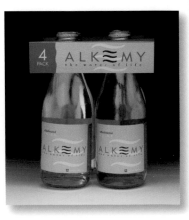

Robert Charles Miller, Texas State University
"Alkemy, alkalinated drinking water"
Instructor: Jeff Davis

Oscar Morris, Texas State University – San Marcos
"Guam Visitors Bureau Paper System"
Instructor: Jeff Davis

George Morrow, University of Texas, Austin
"Mafia"
Instructor: Chris Taylor

Angela R. Mosera, Texas A&M – Commerce
"The American Museum of Miniature Arts"
Instructor: Todd Sturgell

Rebecca Pequeno, Texas State University – San Marcos
"Isla Mujeres Resort"
Instructor: Jeff Davis

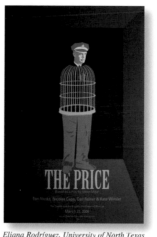

Eliana Rodríguez, University of North Texas
"The Price"
Instructor: Eric Ligon

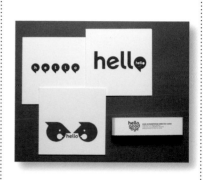

Nathan Sharp&Charlie Howlett, Texas Christian University
"Hello Greeting Cards"
Instructor: Pat Sloan

Sara Sparrow, Texas State University
"Hula Fest"
Instructor: Bill Meek

Michael Thao, The University of Texas at Arlington
"illustration & design by michael thao-website"
Instructor: Lisa Graham

John Tullis, Texas State University
"Passenger '46"
Instructor: Eric Weller

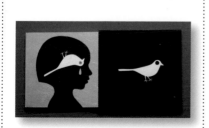

Yoshimi Umekawa, Texas A&M University – Commerce
"To Kill A Mockingbird"
Instructor: David Beck

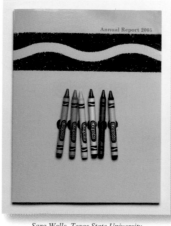

Sara Wells, Texas State University
"Crayola Annual Report"
Instructor: Jeff Davis

Whitney Leigh Wiedner, Texas State University – San Marcos
Art & Design
Instructor: Holly Shields

Thipchat Arthasarnprasit, Art Institute Houston
"White Leaf Book"
Instructor: Greg Lofgren

Zach Bard, Texas A & M – Commerce
"Yellow Tennis Shoe Poster"
Instructor: David Beck

Ben Barry, University of North Texas
"Land of the Free Poster"
Instructor: Eric Ligon

Sarah Beattle, Texas State University
"Guitar Picks Crocodile"
Instructor: Bill Meek

Clint Breslin, Texas State University
"Red Cross Sewing Machine"
Instructor: Carolyn Kilday

Debby Chang, Texas State University
"Birds and Bees"
Instructor: Bill Ward

Caleb Everitt, Texas State University
"Identification Tag BS Cards"
Instructor: Michelle Hays

David Irias, Art Institute Houston
"Ethanol White Corn on Green "
Instructor: Greg Lofgren

Sarah Joy Jones, Texas State University
"Girl Scout Boy Scout Book"
Instructor: David Shields

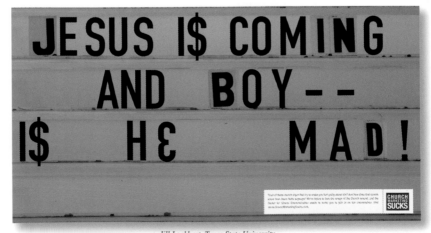

Jill Lockhart, Texas State University
"Jesus is coming and boy is He mad"
Instructor: Claudia Roeschmann

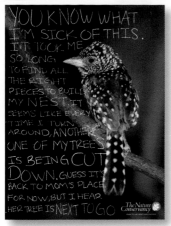

Patton King & Adrienne Rosales, University of North Texas
"Bird with Writing"
Instructor: Holly Shields

Royal King, University of North Texas
"This is my toilet seat book"
Instructor: David Shields

slightly used.

Andrew Lopez, Texas State University
"Apple on Blue Poster"
Instructor: Michelle Hays

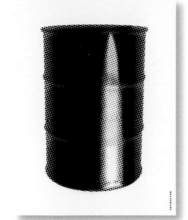

Cesar Rivera, Texas State University
"Big Black Barrell Bullet Poster"
Instructor: Bill Meek

Jedidiah Rogers, Texas State University
"158273 Book"
Instructor: David Shields

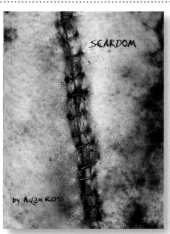

Adam Ross, Texas State University
"Scardom Book"
Instructor: David Shields

Arely Santos, Art Institute Houston
"Intestinal Alphabet"
Instructor: Michele Damato

Christal Sedlock & Jeffrey Schanzer, Texas State University
"Birds and Bees"
Instructor: Holly Shields

Jennifer Stouffer, Texas State University
"Raindogs Folded Box"
Instructor: David Shields

PlatinumWinningInstructors:

Frank Anselmo, *School of Visual Arts*
18 winning projects

Jack Mariucci, *School of Visual Arts*
15 winning projects

Jeffrey Metzner, *School of Visual Arts*
13 winning projects

Award photograph by Henry Leutwyler

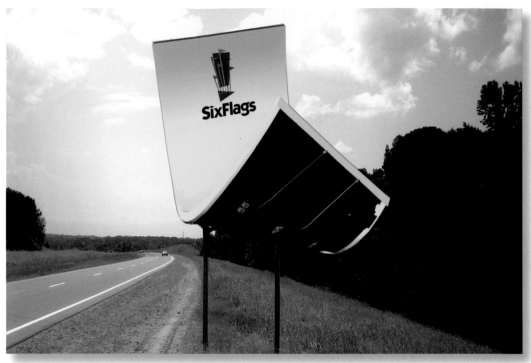

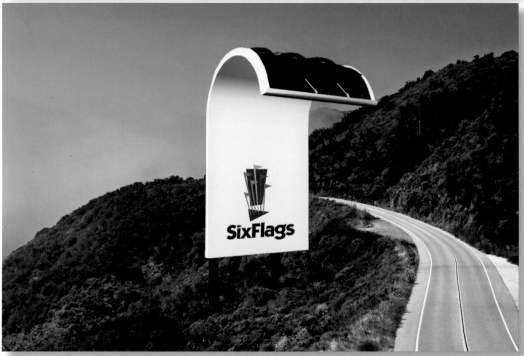

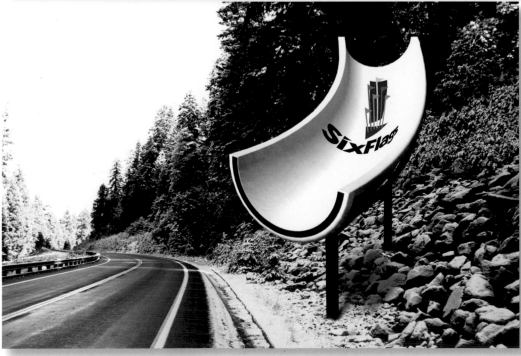

Jeffrey Metzner School of Visual Arts **Raisa Ivannikova**

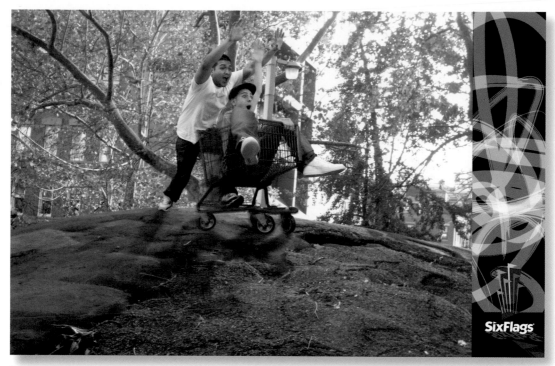

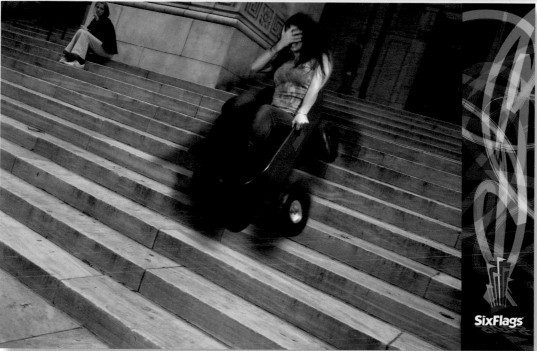

Jeffrey Metzner School of Visual Arts **Jon Barco** Amusement Parks|Advertising**25**

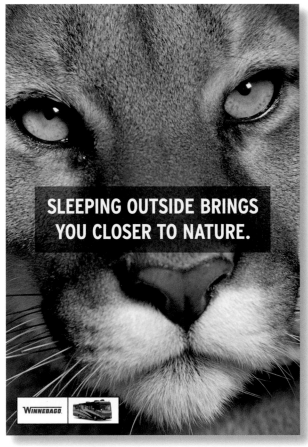

SLEEPING OUTSIDE BRINGS YOU CLOSER TO NATURE.

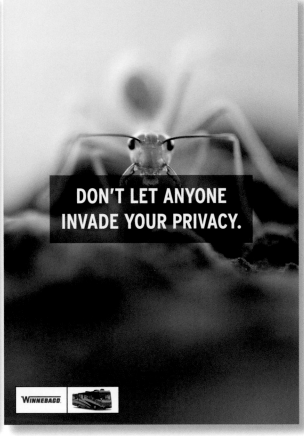

DON'T LET ANYONE INVADE YOUR PRIVACY.

Sal Devito School of Visual Arts **Raymond Lee**

Sal Devito School of Visual Arts **Jordan T. Farkas**

OBJECTS? WHAT OBJECTS?

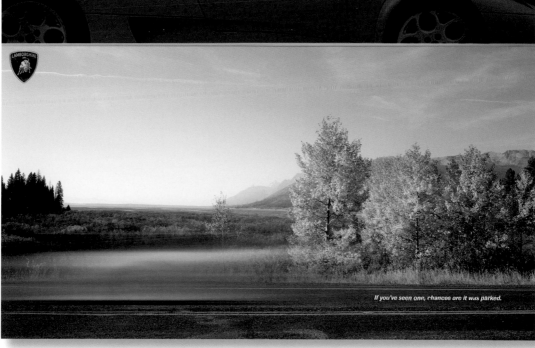

If you've seen one, chances are it was parked.

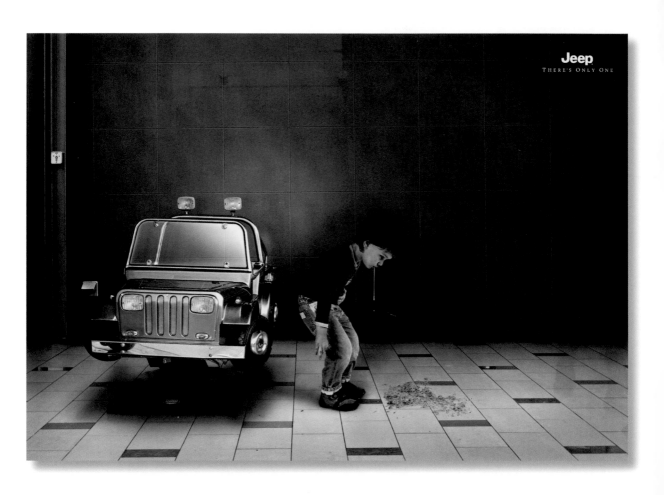

Claudia Bach Miami Ad School Europe, Hamburg, Germany
Armands Leitis, Emilia Bergmans

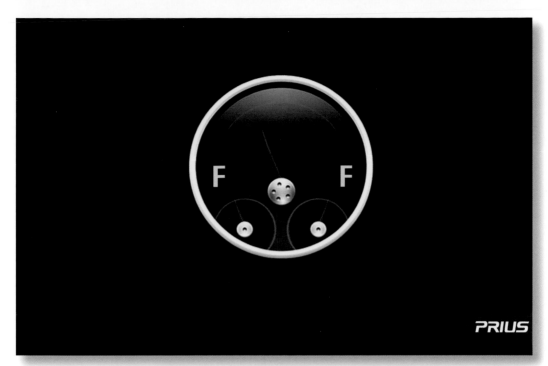

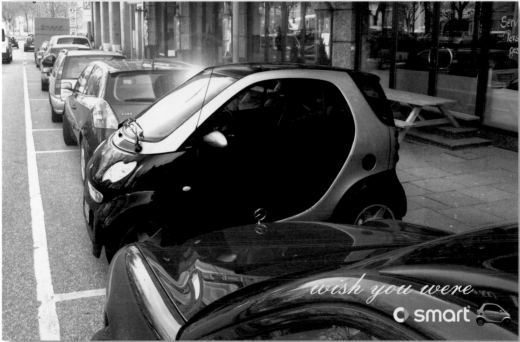

Jack Mariucci School of Visual Arts **Andrew Seagrave**
Jeffrey Metzner School of Visual Arts **Lauren Moreau**
Jack Mariucci School of Visual Arts **Kianga Williams**

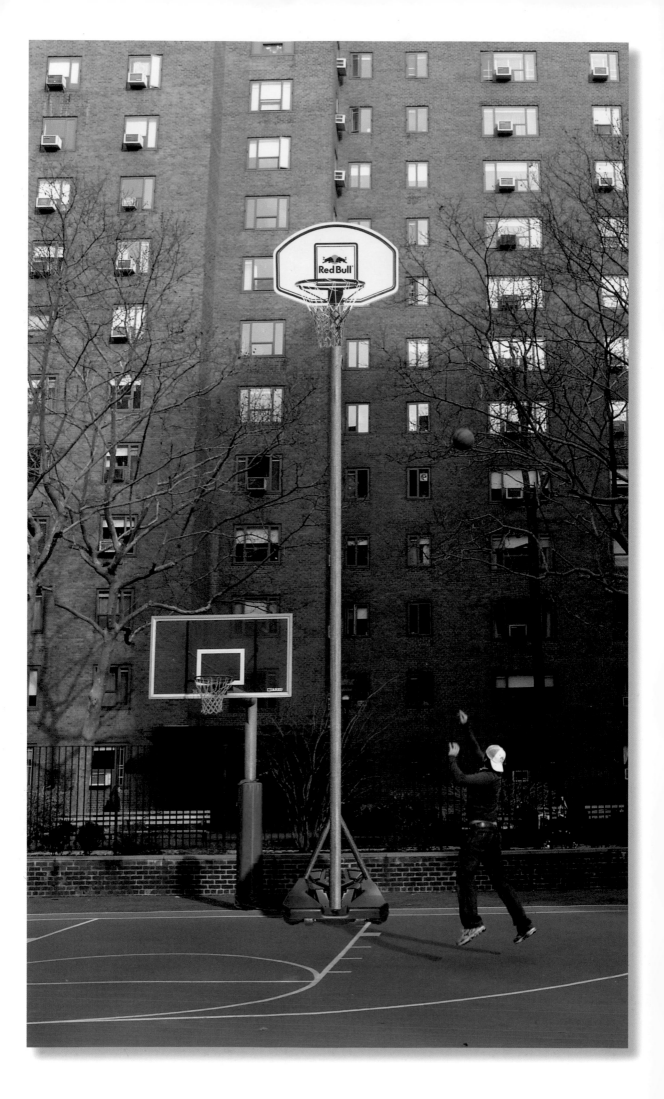

Frank Anselmo School of Visual Arts **Benjamin Rogan, Deniz Yegen**

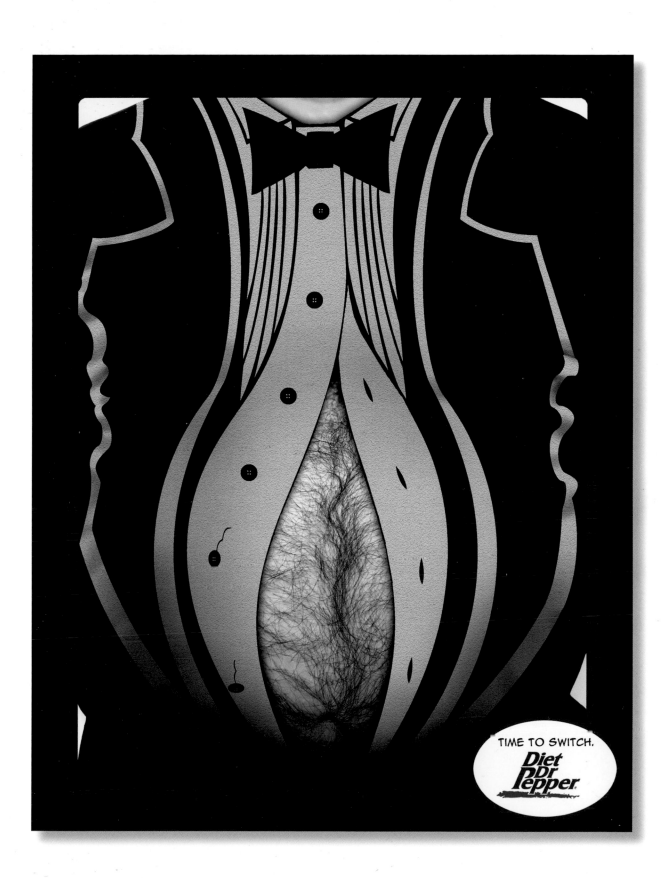

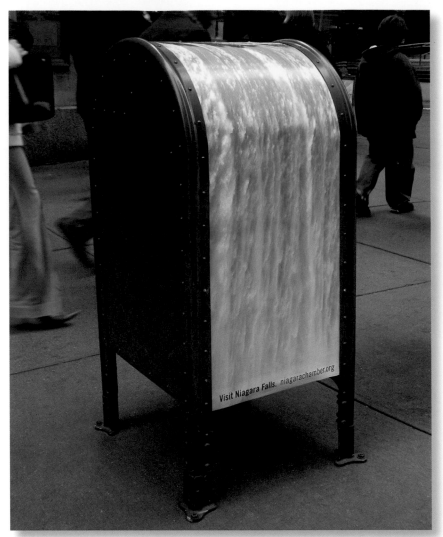

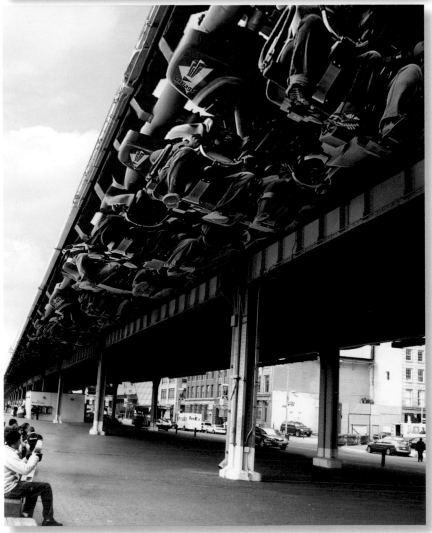

Frank Anselmo School of Visual Arts **Ji Hyun Lee, Su Won Chang**
Jeffrey Metzner School of Visual Arts **Ji Hyun Lee**

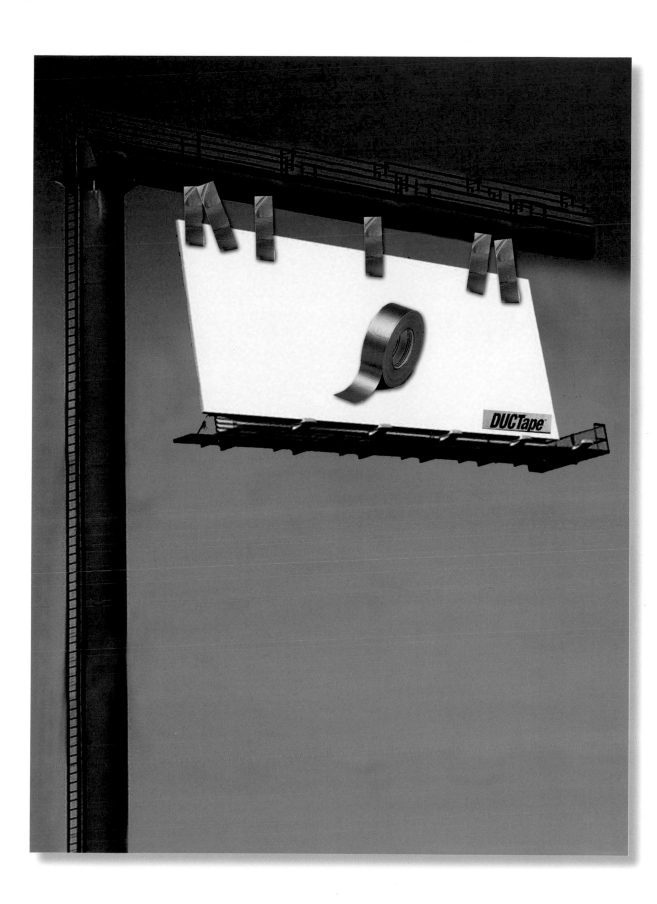

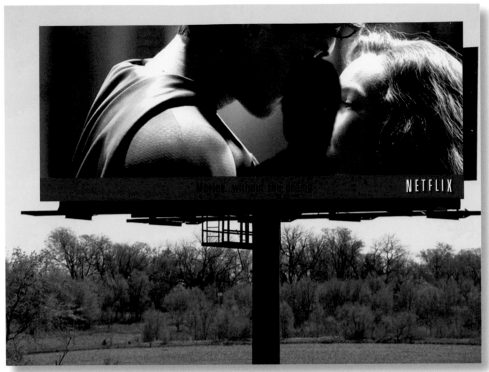

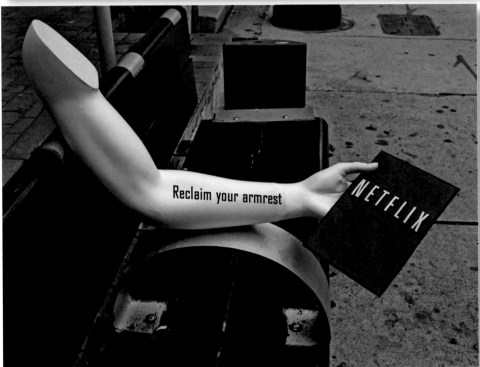

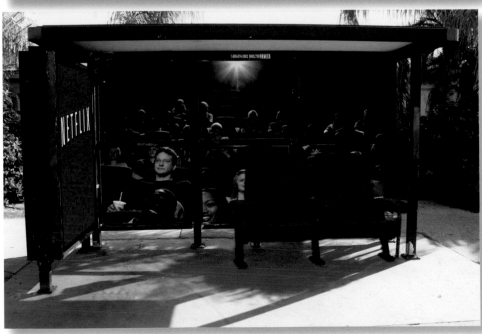

Ian Mavaroh Miami Ad School, Miami **Olivia Rios**

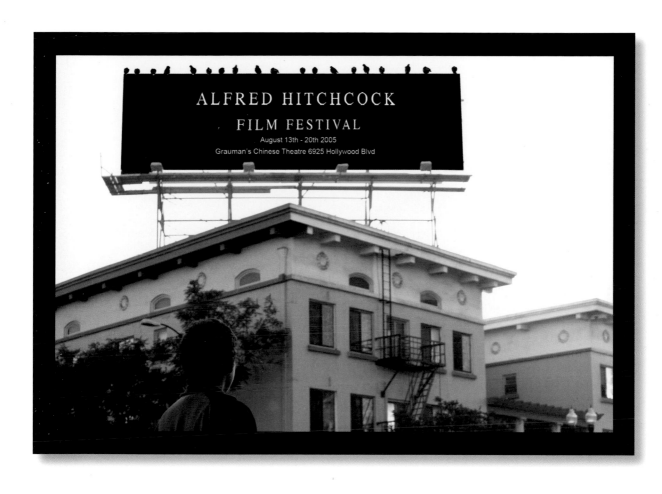

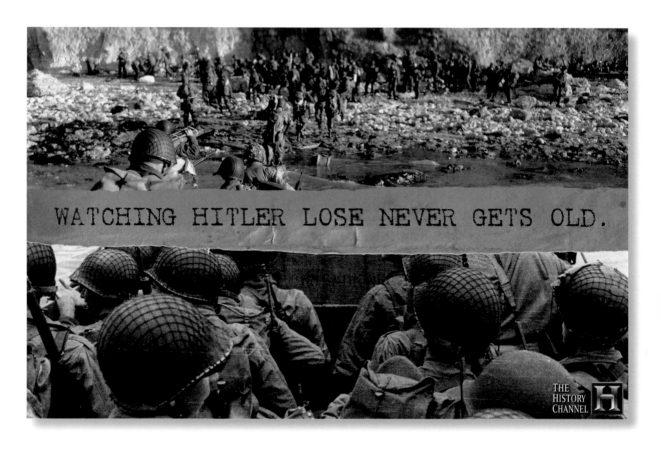

Vincent Tulley School of Visual Arts **Alexei Beltronel, Jay Marsen**

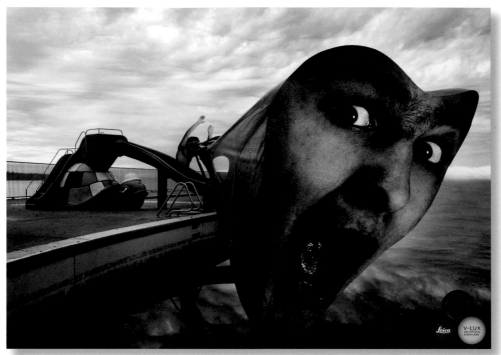

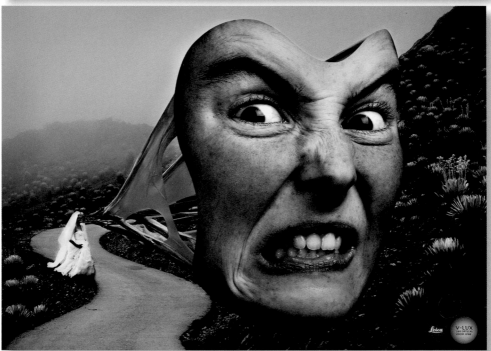

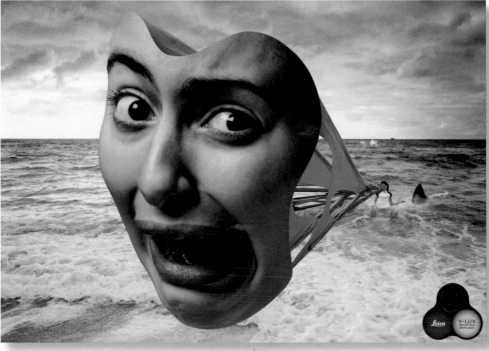

Timm Weber Miami Ad School Europe, Hamburg, Germany
Siavosh Zabeti, Clemens Ascher, Alexander Kalchev, Fabian Tritsch

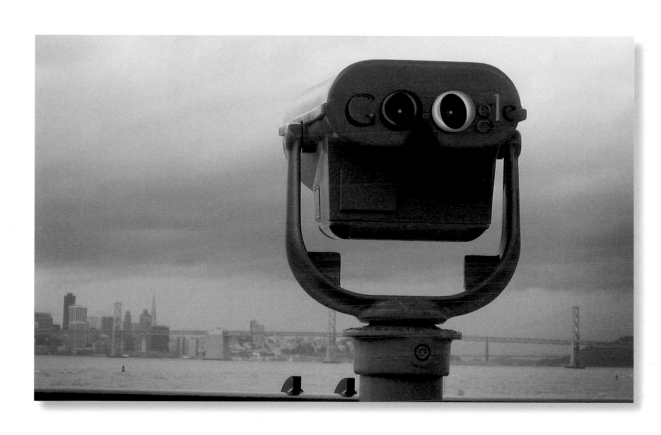

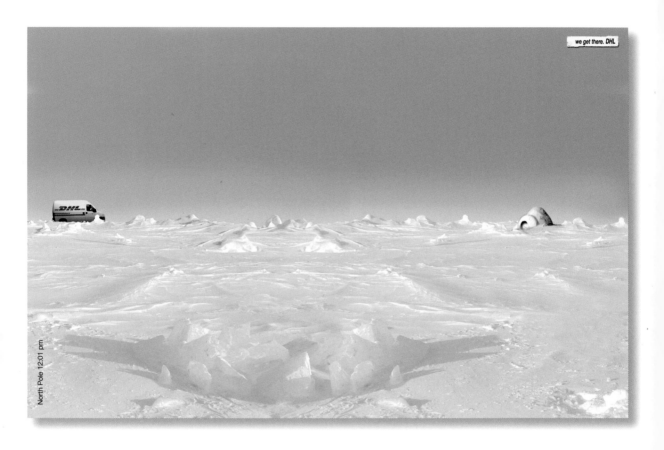

Sal Devito School of Visual Arts **Maria Lotuffo**

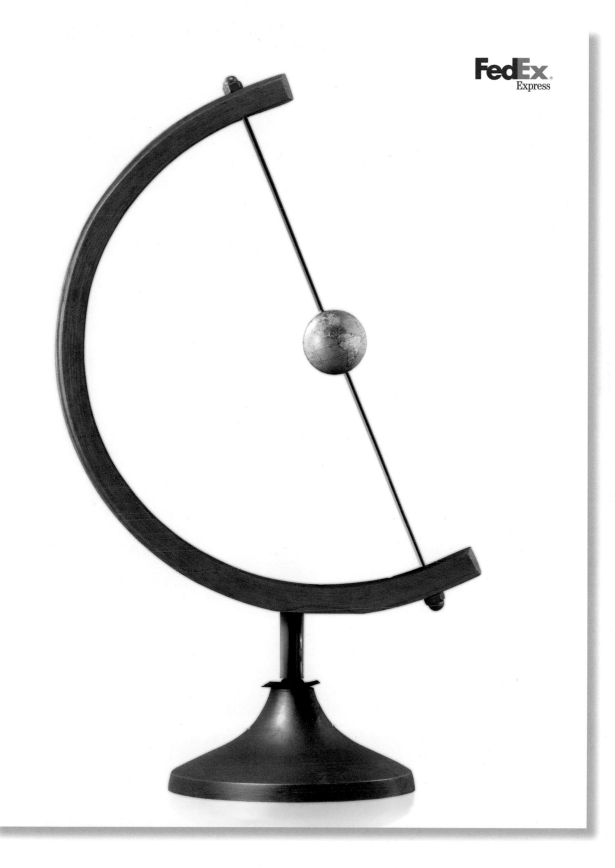

Frank Anselmo School of Visual Arts **Jeseok Yi** DeliveryService|Advertising**43**

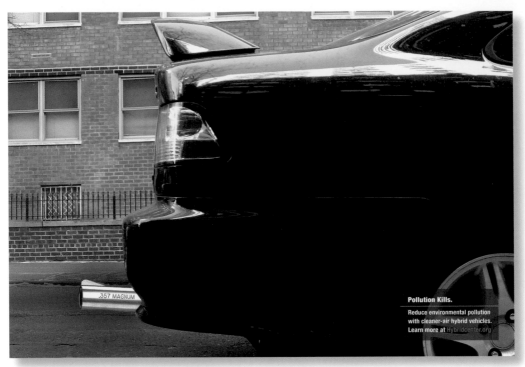

Pollution Kills.

Reduce environmental pollution with cleaner-air hybrid vehicles. Learn more at Hybridcenter.org

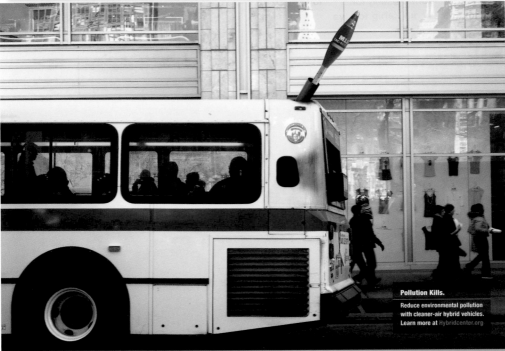

Pollution Kills.

Reduce environmental pollution with cleaner-air hybrid vehicles. Learn more at Hybridcenter.org

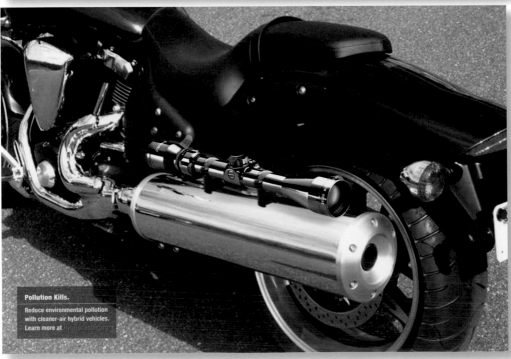

Pollution Kills.

Reduce environmental pollution with cleaner-air hybrid vehicles. Learn more at Hybridcenter.org

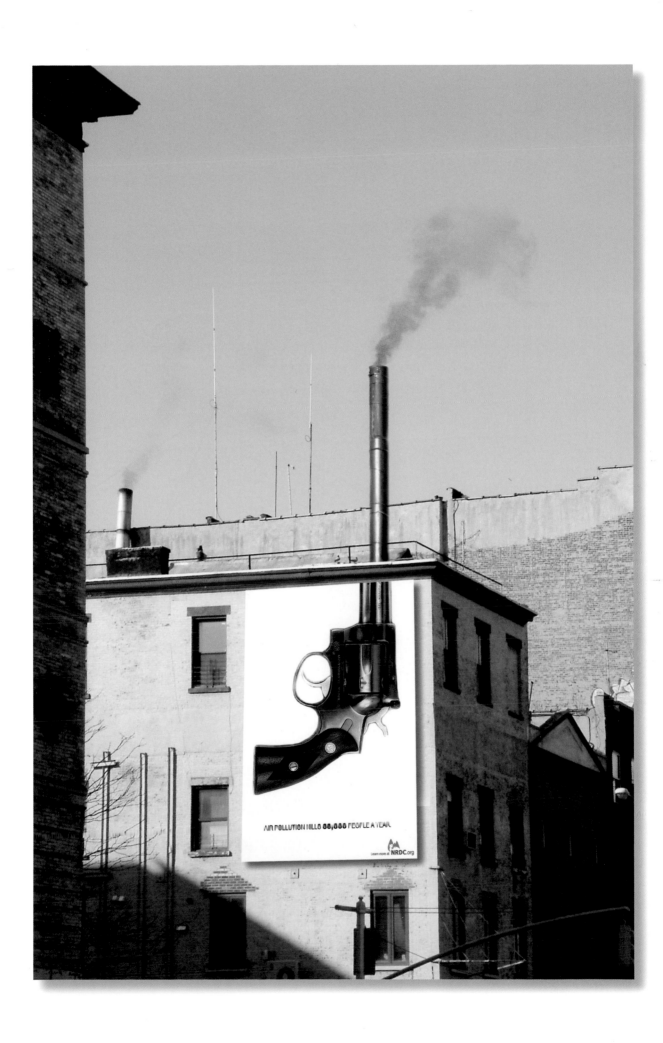

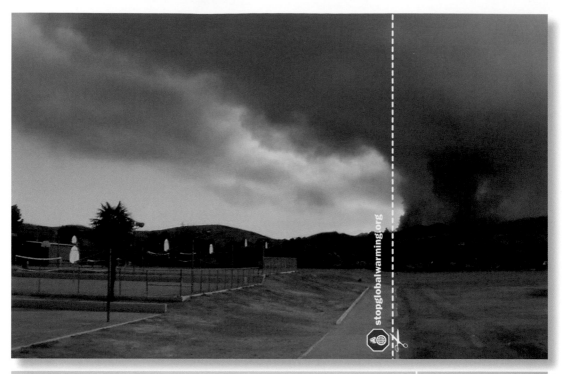

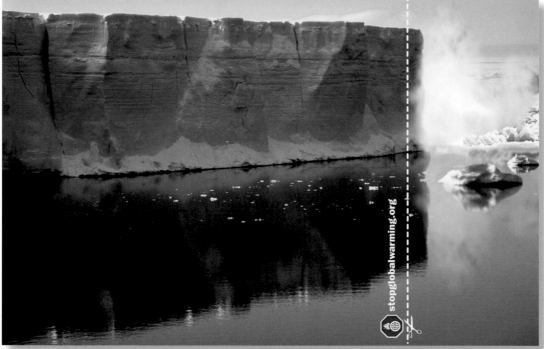

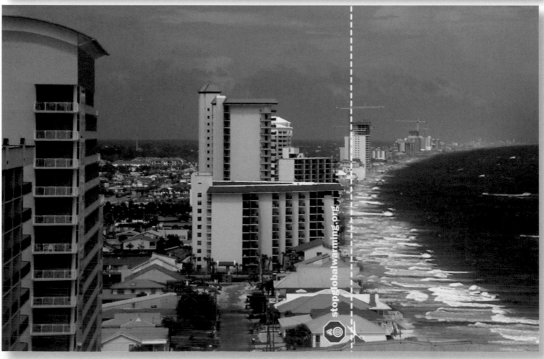

Frank Anselmo School of Visual Arts **Benjamin Rogan, Deniz Yegen**

Frank Anselmo School of Visual Arts **Ashley Montgomery**

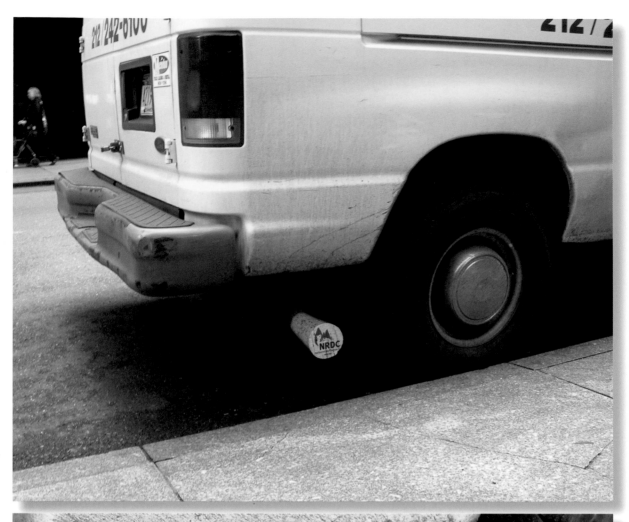

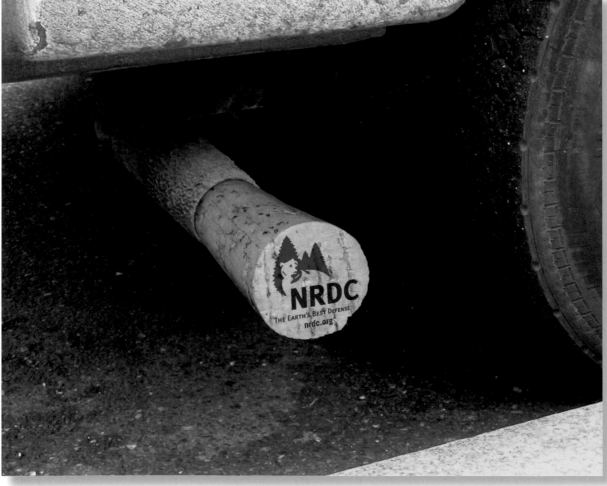

Frank Anselmo School of Visual Arts Ashley Montgomery

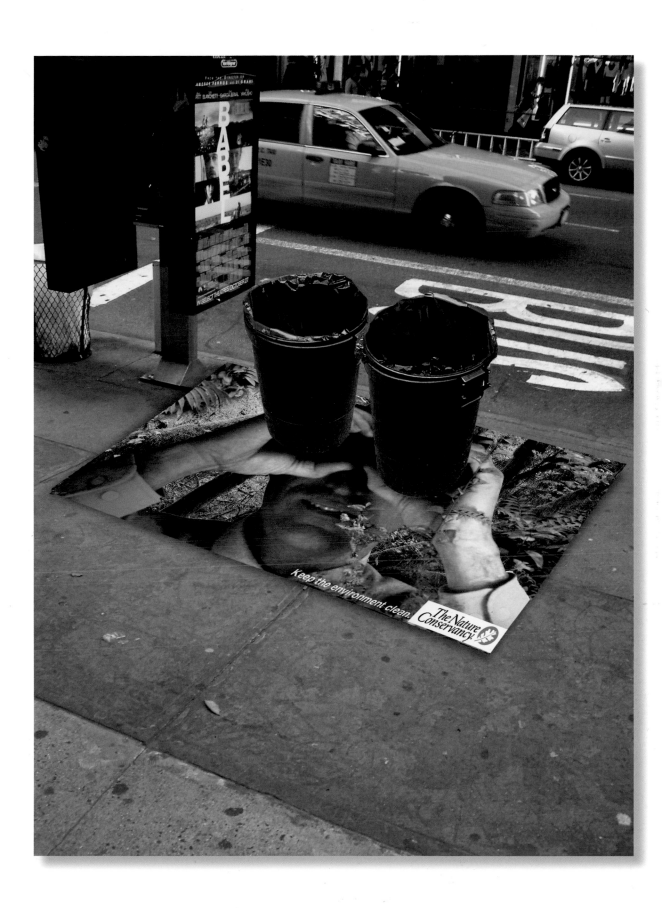

Keep the environment clean.

The Nature Conservancy

FOREST GREEN

SAVE OUR ENVIRONMENT NRDC.ORG

ARCTIC BLUE

SAVE OUR ENVIRONMENT NRDC.ORG

EARTH BROWN

SAVE OUR ENVIRONMENT NRDC.ORG

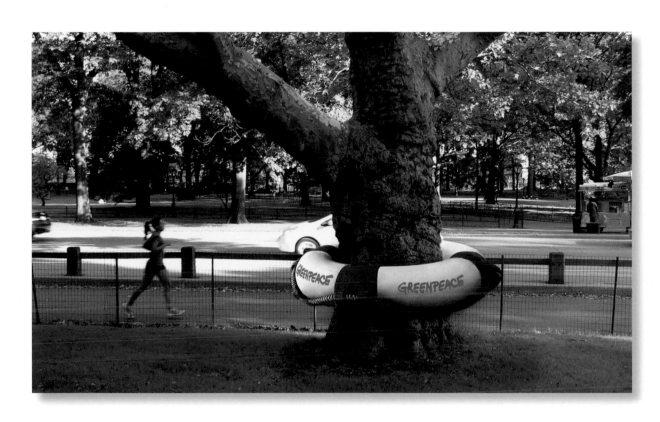

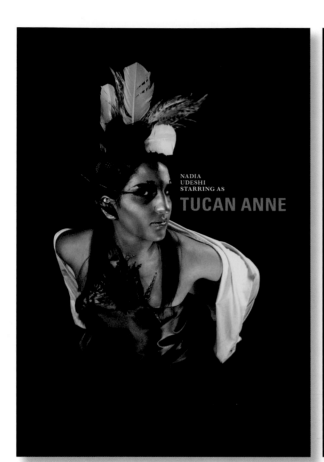

NADIA
UDESHI
STARRING AS
TUCAN ANNE

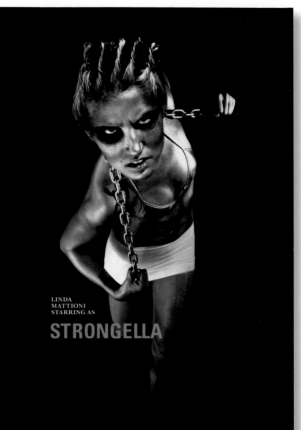

LINDA
MATTIONI
STARRING AS
STRONGELLA

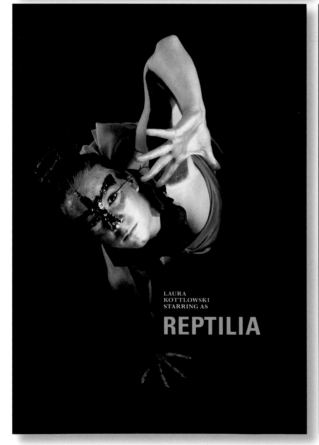

LAURA
KOTTLOWSKI
STARRING AS
REPTILIA

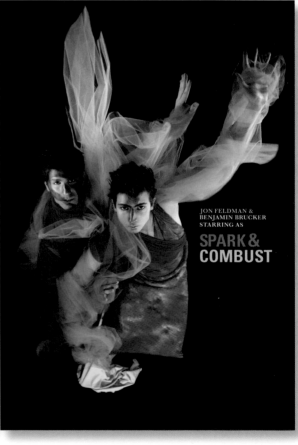

JON FELDMAN &
BENJAMIN BRUCKER
STARRING AS
SPARK &
COMBUST

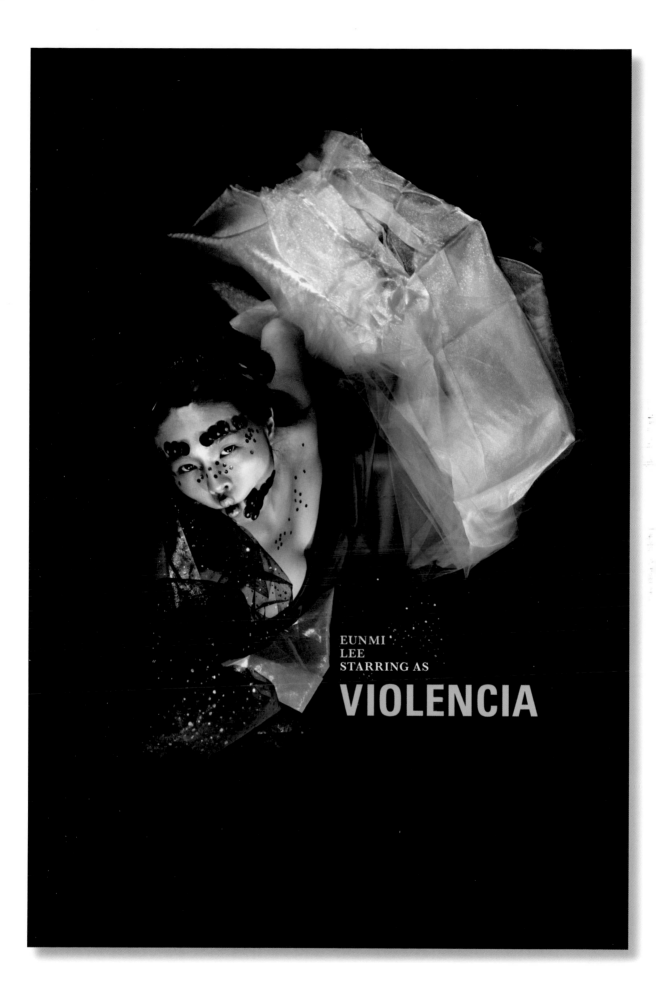

EUNMI
LEE
STARRING AS

VIOLENCIA

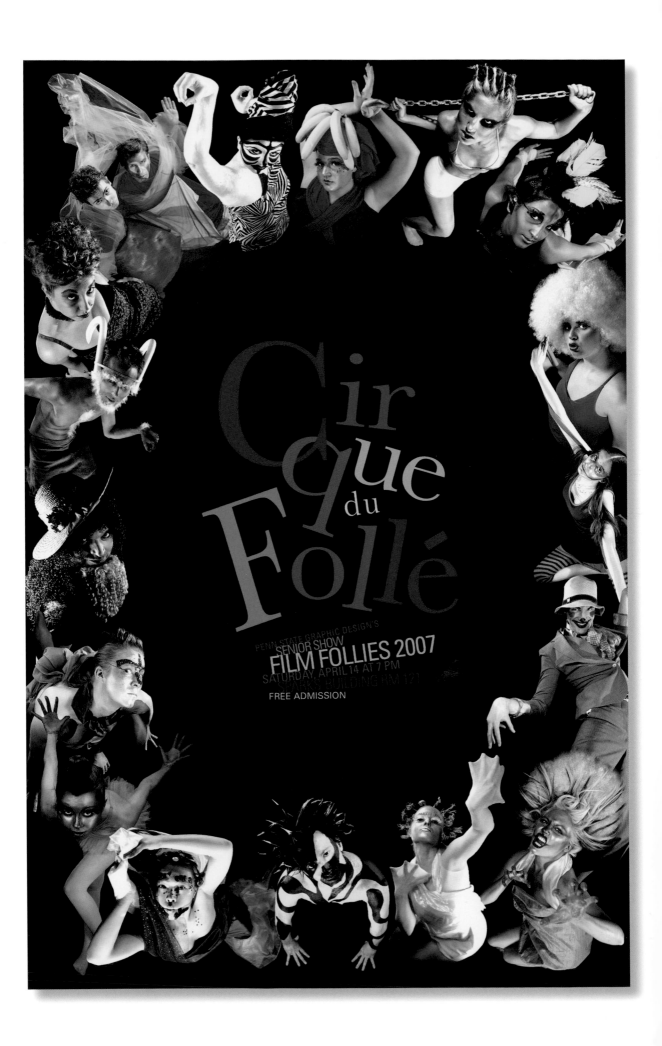

Cirque du Follé

Lanny Sommese *Pennsylvania State University*
Laura Kottloski, Emily Guman, Melinda Reidenbac

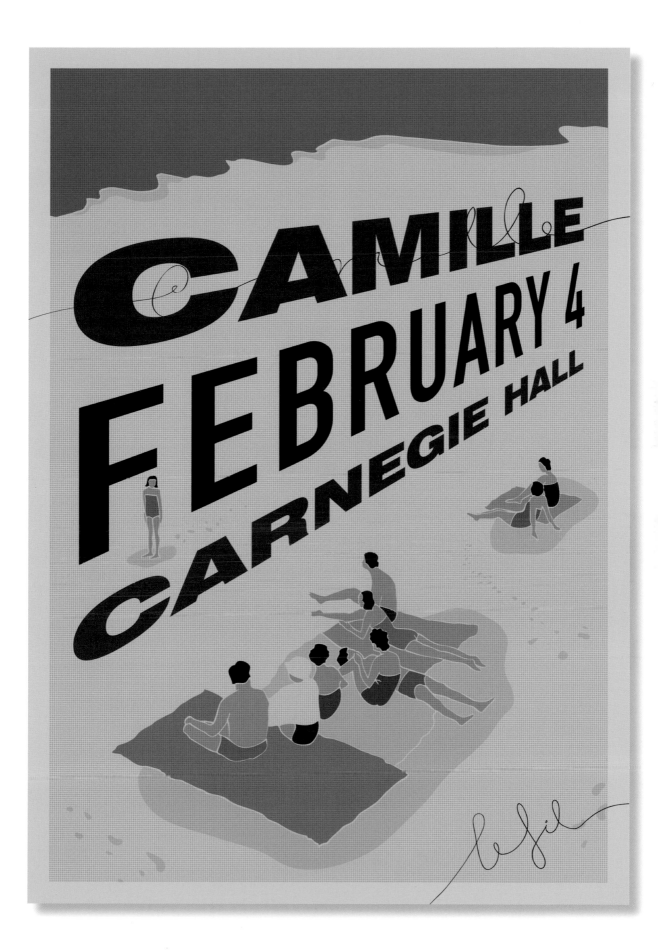

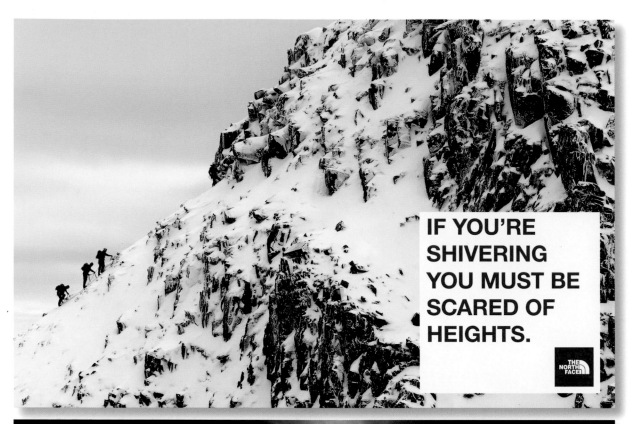

IF YOU'RE
SHIVERING
YOU MUST BE
SCARED OF
HEIGHTS.

THE NORTH FACE

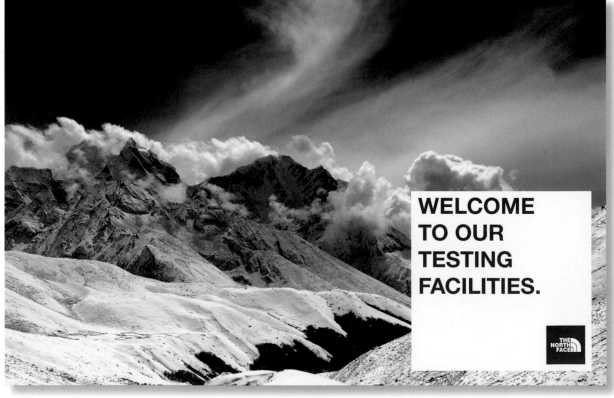

WELCOME
TO OUR
TESTING
FACILITIES.

THE NORTH FACE

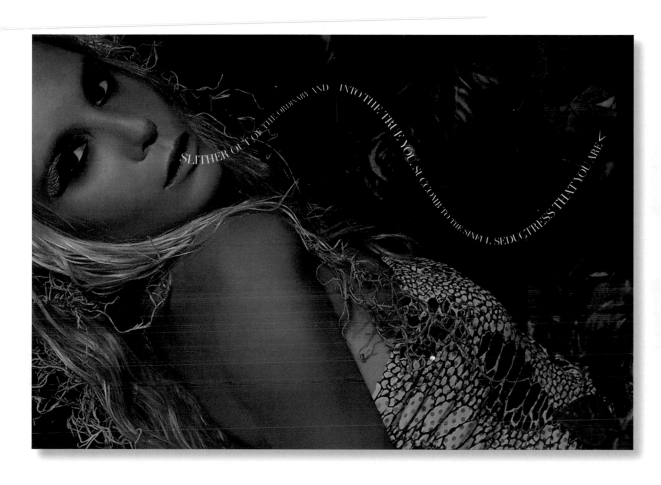

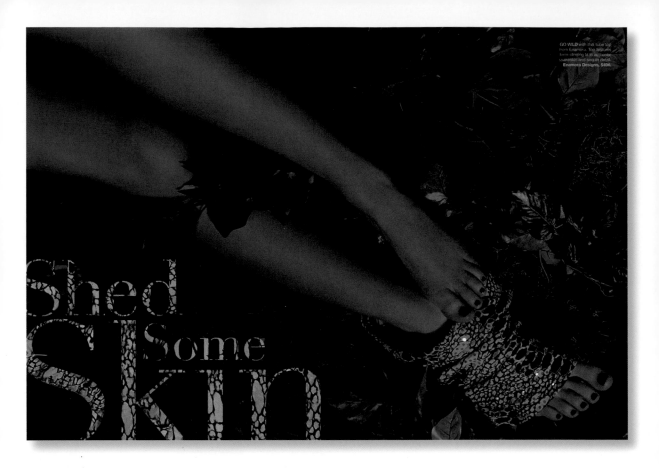

GO WILD with this tube top
from Enamora. Top features
form-fitting faux snakeskin
and sequin detail.
Enamora Designs, $498.

Shed Some Skin

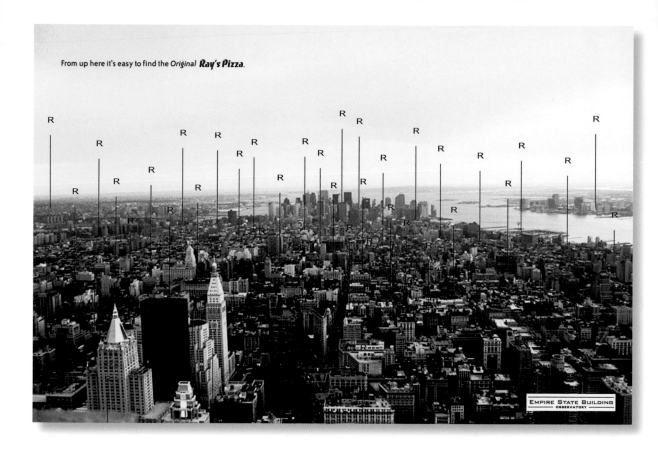

From up here it's easy to find the *Original* **Ray's Pizza**.

Jeffrey Metzner School of Visual Arts **Stephen Minasvand**

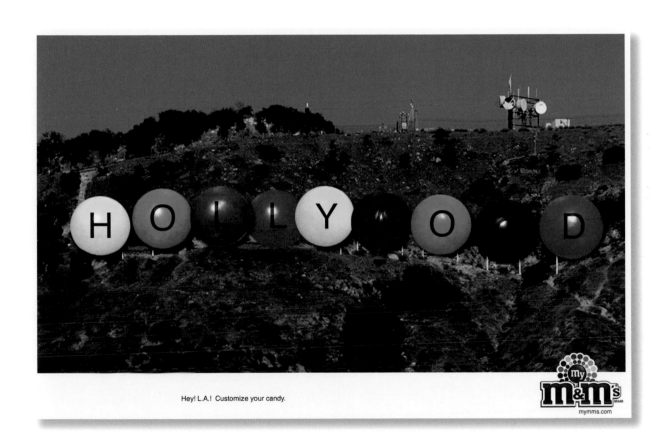

Hey! L.A.! Customize your candy.

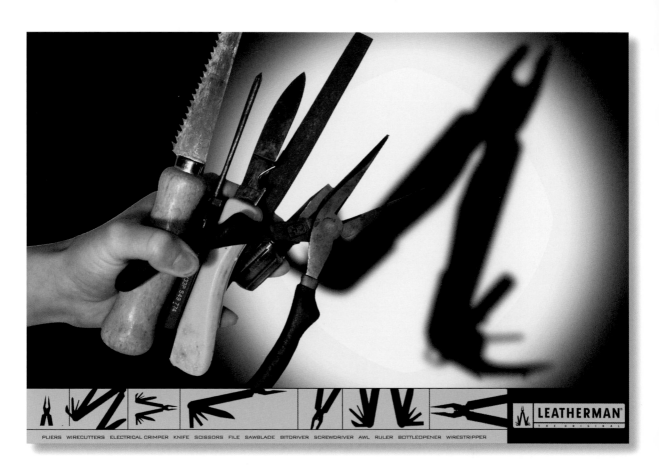

PLIERS WIRECUTTERS ELECTRICAL CRIMPER KNIFE SCISSORS FILE SAWBLADE BITDRIVER SCREWDRIVER AWL RULER BOTTLEOPENER WIRESTRIPPER

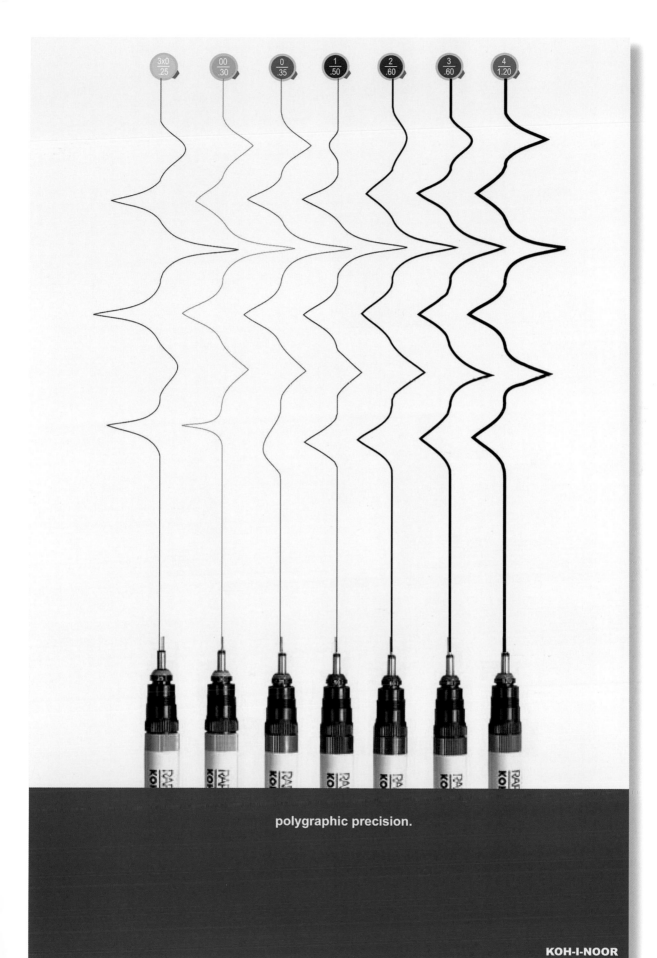

polygraphic precision.

KOH-I-NOOR

Jeffrey Metzner School of Visual Arts **Andrew Seagrave**

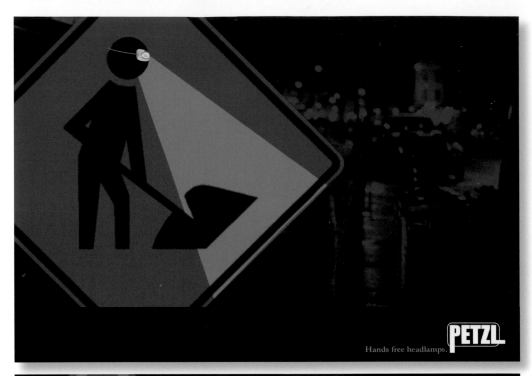

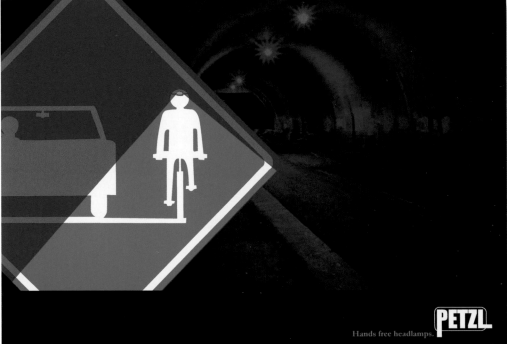

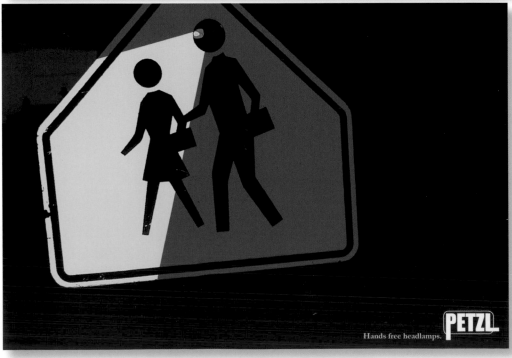

Jeffrey Metzner School of Visual Arts **Heather Monetti**

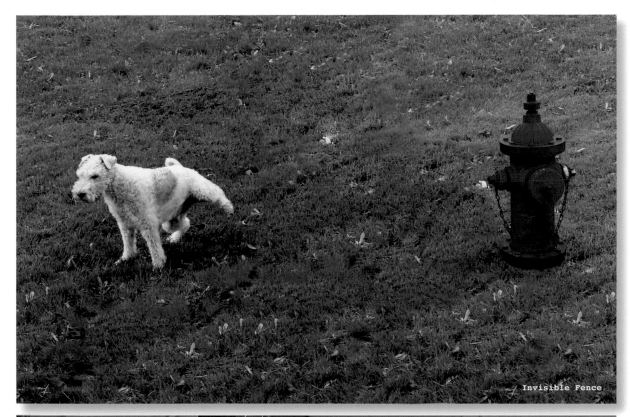

Invisible Fence

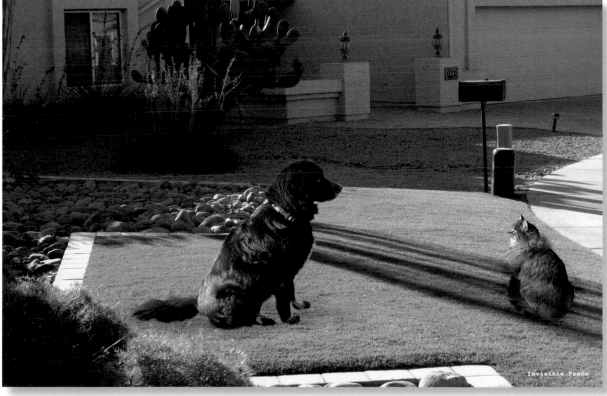

Invisible Fence

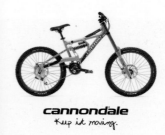

cannondale
Keep it moving.

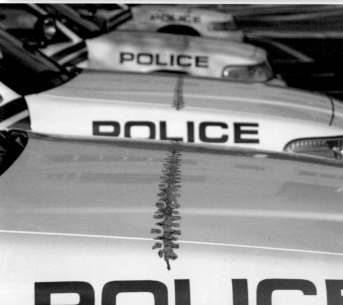

cannondale
Keep it moving.

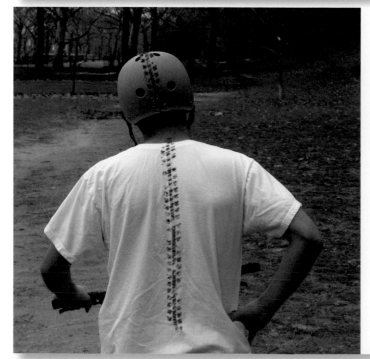

cannondale
Keep it moving.

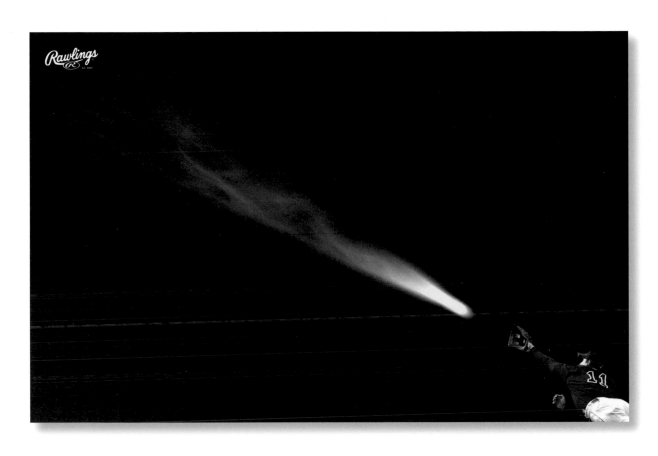

Menno Kluin, Icaro Doria Miami Ad School Europe, Hamburg, Germany
Siavosh Zabeti, Dirk Gelijsteen

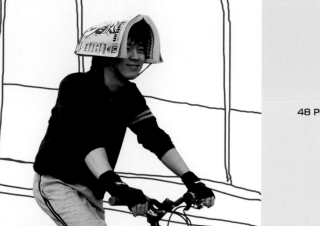

48 PLACES TO BUY A BIKE HELMET.

Yellow Book

72 PLACES TO BUY A BASEBALL GLOVE.

Yellow Book

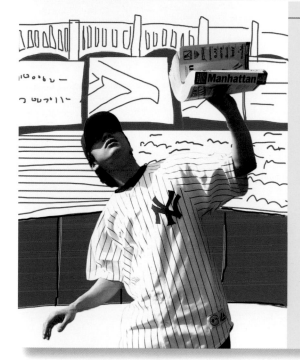

121 PLACES TO GET A MOP.

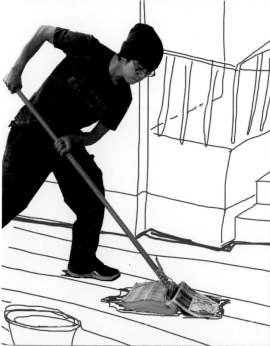

Yellow Book

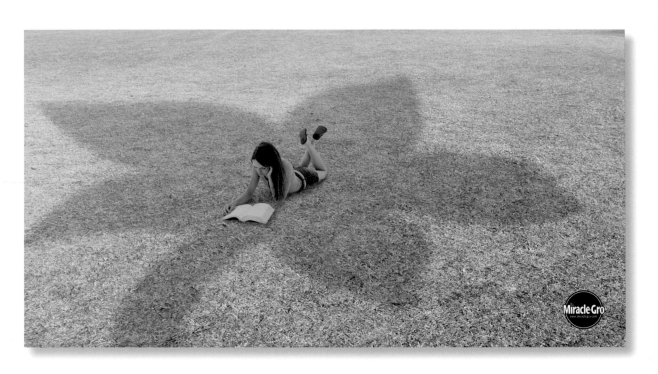

Bill Meek Texas State University **Alline Forastieri**

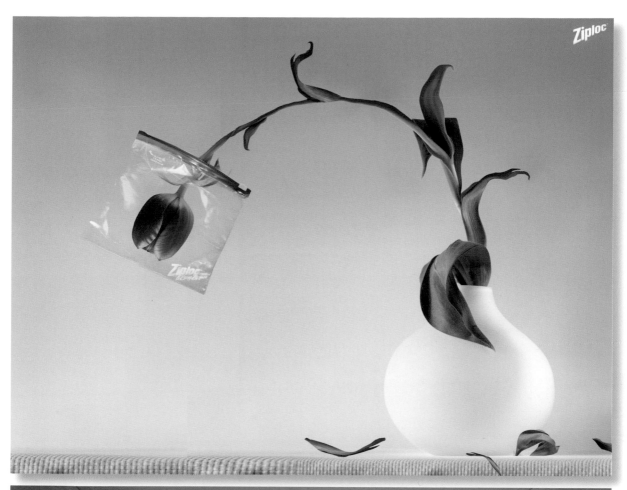

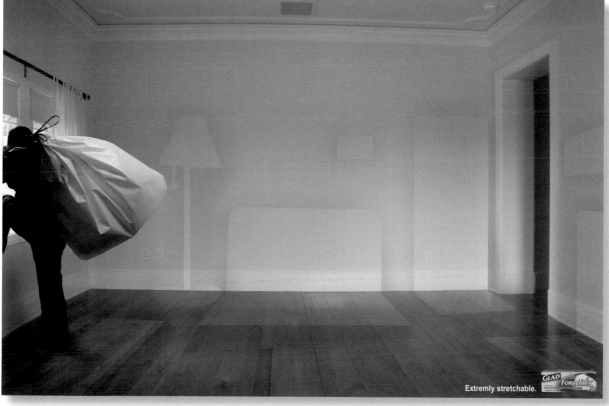

Extremly stretchable.

Naturally Sticky (*naturaliter glutinosum*)

Scotch

WATCHING A MAN'S HEART BREAK AIN'T PRETTY BUT LISTENING CAN BE DOWN RIGHT BEAUTIFUL

BEHIND EVERY NASTY GUITAR LICK IS A MAN BLEEDING WITH DIVINITY

YOU CAN'T SEE A MAN'S SOUL BUT YOU CAN DAMN WELL HEAR IT

Sal Devito School of Visual Arts **Justin Pedone**

WITH THE SUDDEN FURY OF A THUNDERBOLT, FOUR ⬢ RIPPED ACROSS THE BOW. WITHOUT HESITATING, THE CREW MANNED THEIR ▬ AND RETURNED FIRE. THIS BOUGHT THEM PRECIOUS MINUTES, BUT THE ▬ WAS TAKING ON WATER. THE CREW QUICKLY LAUNCHED THE ⬢ AND ESCAPED UNHARMED, JUST AS THEIR BELOVED ▬ LISTED AND SANK...

IT'S WHAT YOU MAKE OF IT. **LEGO**

SMOKE POURED FROM THE WHEELS AS THE GETAWAY ▬ ROARED OFF INTO TRAFFIC. POLICE SIRENS WAILED IN THE DISTANCE. THE ROBBERS CAREENED OFF THE TRAILER OF A PASSING ▬ AS THEY DASHED ONTO THE FREEWAY. OVERHEAD, A ▬ HOVERED AS THE POLICE SET UP AN IMPENETRABLE ▬ TWO MILES DOWN THE ROAD. THEIR RUN WAS OVER...

IT'S WHAT YOU MAKE OF IT. **LEGO**

BLISTERING LASER-FIRE TORE AT THE SHELL OF THE NEWLY BUILT ▬. ENEMY ▬ WERE EVERYWHERE, FIRING WILDLY. THE ONLY CHANCE WAS TO OUTRUN THEM. A BLINDING FLASH OF LIGHT ENGULFED THE COCKPIT AS THE ▬ MADE THE JUMP TO HYPERSPACE. TWO ▬ GAVE CHASE BUT COULD NOT KEEP UP. THE ▬ WAS SAFE, FOR NOW...

IT'S WHAT YOU MAKE OF IT. **LEGO**

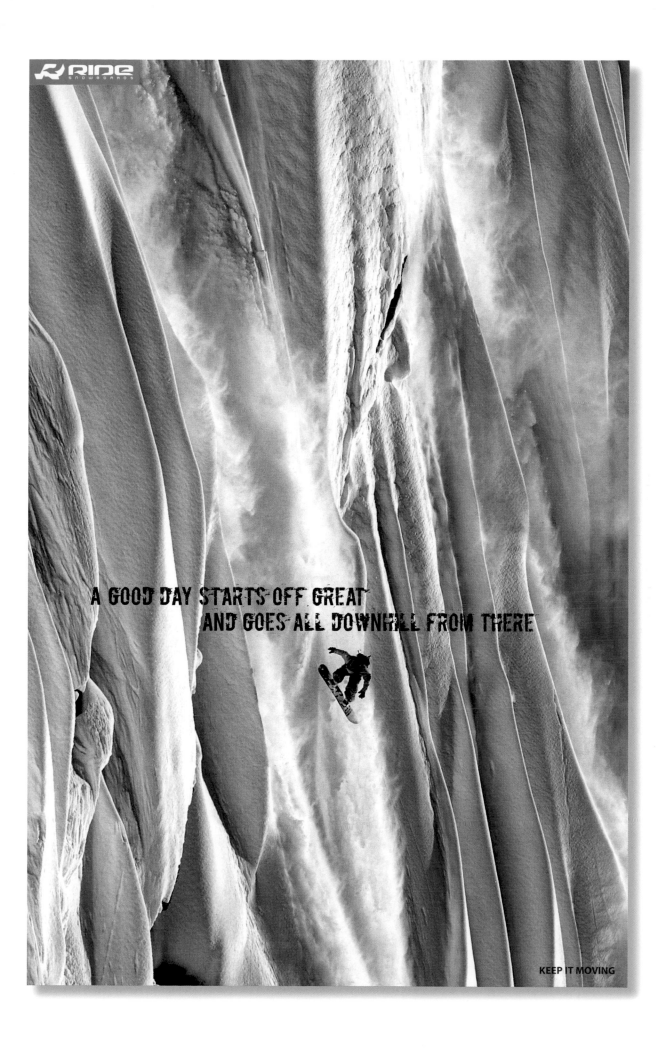

A TOOTHPICK.

DREMEL®
THE WORLD'S FINEST ROTARY TOOL

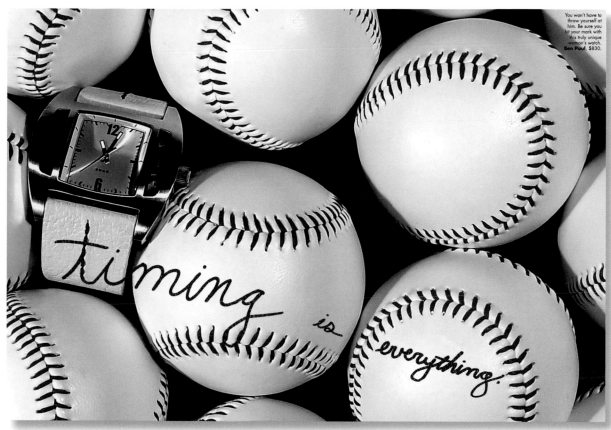

You won't have to throw yourself at him. Be sure you hit your mark with this truly unique woman's watch. **Ben Paul**, $830.

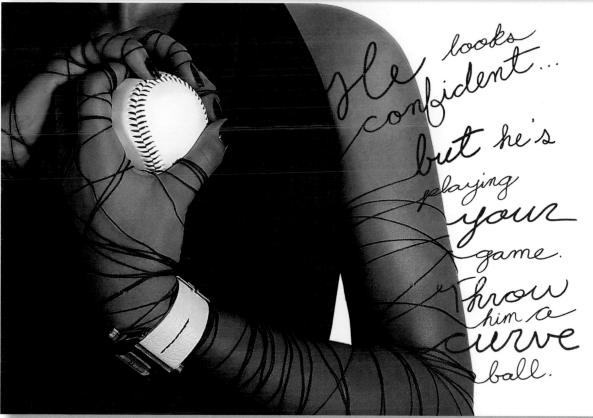

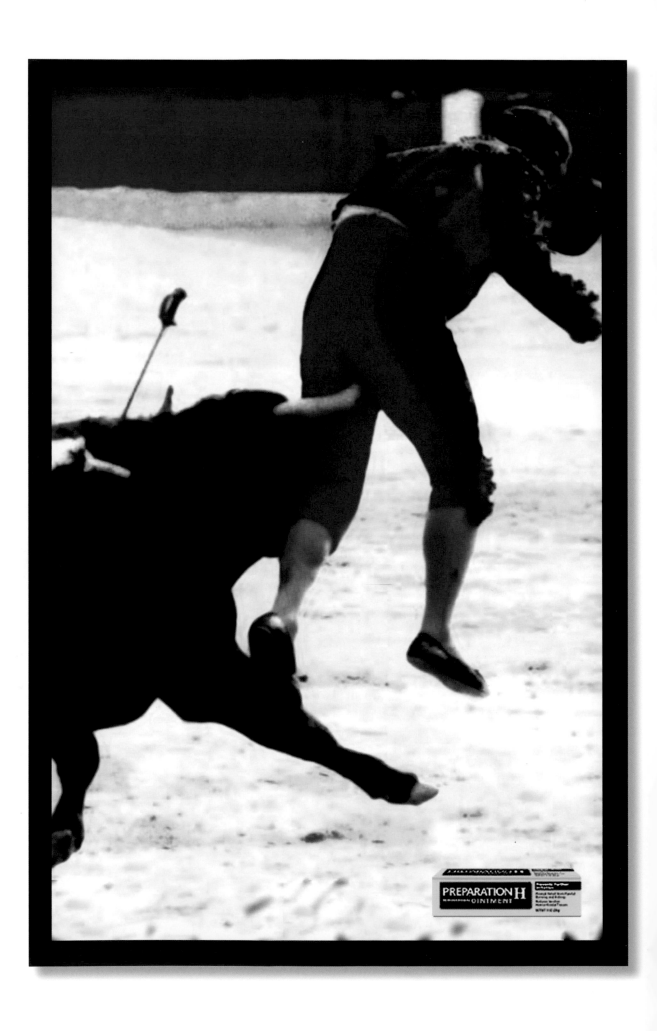

Vincent Tulley School of Visual Arts Stephanie Sarnelli

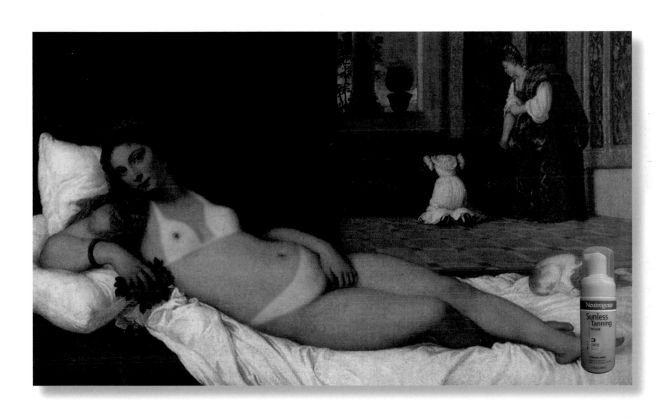

What will happen if you don't give? Nothing. Absolutely nothing.

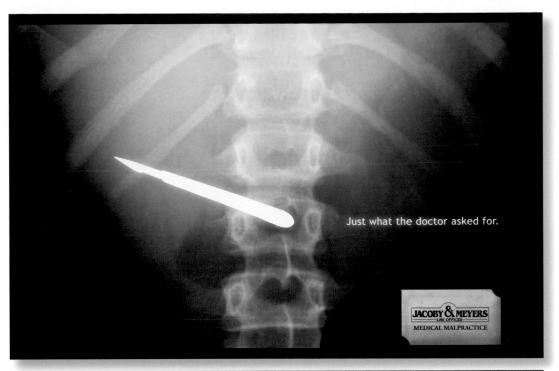

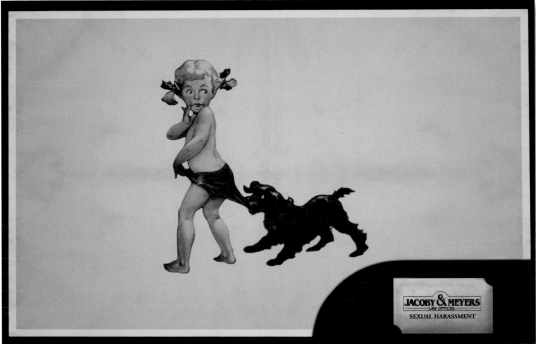

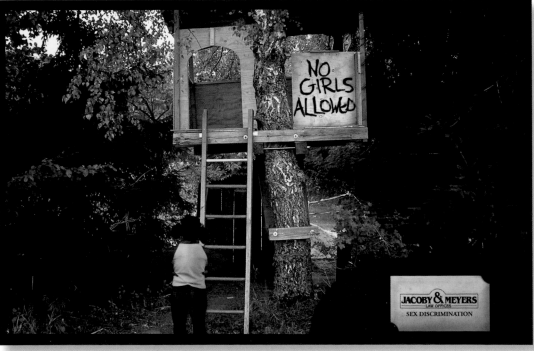

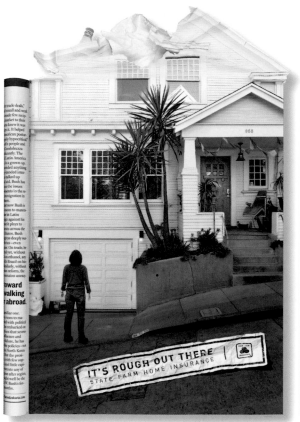

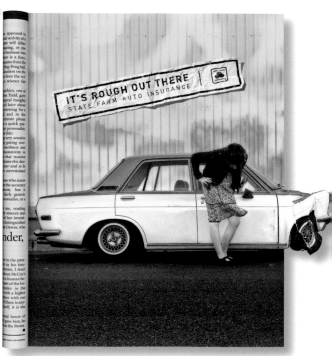

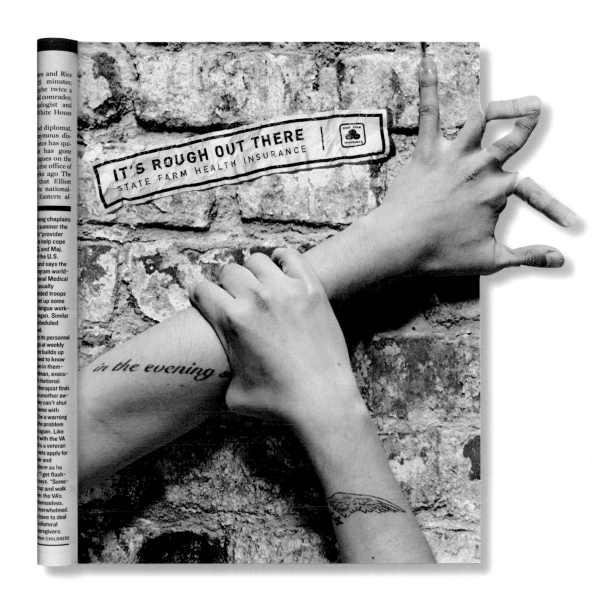

IT'S ROUGH OUT THERE | STATE FARM HEALTH INSURANCE

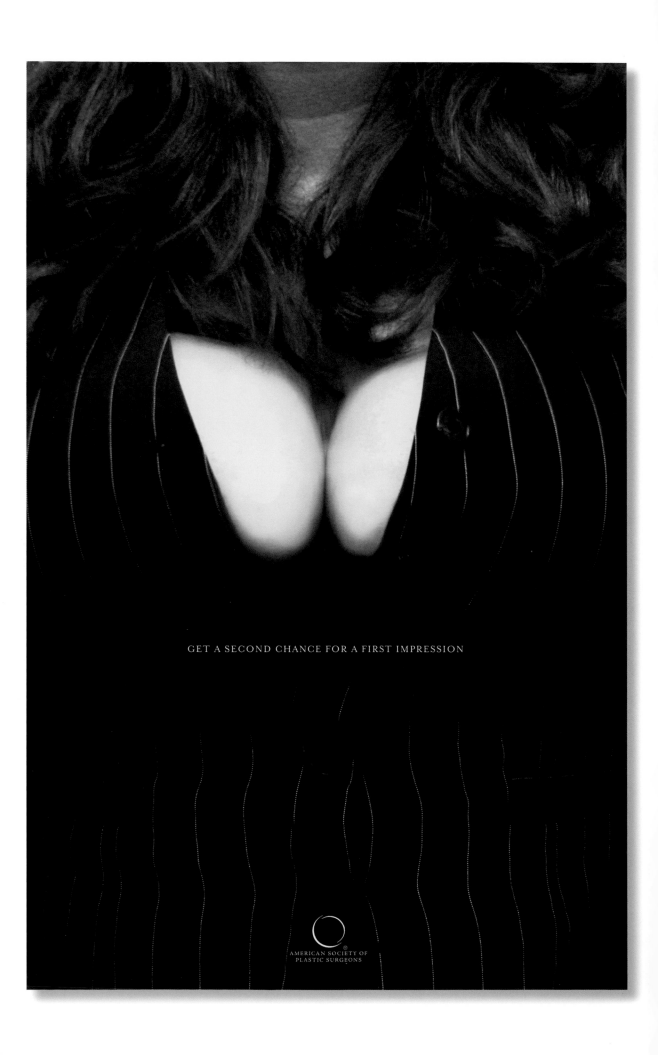

GET A SECOND CHANCE FOR A FIRST IMPRESSION

AMERICAN SOCIETY OF
PLASTIC SURGEONS

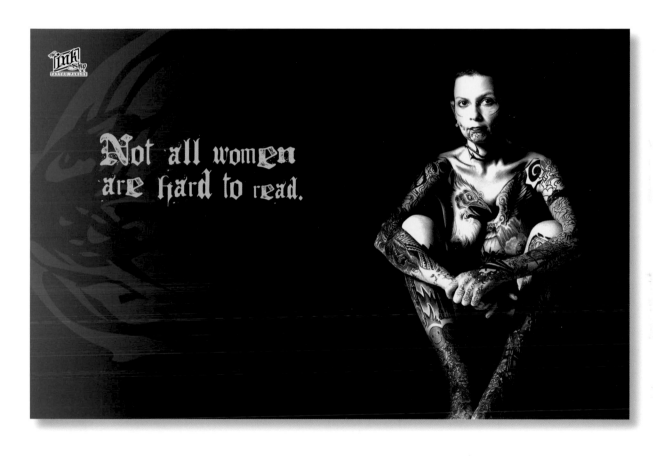

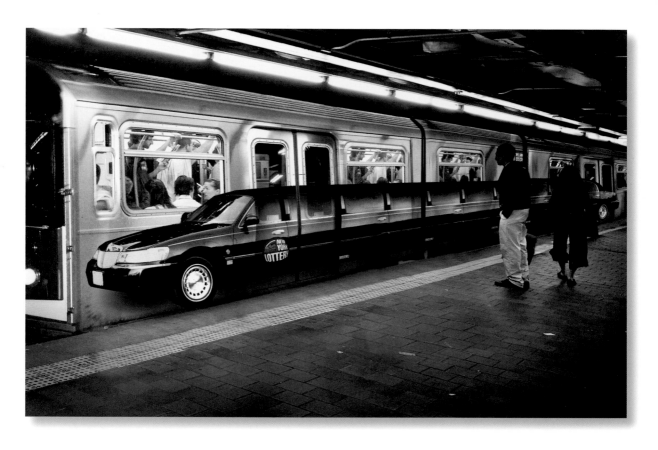

Frank Anselmo School of Visual Arts **Jeseok Yi**

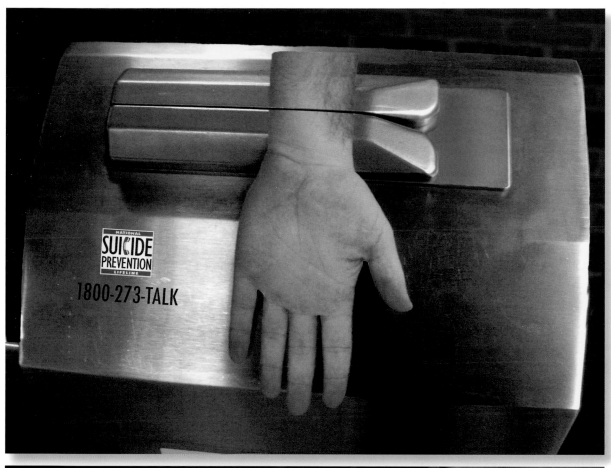

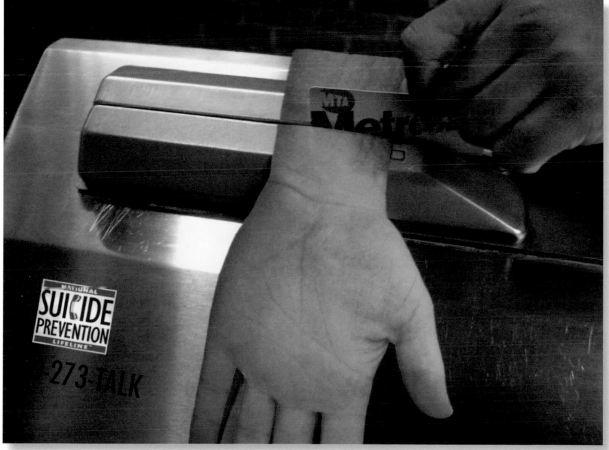

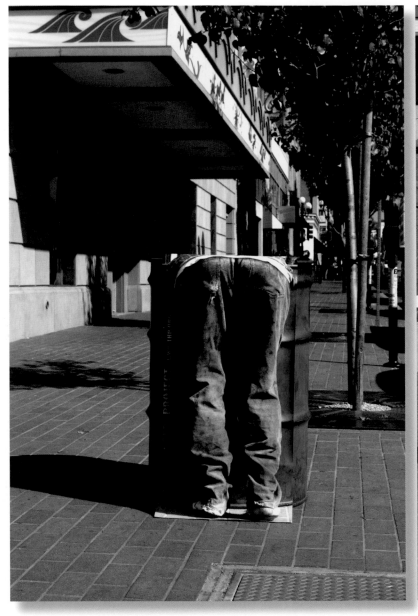

Henry Hikima Art Institute of California, San Diego **David Gonsalves**

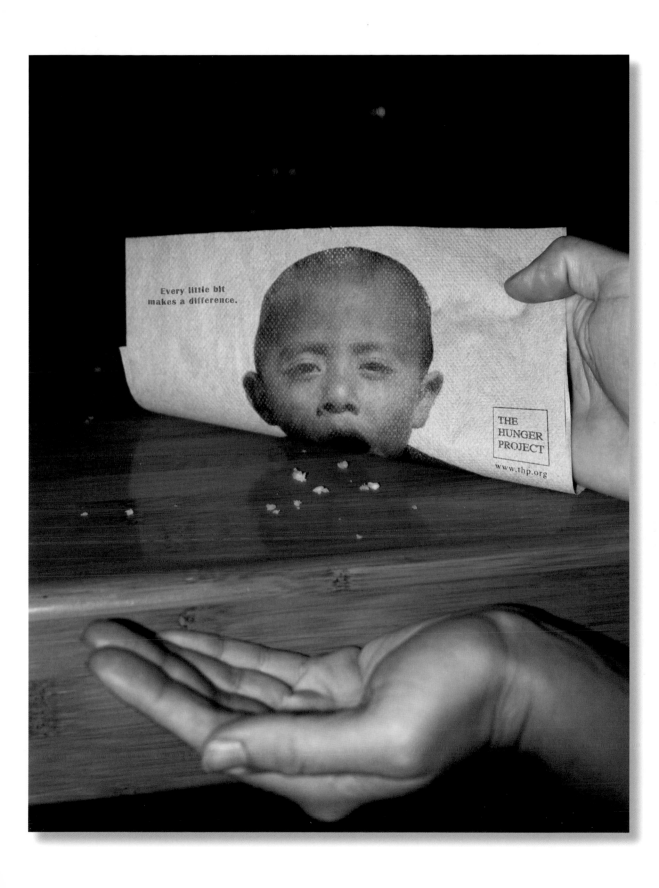

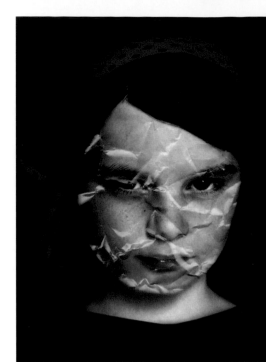

HIDE AND SEEK
WAS NEVER
A GAME.

Name: BRANDON HENRY
Age: 8
Height: 4'1"
Hair: BROWN
Eyes: BLACK AND BLUE

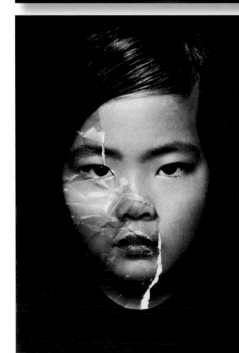

THE MONSTER DOESN'T
SLEEP UNDER MY BED

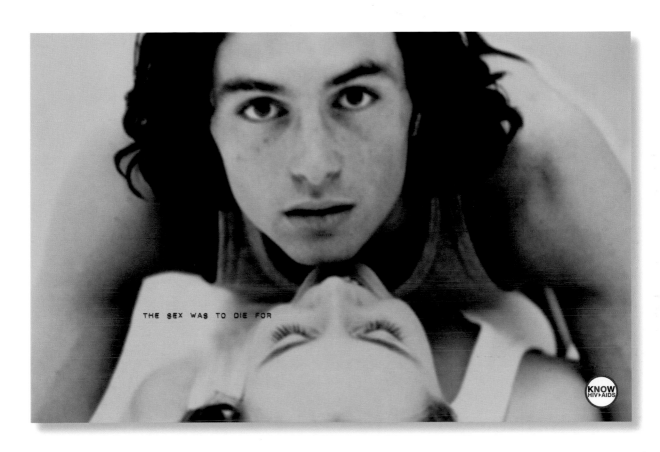

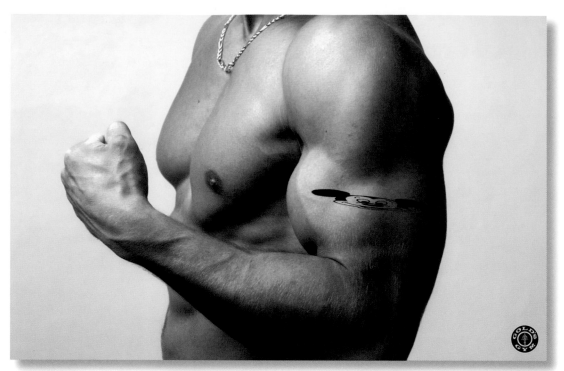

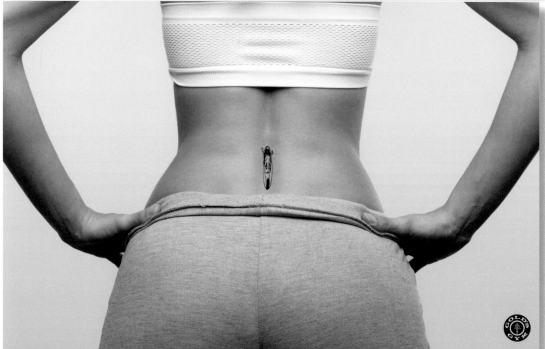

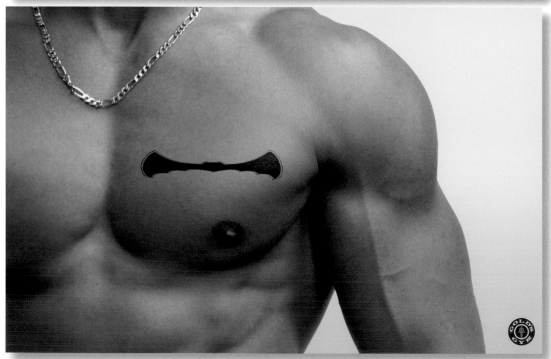

Vincent Tulley School of Visual Arts **Su Won Chang**

Frank Anselmo School of Visual Arts **Alexei Beltronel, Jay Marsen**

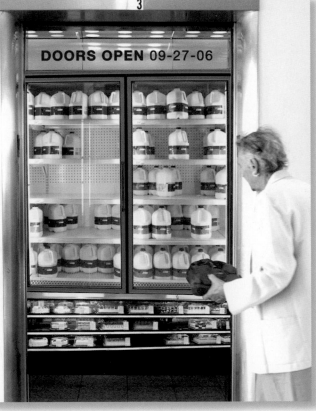

Salvador Veloso, Marco Vega Miami Ad School, Miami **Rhea Hanges**

METRO & STATE | MORE COVERAGE, 4-7A

ENTERTAINMENT

Lindsay Lohan celebrates 80th birthday in space

BLUNT MESSAGE: With an image of an American eagle in the backdrop, President Bush speaks on comprehensive immigration reform in Irvine, Calif., on Monday.

d President Bush pushed for an overhaul of immigration policy after Congress returned from its two-week spring recess.

BY JENNIFER LOVEN
Associated Press

IRVINE, Calif. — President Bush had a blunt message Monday for fellow Republicans focusing only on getting tough immigration policies: Sending all the nation's estimated 11 million illegal immigrants back to their home countries is not the answer.

"Massive deportation of the people here is unrealistic — it's just not going to work," Bush said. "You know, you can hear people out there hollering it's going to work. It's not going to work."

With Congress coming back from a two-week spring recess to a long election-year to-do list and tensions flaring nationwide over immigration, Bush urged lawmakers to adopt a middle-ground policy. He called a Senate bill, which creates a way for illegal immigrants to work legally in the United States and for some to eventually become citizens, as

deportation, a Time magazine poll in January found 50 percent of the country favored deporting all illegal immigrants.

Well aware that November elections could end GOP control of Congress, Bush is walking a fine line on the emotional Mexico have pleaded for better policing of U.S. borders while other communities complain about the pressure that burgeoning immigrant populations are placing on local services. At the same time, tens of thousands of Hispanics and others — a potentially immense

questions. Three of the eight queries he took were on immigration, including one from a woman who asked for his solution to emergency rooms crowded with poor people seeking routine care. Southern California's Orange County is a heavily Republican swath of sprawling Los Angeles suburbs that has been known — even parodied — as white, rich and conservative, but minorities now make up a majority of residents.

First artificial heart grown in lab

Bush said community health centers are the best place for the poor to get primary care. He sought to highlight the contributions of immigrants to American society, and lamented the harsh — and sometimes deadly — conditions that many people face trying to illegally enter the country.

"One thing we cannot lose sight of is that we're talking about human beings, decent human beings that need to be treated with respect," the president said.

We won't have to wait that long

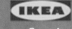

Coming to Sunrise

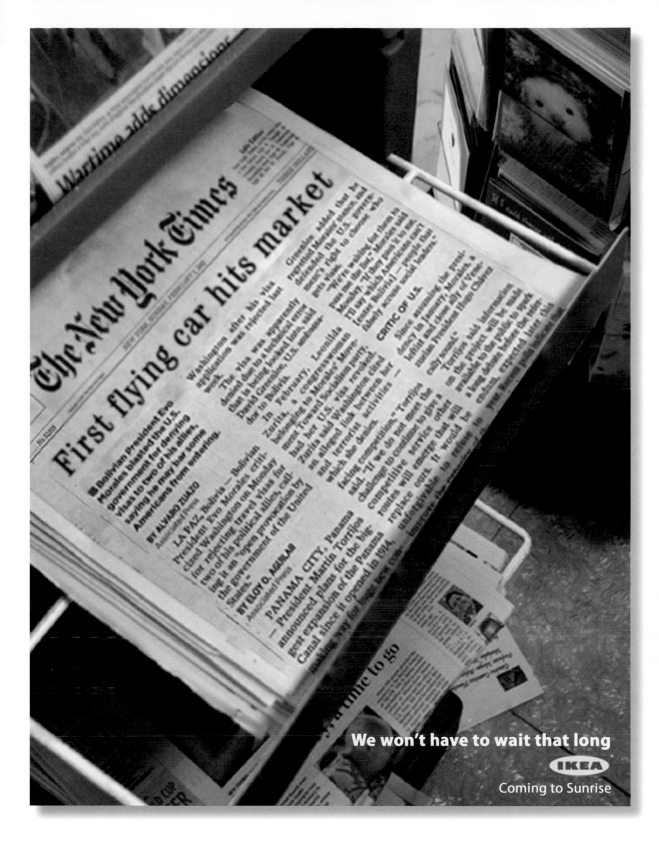

We won't have to wait that long

IKEA

Coming to Sunrise

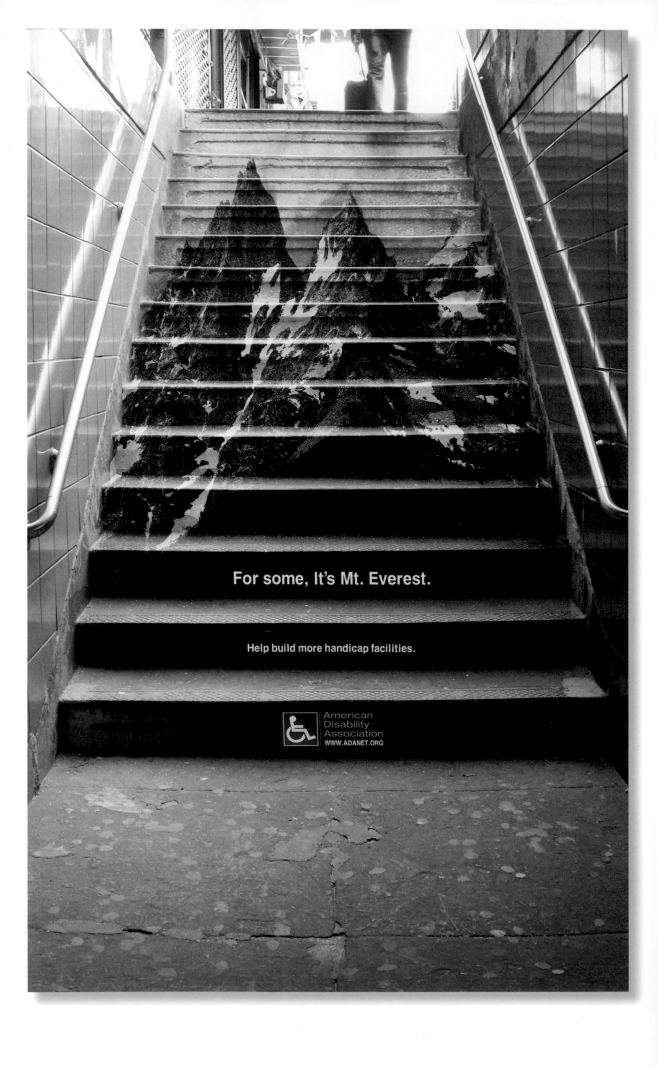

For some, It's Mt. Everest.

Help build more handicap facilities.

American Disability Association
WWW.ADANET.ORG

Frank Anselmo School of Visual Arts Jeseok Yi

Design

PlatinumWinningInstructor:

Kevin O'Callaghan, *School of Visual Arts*
11 winning projects

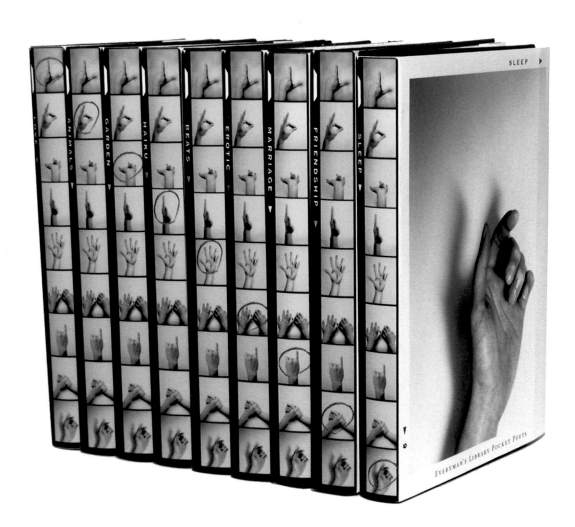

 Adrian Pulfer Brigham Young University **Sam Gray**

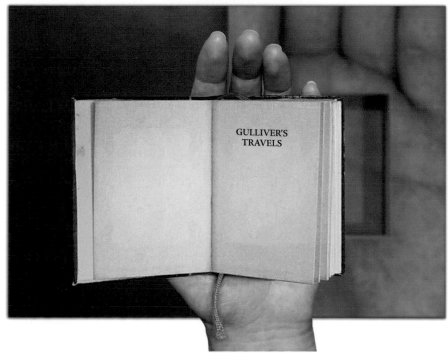

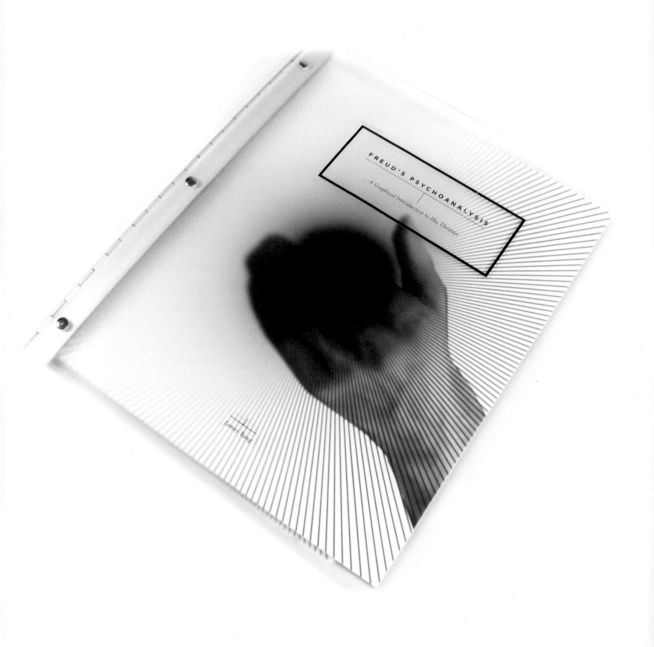

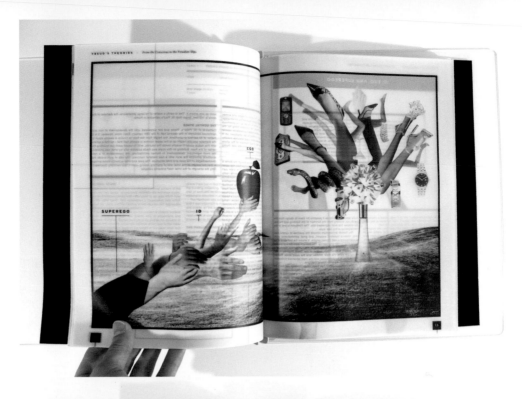

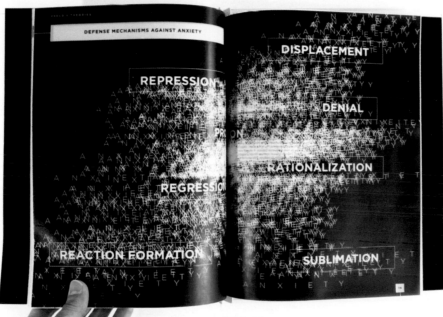

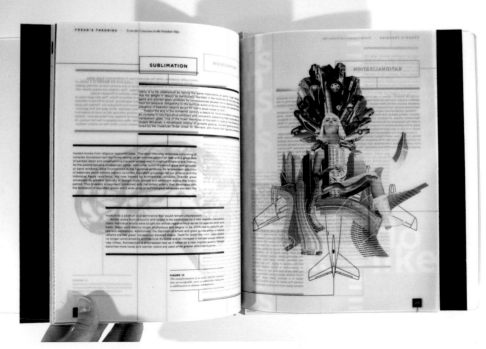

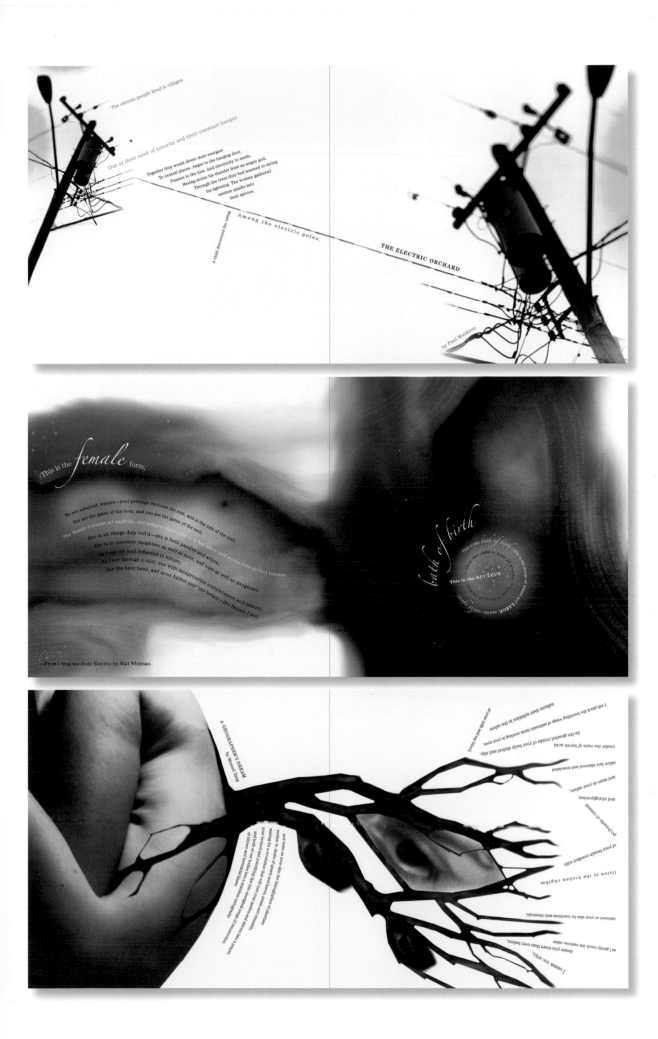

THE ELECTRIC ORCHARD

'The electric people lived in villages

Out of their need of security and their constant hunger.

Together they would divert their energies
To neutral places. Anger to the banging door,
Passion to the kiss. And electricity to earth.
Having stolen his thunder from an angry god,
Through the trees they had learned to string
his lightning. The women gathered
random sparks into
their aprons,

Among the electric poles.

A child discovered the switch

by Paul Muldoon

This is the *female* form;

Be not ashamed, women—your privilege encloses the rest, and is the exit of the rest,
You are the gates of the body, and you are the gates of the soul.
The female contains all qualities, and tempers them—she is in her place, and moves with perfect balance.
She is all things duly veil'd—she is both passive and active,
She is to conceive daughters as well as sons, and sons as well as daughters.
As I see my soul reflected in nature,
As I see through a mist, one with inexpressible completeness and beauty,
See the bent head, and arms folded over the breast—the female I see.

—From I Sing the Body Electric by Walt Whitman.

bath of birth

This is the *bath of birth*
This is the child is born
is born of woman
This is the NUCLEUS
LARGE and the child

A GEOGRAPHER'S DREAM
by Manuel Yang

ARROYO SECO
Route and Place

TRIALS
& Tribulations
of the
NOT so SERIOUS
Baseball Card
COLLECTOR

WRITTEN AND ILLUSTRATED BY RYAN HAYES

Brad Bartlett Art Center College of Design **Timothy Moraitis**
Frank Baseman Philadelphia University **Ryan Hayes**

THE SEA LADY

MARGARET DRABBLE

Wes Youssi Seattle Pacific University **Nate Salciccioli**
Charles Brock Seattle Pacific University **Nate Salciccioli**

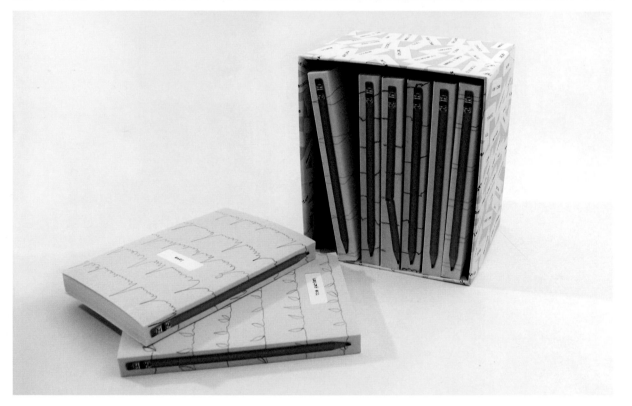

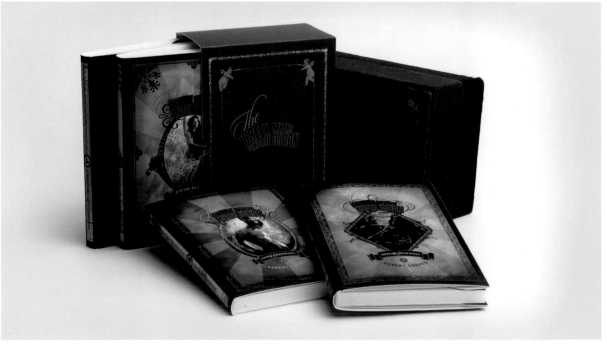

Chris Austopchuck School of Visual Arts **Christina Kim**
Carin Goldberg School of Visual Arts **Dana Goor**
John Fulbrook School of Visual Arts **Seulgi Ho**

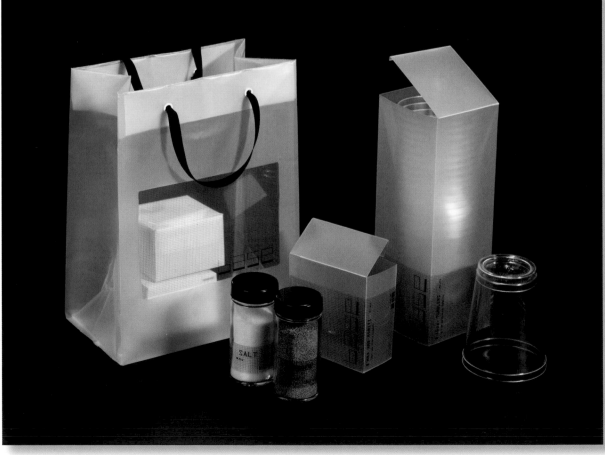

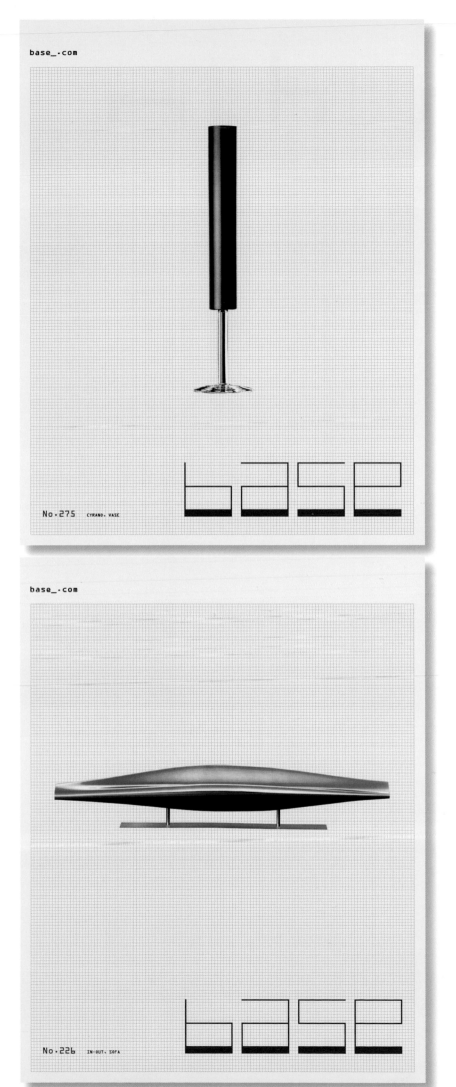

01 TABLES

02 SEATING

03 BEDS

04 OBJECTS

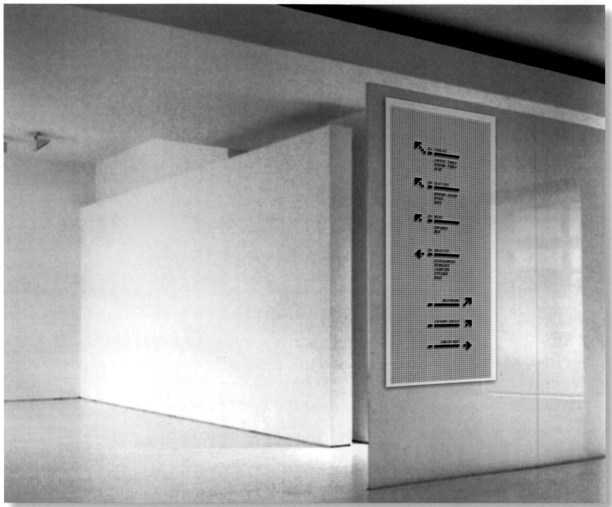

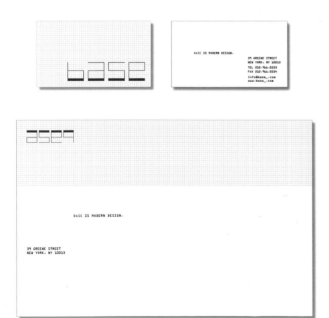

ETHAN ALEXANDER MONROE
OWNER & FOUNDER

350 5TH AVE NEW YORK, NY 1001

350 5TH AVE NEW YORK, NY 10012

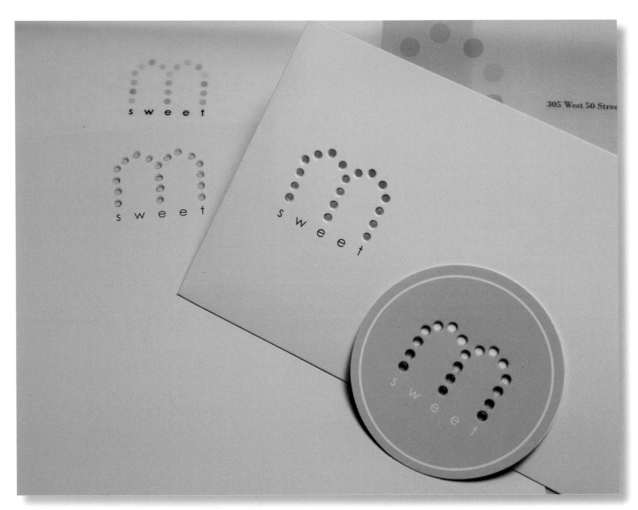

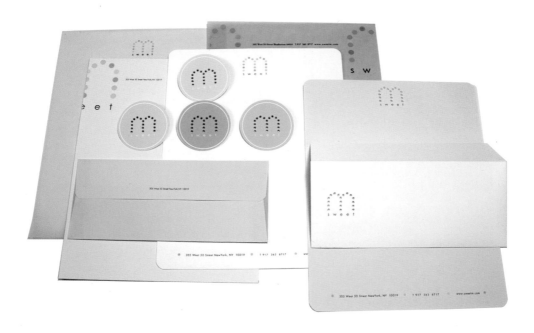

Roswitha Rodrigues School of Visual Arts **JungMin Byun**

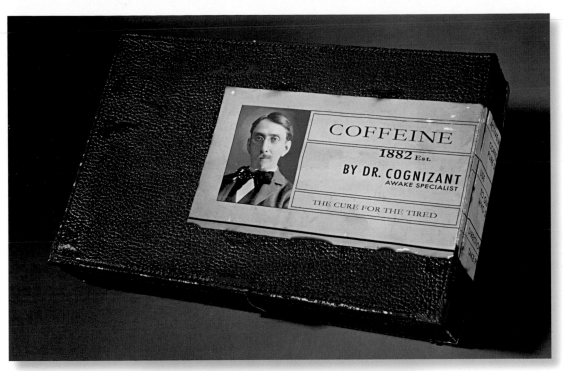

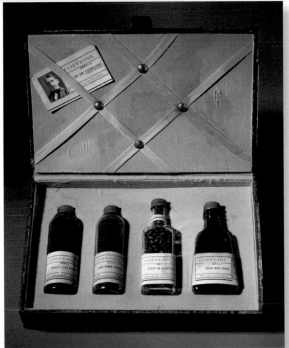

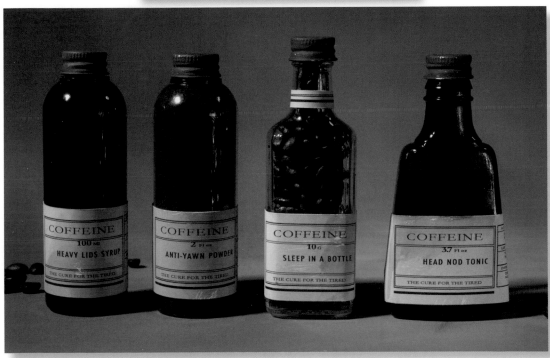

David Copestakes Pennsylvania State University **Megan Bailey**

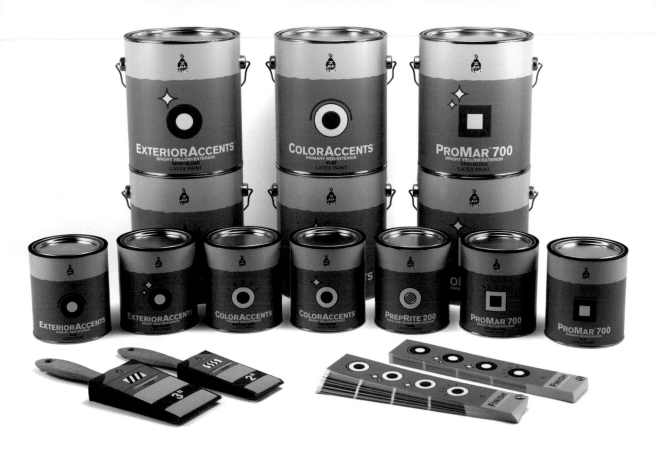

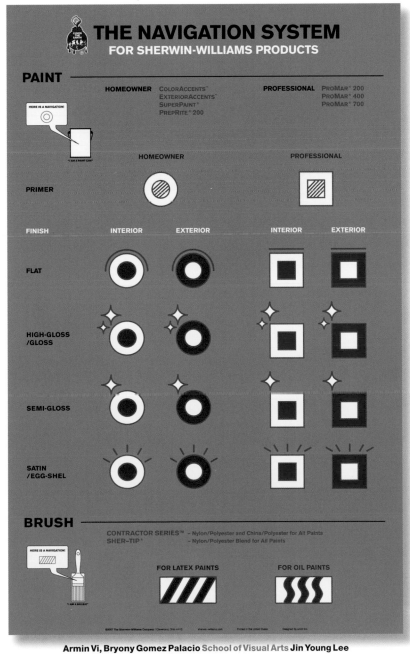

Kristin Sommese Pennsylvania State University **Jonathan Feldman**

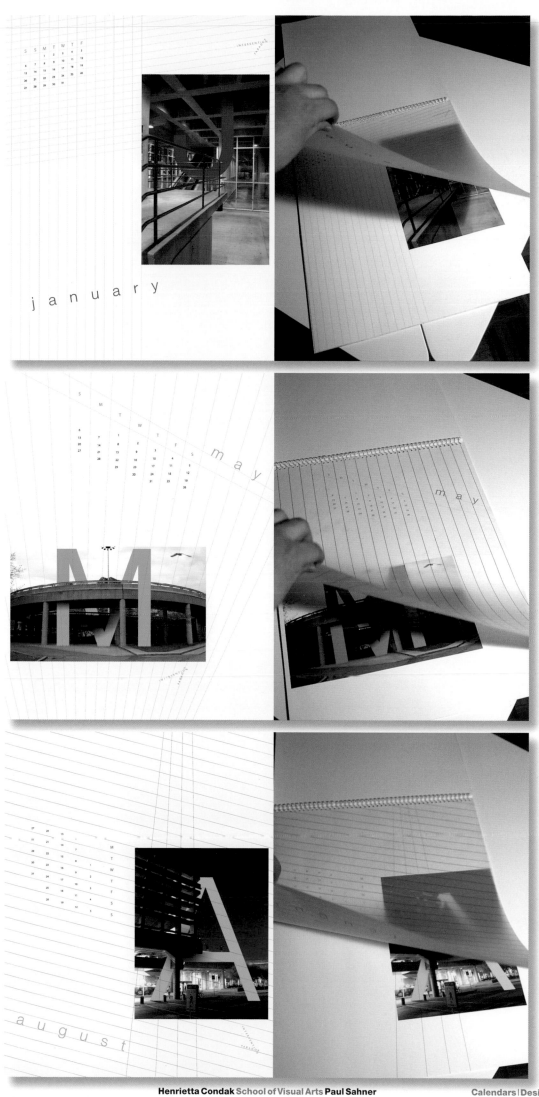

january

may

august

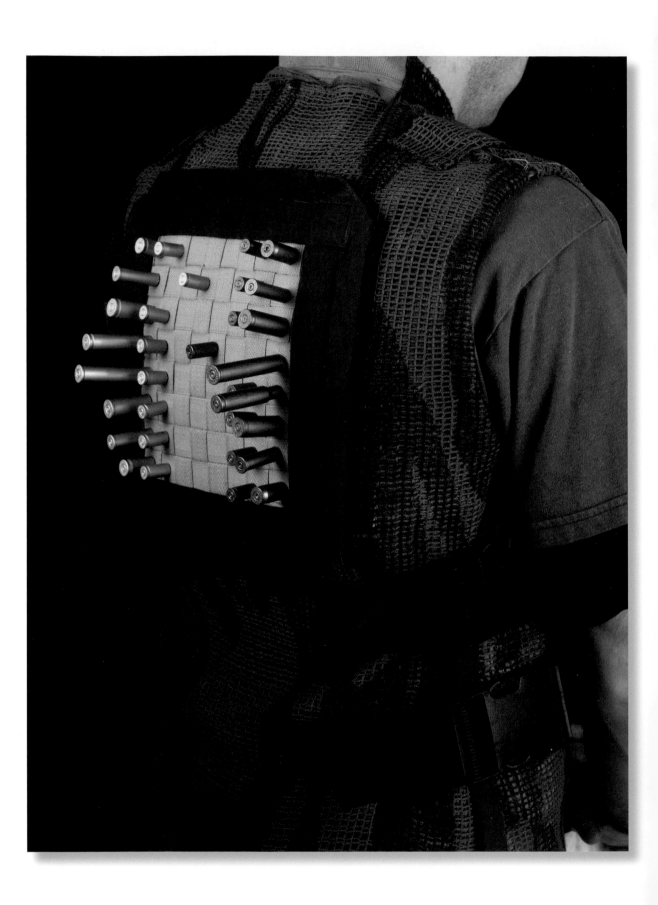

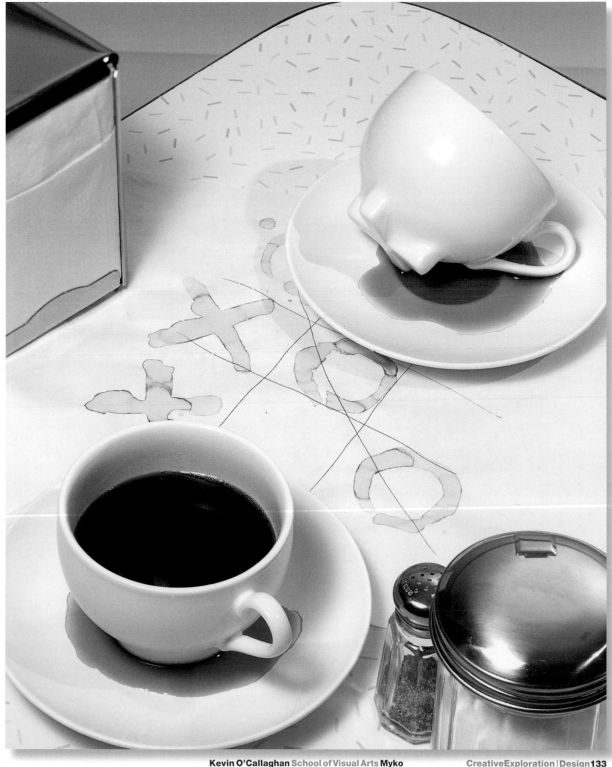

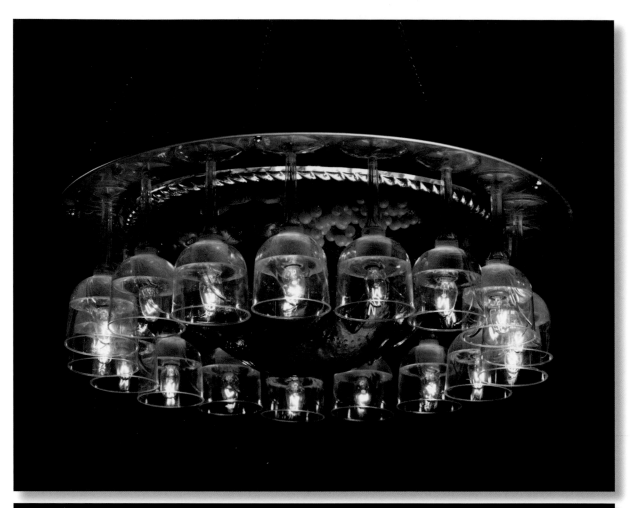

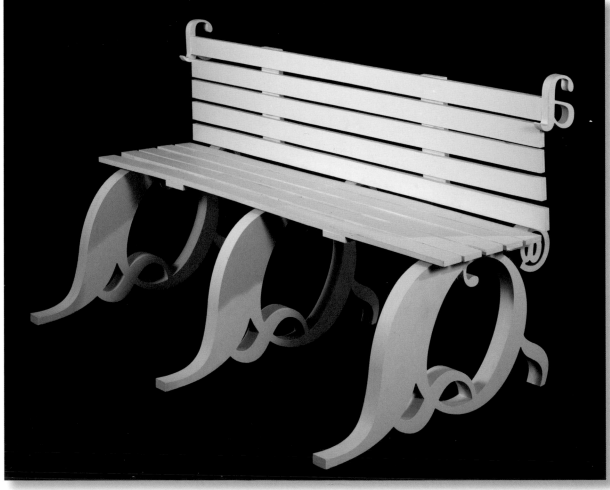

Kevin O'Callaghan School of Visual Arts **Myung Ha Chang**
Kevin O'Callaghan School of Visual Arts **Donnie Miller**

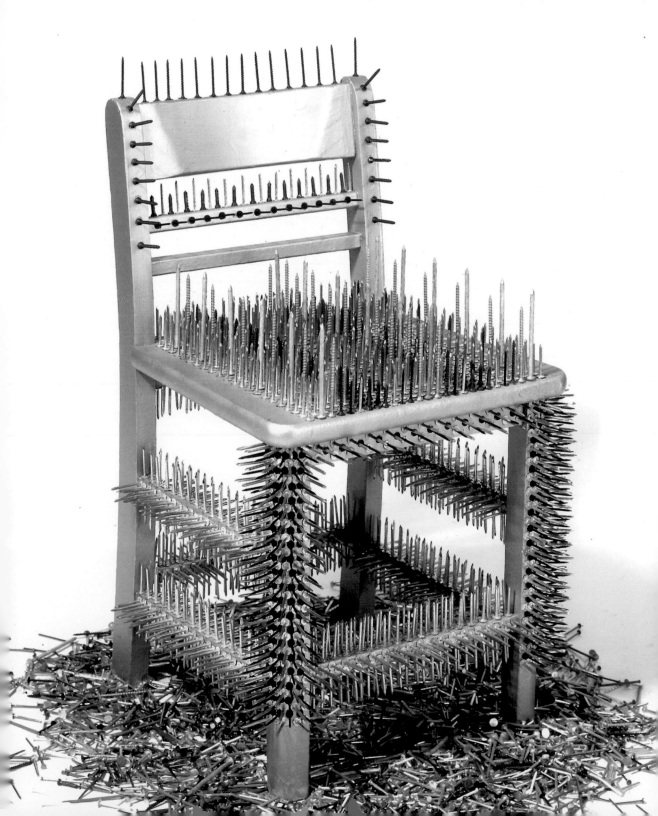

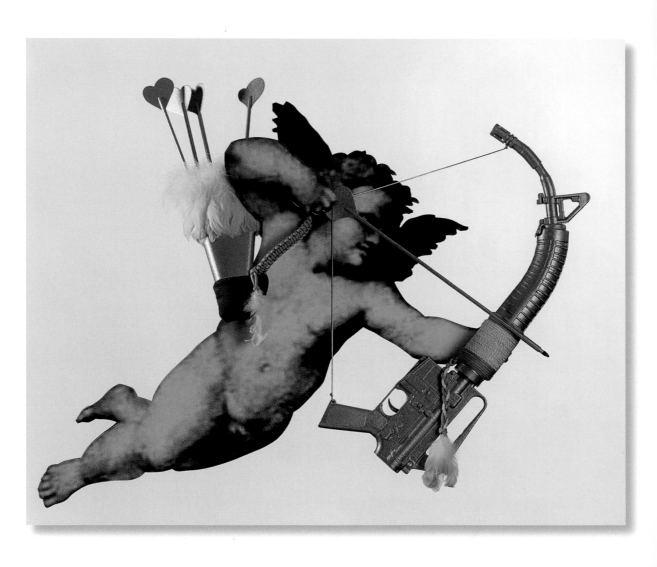

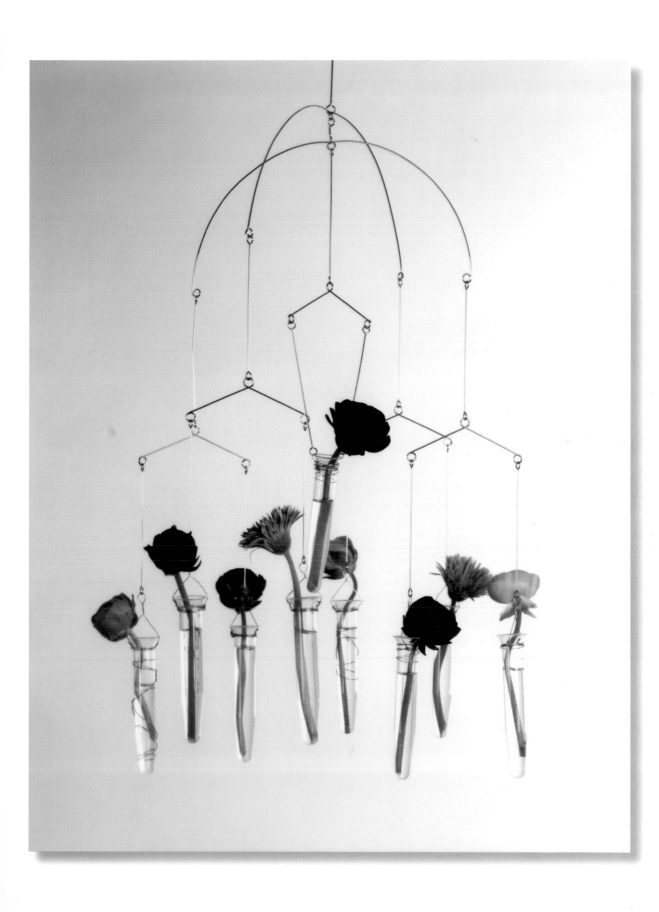

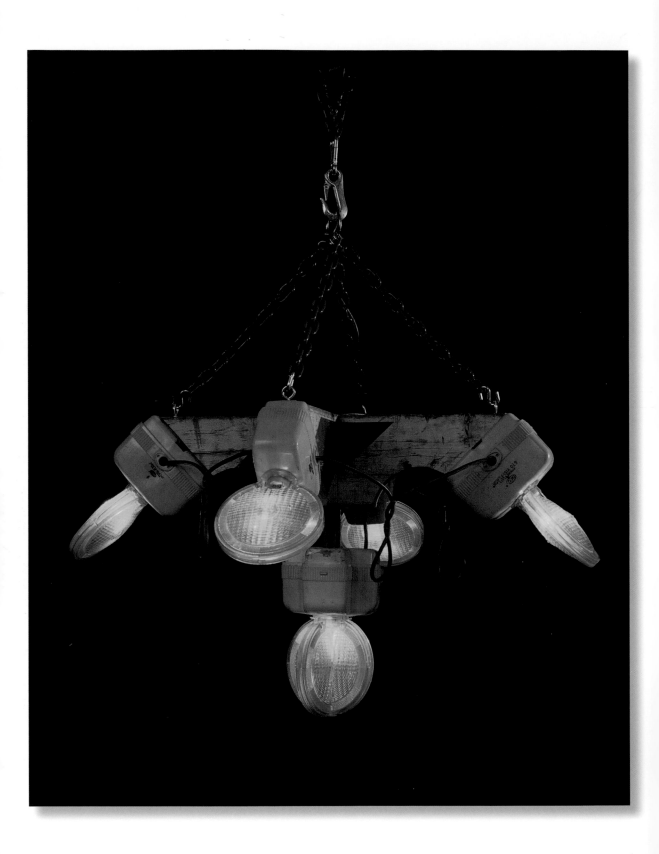

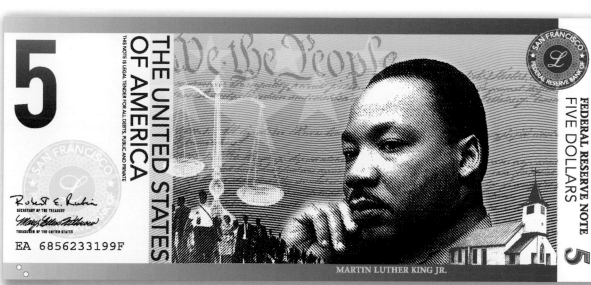

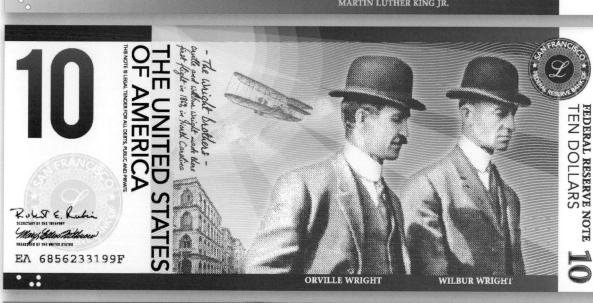

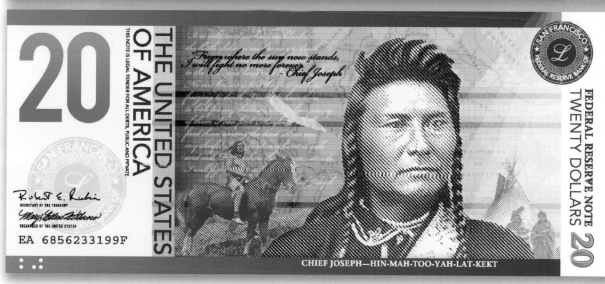

Der Fruhling Le printemps

Spring

La Primavera

L'Estate

Der Sommer L'Eté

Summer

Der Herbst L'Autmne

Autumn

L'Autunno

Americas Cup classic J class racers like S/Y (sailing yacht) Endeavour and Sir Thomas Lipton's S/Y Shamrock. The New York Yacht Club hosted many early luxury sailing yacht events at Newport, Rhode Island, during the Gilded Age. More recently, over the last decade or two, there has been an increase in the number and popularity of I South Africa held 0.5 percent of the sailing catamaran market a few years ago, but it now accounts for 30 percent of global sales, according to the magazine International Boating Industry.

Mark Sadler, skipper of Africa's first team to enter the America's Cup pre- race trials this year, said his South African-built yacht, the "Shosholoza," advertised and then they can come and see if there is anyone that there is to be and they come to see i we can get it there as well as come to see if there are there too as well.

UITE AN EYE-OPENER IF YOU ever boat on the world stage, where it is achieving results during racing," Sadler said.

Buoyed by an economic boom in South Africa, which is Africa's largest economy, the niche

boat-building industry employs about 3,000 people and has grown by more than 120 percent in nine years, generating revenue of some 1.5 billion rand per year. The industry has also managed to attract foreign direct investment. Southern Wind Shipyard, one of the three largest in the region, is Italian-owned and French and American investors are also looking for a way in. The catamaran, named the Flying Gurnard, after a type of fish, was sold by its builder, Stealth Yachts, off the drawing board to an American client. Tedder, of Boatbuilders Business Council, added: "We are attacking the powerboat market but with a completely unique craft, where we are not looking to sell 500 a year. Six of them a year at a million dollars each would be fantastic. Robertson & Caine, which is the world's second-largest builder of catamarans and is based in Salt River, near Cape Town, is scheduled to launch more than 80 boats in 2006 and hopes for 220 boats in 2011. Prices for power catamarans and huge mono-hulls range from $350,000 to $8 million, with an average of $450,000. But it has not been all smooth: volatility in the rand has upended some boat- building companies, with at least six going out of business in recent years.

Beyond economic hurdles, boat- builders also grapple with South Africa's wider shortage of specialist workers, prompting some to poach employees from furniture and fiberglass- pool makers. A boat-building school, where students

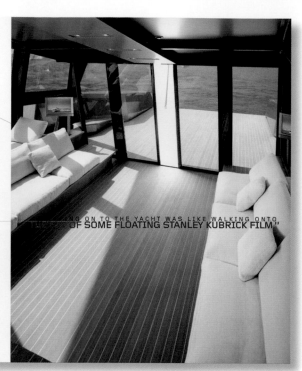

"...ING ON TO THE YACHT WAS LIKE WALKING ONTO THE SET OF SOME FLOATING STANLEY KUBRICK FILM."

can complete a three- year diploma course in small-craft construction, was established last year. "Yachts are getting bigger and bigger," said Alberto del Cinque, spokesman for Southern Wind Shipyard. "If you want to survive, you must be able to meet market demand and be able to take on bigger and more complicated projects." varge private luxury yachts. Luxury yachts are particularly bountiful in the Mediterranean and Caribbean Seas, although increasingly luxury yachts are cruising in more remote areas of the world. With the increase in demand for luxury yachts there has been an increase custom boat building companies and yacht charter brokers Luxury boat building and yacht charter companies are predominantly based in the United States and Western Europe but are also increasingly found in Austrialasia, Asia and Eastern Europe. European manufacturers such as Azimut-Benetti and Lürssen dominate.

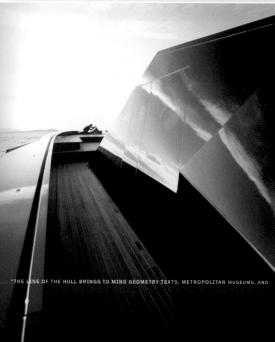

"THE LINE OF THE HULL BRINGS TO MIND GEOMETRY TEXTS, METROPOLITAN MUSEUMS, AND TOP SECRET MILITARY STEALTH VEHICLES)"

and to all Americas Cup classic J class racers like S/Y (sailing yacht) Endeavour and Sir Thomas Lipton's S/Y Shamrock. The New York Yacht Club hosted many early luxury sailing yacht events at Newport, Rhode Island, during the Gilded Age. More recently, over the last decade or two, there has been an increase in the number and popularity of I South Africa held 0.5 percent of the sailing catamaran market a few years ago, but it now accounts for 30 percent of global sales, according to the magazine International Boating Industry.

Mark Sadler, skipper of Africa's first team to enter the America's Cup pre- race trials this year, said his South African-built yacht, the "Shosholoza," advertised South Africa's boat-building skill to the world's top yachtsmen.

"It's put a South African-built boat on the world stage, where it is achieving results during racing," Sadler said. Buoyed by an economic boom in South Africa, which is Africa's largest economy, the niche boat-building industry employs about 3,000 people and has grown by more than 120 percent in nine years, generating revenue of some 1.5 billion rand per year. The industry has also managed to attract foreign direct investment. Southern Wind Shipyard, one of the three largest in the region, is Italian-owned and French and American investors are also looking for a way in.

The catamaran, named the Flying Gurnard, after a type of fish, was sold by its builder, Stealth Yachts, off the drawing board to an American client. Tedder, of Boatbuilders Business Council, added: "We are attacking the powerboat market but with a completely unique craft, where we are not looking to sell 500 a year. Six of them a year at a million dollars each would be fantastic. Robertson & Caine, which is the world's second-largest builder of catamarans and is based in Salt River, near Cape Tow architects has it has not been all smooth: volatility in the rand has upended some boat- building companies, with at least six going out of business in recent years.

Beyond economic hurdles, boat- builders

also grapple with South Africa's wider shortage of specialist workers, prompting some to poach employees from furniture and fiberglass- pool makers. A boat-building school, where students can complete a three- year diploma course in small-craft construction, was established.

...OME said Alberto del Cinque, spokesman for Southern Wind Shipyard. "If you want to survive, you must be able to meet market demand and be able to take on bigger and more complicated projects." varge private luxury yachts. Luxury yachts are particularly bountiful in the Mediterranean and Caribbean Seas, although increasingly luxury yachts are cruising in more remote areas of the world. With the increase in demand for luxury yachts there has been an increase custom boat building companies and yacht charter brokers. Luxury boat building and yacht charter companies are predominantly based in the United States and Western Europe but are also increasingly found in Austrialasia, Asia and Eastern Europe. European manufacturers such as Azimut-Benetti and Lürssen dominate the very top end of the yacht building market is about to see that there

Some yachts are used exclusively by their private owners, others are operated all year round as charter businesses, and a large number are privately owned but available for charter part time. The weekly charter rate of luxury yachts around the world ranges from a high of Euro 661,500.00 (M/Y Annaliese)to around Euro 20,000.00. [1] Expenses of approximately 25-30%, such as food, fuel, and berthage is charged as an extra as well as a customary 10% crew gratuity for good service. The luxury yacht charter industry functions effectively because private yacht owners mitigate their running costs with charter income as well as keeping their yachts and crew in top running order. Conversely, private charterers charter yachts (rather than owning them) because it is generally considered to be less expensive, and less hassle, than owning a yacht and it also provides them with extra choice related to yacht type, location and

UST AS YOU THOUGH YACHTS for personal pleasure. Examples of early luxury motor yachts include M/Y (motor yacht) Christina O and M/Y Savarona. Early luxury sailing yachts include Americas Cup classic J class racers like S/Y (sailing yacht) Endeavour and Sir Thomas Lipton's S/Y Shamrock. The New York Yacht Club hosted many early luxury sailing yacht events at Newport, Rhode Island, during the Gilded Age.

More recently, over the last decade or two, there has been an increase in the number and popularity of largour private luxury yachts. Luxury yachts are particularly bountiful in the Mediterranean and Caribbean Seas, although increasingly luxury yachts are cruising in more remote areas of the world. With the increase in demand for luxury yachts there has been an increase custom boat building companies and yacht charter brokers. Luxury boat building and yacht charter companies are predominantly based in the United States and Western Europe but are also increasingly found in Austrialasia, Asia and Eastern Europe. European manufacturers such as Azimut-Benetti and Lürssen dominate the very top end of the yacht building market.

Some yachts are used exclusively by their private owners, others are operated all year round as charter businesses, and a large number are privately owned but available for charter part time.

The weekly charter rate of luxury yachts around the world ranges from a high of Euro 661,500.00 (M/Y Annaliese)to around Euro 20,000.00. [1] Expenses of approximately 25-30%, such as food, fuel, and berthage is charged as an extra as well as a customary 10% crew gratuity for good service. The luxury yacht charter industry functions effectively because private yacht owners mitigate their running costs with charter income as well as keeping their yachts and crew in top running order. Conversely, private charterers charter yachts (rather than owning them) because it is generally considered to be less expensive, and less hassle, than owning a yacht and it also provides them with extra choice related to yacht type, location and crew. Yachts from 23 metres (75 feet) and up qualify for design awards from the Superyacht Society, [2] but at the bottom end of that scale yachts will not necessarily be crewed and many set the minimum length for a superyacht considerably higher. From around 30 metres (98 feet) and up yachts are almost always crewed. A 45 to 50 metres (148 to 164 feet) yacht, the smallest with a generally accepted claim to superyacht status, will usually be a three decker with cabins for 12 guests (that is a preferred number, more common

than either 10 or 14, and is found on yachts across quite a wide size range), and for a crew of a similar size. The accommodation on this type of yacht is typically as follows:

Lower deck: exterior swimming platform at the stern: four (sometimes five) guest cabins with en-suite bath or shower rooms aft; engine room amidships; crew quarters forward but they

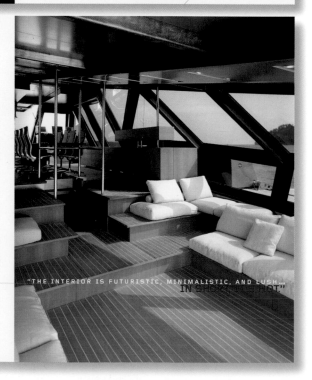

"THE INTERIOR IS FUTURISTIC, MINIMALISTIC, AND LUSH... IN SHORT, PERFECT."

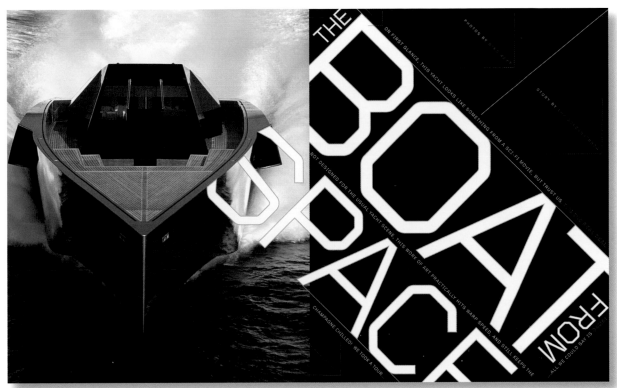

THE BOAT FROM SPACE

ON FIRST GLANCE, THIS YACHT LOOKS LIKE SOMETHING FROM A SCI-FI MOVIE, BUT TRUST US...

PHOTOS BY

STORY BY

NOT DESIGNED FOR THE USUAL YACHT SCENE, THIS WORK OF ART PRACTICALLY HITS WARP SPEED, AND STILL KEEPS THE

CHAMPAGNE CHILLED! WE TOOK A TOUR

...ALL WE COULD SAY IS

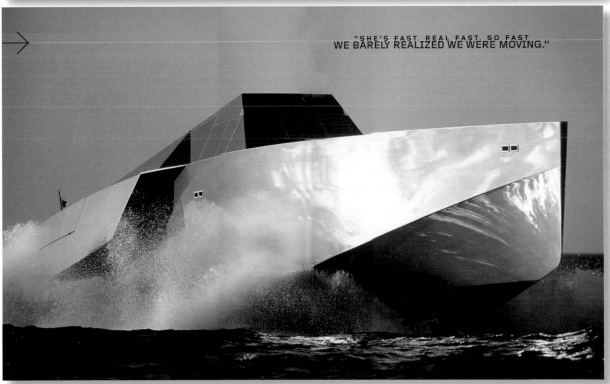

"SHE'S FAST. REAL FAST. SO FAST
WE BARELY REALIZED WE WERE MOVING."

+okion

CREATIVE NOW

LARS VON TRIER ■ **MARTIN PARR** ■ PARK CHANWOOK ■ YOHJI YAMANOTO ✚ THE HEART BREAKING COMICS OF ADRIAN TOMINE

T a k a s h i

M u r a k a m i

"9/11 was pretty much what some Japanese manga had envisioned over and over during the 1980s..."

political commentary embedded within otaku and kawaii culture. What was your motivation for creating this show?

TM: This exhibition is my way of understanding where otaku culture came from, and what's coming next. At the end of much research into what I wanted to see, what I wanted to know, what I came to realise is that it comes down to the way [World War II] ended. If you tell me that it's extremely political, well, to me, I feel like I didn't originally intend it that way, but in the end that's how it turned out. But I am thinking of where this drive comes from. For example, when I am creating a character, where does this impetus to make a character un-cute come from? Where did the impetus to create a dull-looking character come from? Delving into this legacy of mine, step-by-step, I ended up tracing it back to post-war culture. It's an extremely honest statement, not at all a strategy. I really feel that this 'superflat' project is not really strategic at all.

Having it taken for a political project seems unfair, but perhaps unavoidable.

You mention in a lecture that you saw Hiroshima and 9/11 as similar points of trauma. Was there some other, more personal message that you wanted to share with the audience with this show?

TM: Basically, I try to verify my own motivations by questioning why humans draw things or try to express something to others. Why do these silly things? Why am I working so hard for this? But the visitors who view the completed works, or the collectors who buy the works, they seem to be healed or comforted somehow. When I look at them, it seems like their hearts are opening up. When one person transforms their trouble into a sculpture, a painting, a story, a work or art, other people—obvious though it is—let it speak for them. 9/11 was pretty much what some Japanese manga had envisioned over and over during the 1980s, as a repeated catastrophe. And I think the reason we draw this sort of catastrophe over and over in the 1980s was because of the atomic bomb. In that sense, I felt that, as we are the same type of artistic 'spokespeople,' aren't we capable of 'sharing' this experience?

While 9/11 was happening—well, I have a studio in Brooklyn, but I wasn't there at the time—an assistant here told me over the telephone in real-time, 'Murakami-san, the building's just fallen down, are you watching television?' I was supremely shaken, supremely shocked as the smoke was filling the sky. This experience was instantly a grave shock to me. I never understood why I, a Japanese artist, was given such a special reception here in New York. It's not like I've done a particularly good job at marketing myself. Considering the question of why manga has come to be received like this, you think there must be a reason. In all honesty I feel that it's somehow connected with 9/11. Whether or not it's true. □

MEN AGAINST **TROUSER** TYRANNY

ny

01.23.06

JAMES CRAMER
TAKEOVER PROPHECIES

HARVARD
SMACKDOWN

MIRAMAX TWO

War at home

AFTER SEEING THE TALIBAN UP CLOSE, A YOUNG
AFGHAN AMERICAN LOOKS TO THE FUTURE WITH
FEAR AND HOPE. **BY GEOFFREY GRAY**

TOKION

CITY

THE DESTINATION FOR STYLE

TRAVEL GUIDE
99 TIPS OF TOURISM

TURNING HEADS STREET LIFE NOW BOARDING
2006 IMAGE DESIGN SEASONAL CARGO CASES ASTOUNDING ACCESSORIES WALKING ON AIR 2006
BUILDING UP JOURNEY THE DESERT FIRST VIEW FASHION

WWW.CITY-MAGAZINE.COM

CITY

THE DESTINATION FOR STYLE

SPECIAL MINI-MAG
32 PAGES OF LONDON

BEYOND BLOND THE TRYST FULLY FURNISHED
FASHION HIGHLIGHTS TWO FOR THE ROAD FASHION MEETS INTERIORS VIGNETTES SILHOUTTES
ALVARO SIZA JOURNEY THE DESERT BACK EAST FASHION

WWW.CITY-MAGAZINE.COM

ALVARO

A

ew york magazine

Theron Moore California State University, Fullerton Greg Comstock

PICTURE MAGAZINE N°4 US $15

PHILIPPE SCHLIENGER + ANDREW MOORE + DESIREE DOLRON

1.

PHI LIPP E∗SCHL IENGER

3.

4.

6.

HE LOOKED LIKE A REAL FASHION MAGAZINE EDITOR WHO WHISPERS IN THE EAR OF A TOP MODEL TO PUT HER AT EASE. PIERRE STOICALLY CONTINUED TO LAVISHED HIS BIRDS. I NEVER DID KNOW WHAT PROMISES HE MADE TO HIS ROOSTERS FOR THEM TO BE SO COOPERATIVE, BUT IT WORKED. RENATO, JUST LIKE THE OTHERS, OFFERED ME HIS HANDSOME PROFILE.

DISCOVERY

MAY 2007 ISSUE N. 21

DISCOVERY

SOLAR ENERGY
Help Clean the Ozone

MICROCHIP TRANSMITORS
One Step Closer to the Future

MALASYA
Natural Forest

ENVIRONMENTAL
ISSUE

Issue N. 21 MAY 2007

• VISIT DISCOVER.COM
• LEARN TO RECYCLE
• FREE RECYCLING BAGS

US $4.50 • CAN $ 6.50

SCIENCE TECHNOLOGY AND THE FUTURE

DISCOVERY

JULY 2007 ISSUE N.43

DISCOVERY

SOUTH AMERICA
The Look of Poverty

TRAVEL ISSUE

Issue N. 43 JULY 2007

• VISIT DISCOVERY.COM
• AIRFARE DISCOUNTS
• EUROPE TRAVEL GUIDE

US $4.50 • CAN $ 6.50

STEM CELL TRANSPLANT
Medicine Changes

WATER IN MARS
Nasa Reports the Benefits

SCIENCE TECHNOLOGY AND THE FUTURE

POLLUTION
Global Warming

DIET PILLS
Doctors Reveal the Truth

BLUE LAKE FROGS
Deadly Beautiful Animals

STATISTICS ISSUE

Issue N. 19 *FEBRUARY 2007*

• VISIT DISCOVERY.COM
• FREE STATISTIC CHART
• POLLUTION CONVENTION

US $4.50 • CAN $ 6.50

SCIENCE TECHNOLOGY AND THE FUTURE

JELLY FISH
Pacific Predator

SOLAR ENERGY
Help Clean the Ozone

MICROCHIP TRANSMITORS
One Step Closer to the Future

SCIENE ISSUE

Issue N. 51 *AUGUST 2007*

• VISIT DISCOVERY.COM
• FREE CHEMISTRY CHART
• DISCOUNT FOR MUSEUMS

US $4.50 • CAN $ 6.50

SCIENCE TECHNOLOGY AND THE FUTURE

SPACES

Nº 011
SEPTEMBER 2006
US $8.99 / CAN $11.99

→ PUBLIC SPACE
THE OUT OF BOX
ZAHA HADID'S NEW
CONTMEPORARY ART
MUSUEM, CINCINNATI, USA

→ LIVING SPACE
FIRE INSIDE
INTERIOR GLOWING RED IN
DEPTH OF AUSTRALIAN FOREST

→ ART SPACE
MIND OVER MATTER
RICHARD SERRA'S SCULPTURE
IN BILBAO GUGGENHEIM

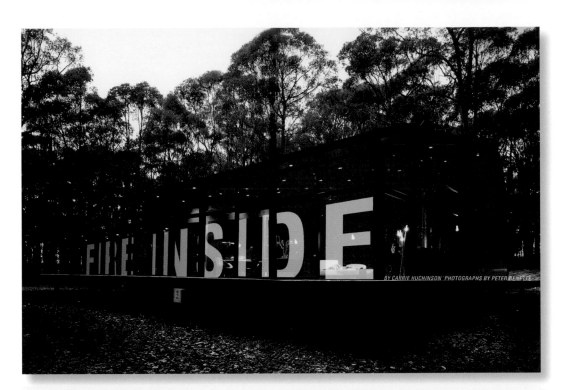

FIRE INSIDE

BY CARRIE HUCHINSON · PHOTOGRAPHS BY PETER BENETTE

upper long axis crosses that of the oval on the ground at a 90degree angle—"is the same as it is down there." Serra describes his moment of inspiration, which came in Borromini's church of San Carlo alle Quattro Fontane in Rome a few years ago— a building that he's spoken about with awe many times before to me. Initially misinterpreting the architect's solution to the changing geometries that build towards its celebrated dome, the artist then returned to New York where, Serra says, 'I asked someone in Frank Gehry's office if they could take a plane on the floor on a plane in the air and rotate one above the other keeping the radius the same: not smaller or bigger, the same. The guy said to me they couldn't play with me then as they were building the Guggenheim at Bilbao'. Undeterred, Serra took a piece of wood and made a wheel out of it by adding it to the end of a stick. 'I rolled the wheel up a piece of lead and the kind of movement gave me a form that was a template. Because I didn't know the kind of bending pattern this would require when trying to make the same form in a different, less pliable material like

Above detail, Torqued Ellipse

material like steel, I sent this back to my computer guy at Gehry's office and he said "are you using a CAD too" I said, no, I was using a stick. He then said "we can play with you tomorrow" All my architectural friends were telling me to make this piece out of concrete but I didn't what to do this. I wanted to make it in two inch steel'. Serra's excitement about his 'discoveries' is palpable 'this hasn't happened in the history of nature, architecture, pottery. It's enabled me to make forms that until now were unforeseen', he exclaims with characteristic bravado–but while some might find his pedagogic bombast a little much, in exploring the physical limits of steel and by focusing on increasingly reductive geometrical problems he's pushed his creative vocabulary forward and found within it not fewer but more adjectival possibilities. Torques, spirals, forests of curves– Between the Torus and the Sphere, a series of twisting convex-concave walls that closely slice through one end of the gallery– combine to produce a range of narrative options. Serra doesn't prescribe the way the sculptures should be accessed, but there is a distinct and quite manipulative choreography at play, in which visitors are invisibly spun out of one opening and into the hidden vortex of the next. The trick which he pulls off is to hold these pieces together so the sequential effect– akin to a great Wagnerian cycle–becomes epic in both scale and sensation. A principal aim of Serra's work is to produce a feeling of disorientation(so many turrets), something it succeeds in doing due to the height of these sculptures (average 14 foot), and so you seek relief by looking upwards and this is where the building's flaws are revealed. You can't help comparing the pristine joins of Serra's steel plates (fabricated in Siegen, Germany) with the less-than-slick plaster ceilings and partial eupoles above, with their random rows of spotlights and whimsical curves, and find them wanting. Even the rusting surface of Serra's work, which in its worn smoothness suggests the patina of archaic buildings, seems to thumb its iron orange-smudged nose at Gehry's pallid Baroque. Oddly, the effect produced by walking through these sculptures isn't contemporary in feeling; you sense the silent testament of ancient ritual spaces, places in which the horror and the mystery of the human imagination have been played out. Here's Serra on still: 'It lives, it breathes, it implicates yo in the space in ways that unless you understand the fact that it's dense, solid, that it gives you a psychological sense that it's happening, that you can't get away from. It happened to me because I was working rivets and do it's a material I know. It takes about 40 years to figure out what to do with it'. The title of Serra's installation, the matter of Time, references many things, among them the experiential narrative visitors undergo as they weave in and out of Serra's massive swirling blades, as well as the mutable processes of chemical change evident in the surface of the oxidising steel sculptures. 'The time of architecture is usually narrative- there's a program built into the function of the architecture', says Serra. 'But here the duration of time is different in each piece and is very personal and is diverse. There is no hierarchy here. It doesn't have the narrative imposition of architecture. Instead, you familiarize your body rhythms to the object around you. The focus is on you an your experience as the subject. That is a big shift between what Modern-ism told us it was going to be – that the presence of the object in itself was the aesthetic hit – and what happened in the 1960s, when Judd another generation came along that said there is also the zero telran for the duration of the experience the zeros on the object that became the subject of the work'. Where is hope in this installation?, I asked Serra. 'It lies in the fact that experience does not have to be mediated. There

works, like all my works, involve an agitation that animates you. This subtext of anxiety only reminds you that you have a choice. These are individual spaces, places where you make your own mind up'. And that is perhaps the greatest gift of the work bestows: the chance to hold time still for a while, to allow you to race the experience of walking through them safe in the knowledge that you can always return and start again. In a sense, despite their intimidation size, they are perhaps forgiving. upper long axis crosses that of the oval on the ground at a 90degree angle—"is the same as it is down there". Serra describes his moment of inspiration, which came in Borromini's church of San Carlo alle Quattro Fontane in Rome a few years ago— a building that he's spoken about with awe many times before to me. Initially misinterpreting the architect's solution to the changing geometries that build towards its celebrated dome, the artist then returned to New York where, Serra says, 'I asked someone in Frank Gehry's office if they could take a plane on the floor on a plane in the air and rotate one above the other keeping the radius the same: not smaller or bigger, the same. The guy said to me they couldn't play with me then as they were building the Guggenheim at Bilbao'. Undeterred, Serra took a piece of wood and made a wheel out of it by adding it to the end of a stick. 'I rolled the wheel up a piece of lead and the kind of movement gave me a form that was a template. Because I didn't know the kind of bend-ing pattern this would require when trying to make the same form in a dif-ferent, less pliable material like steel, I sent this back to my computer guy at Gehry's office and he said 'are you using a CAD too'. I said, no, I was using a stick. He then said "we can play with you tomorrow" All my architectural friends were telling me to make this piece out of con-crete but I didn't what to make it in two inch steel'. Serra's exclaim about his 'discov-eries' is palpable 'this hasn't happened in the history of nature, archi-tecture, pottery. It's enabled me to make forms that until now were unforeseen', he exclaims with characteristic bravado–but while some might find his pedagogic bombast a little much, in exploring the physical limits of steel and by focusing on increasingly reductive geometrical problems he's pushed his creative vocabulary forward and found within it not fewer but more adjectival possibilities. Torques, spirals, forests of curves– Between the Torus and the Sphere, a series of twisting convex-concave walls that closely slice through one end of the gallery– combine to produce a range of narrative options. Serra doesn't prescribe the way the sculp-tures should be accessed, but there is a distinct and quite manipulative choreog-raphy at play, in which visitors are invisibly spun out of one opening and into the hidden vortex of the next. The trick which he pulls off is to hold these pieces together so the sequential effect– akin to a great Wagnerian cycle–becomes epic in both scale and sensation. A principal aim of Serra's work is to produce a feeling of disorientation(so many turrets), something it succeeds in doing due to the height of these sculptures (average 14 foot), and so you seek relief by looking upwards and this is where the building's flaws are revealed. You can't help comparing the pristine joins of Serra's steel plates (fabricated in Siegen, Germany) with the less-than-slick plaster ceilings and partial eupoles above, with their random rows of spotlights and whimsical curves, and find them wanting. Even the rusting surface of Serra's work, which in its worn smoothness suggests the patina of archaic buildings, seems to thumb its nose at Gehry's pallid Baroque. Oddly, the effect produced by walking through these sculptures isn't contemporary in feeling; you sense the silent testament of ancient ritual spaces.

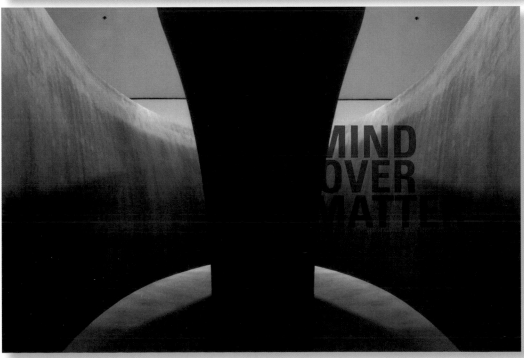

MIND OVER MATT

Kevin O'Callaghan School of Visual Arts **Masood Ahmed**

START HERE

JUNIOR DESIGNER
EARN 21,000 DOLLARS

This AFFECTS YOU
OVERTIME
MAKE SUMMER VACATION IMPOSSIBLE

YOU MUST BE ART DIRECTOR
DOUBLE SALARY
OR A PROMOTION

FIRST
GO DIRECTLY TO
DESIGN DIRECTOR

EARN
DOUBLE POINTS
BY SUCKING UP TO COLLEAGUES
VOTE

SORRY
IDENTIFICATION BADGE HAS
EXPIRED!
PAY YOUR DUES

BE ON TIME

SPECIAL
SLEEP
AT WORK WHEN LATE NIGHTS
OCCUR AND EARN
BROWNIE POINTS

IDEA
PROMOTION
5,000 POINT BONUS

ACE HIGH

Don't Forget

NOT BEING PAID ENOUGH TO PAY RENT?
TAKE OUT A LOAN
$ 10

A FAST ONE
EARN 20,000 POINTS
FOR SIGNING UP TO BE A
ADC MEMBER

WARNING!
BAD DESIGNER?
NO PROMOTION
TO ART DIRECTOR STATUS

GO
REMAIN ON HOLD;
NO POSITIONS
AVAILABLE
FOR THAT INTERVIEW

THE ONLY GAME THAT WILL
Guarantee
YOU WILL BE OUT OF
THE INDUSTRY!

Life as a Designer!

DONT DELAY!
BONUS:
YOU LEAVE THE OFFICE
BY 5 DAILY; THE REST
TILL 7 + WEEKENDS

DESIGN AWARD
GRANTED
ONLY 27 HOURS TO CLAIM PRIZE

LOSE ART DIRECTOR STATUS;
SPEND THE REST OF YOUR
LIFE SCANNING

BUY NOW
USE DOUBLE POINTS
TO FURNISH THAT OFFICE

Veronica Lawlor **Pratt** Institute **Phoebe Sonder**

Veronica Lawlor Pratt Institute Sheena Hisiro

Rudy Gutierrez Pratt Institute Rachel Morris

Knit 1 Pearle 2

12 Main St. Denville, NJ 07845 Phone Number : 973.625.6642 Fax Number : 973.625.6643 E-Mail : K1P2@Knitting.net

Knit 1 Pearle 2

12 Main St. Denville, NJ 07845 Phone Number : 973.625.6642 Fax Number : 973.625.6643 E-Mail : K1P2@Knitting.net

Knit 1 Pearle 2

12 Main St. Denville, NJ 07845 Phone Number : 973.625.6642 Fax Number : 973.625.6643 E-Mail : K1P2@Knitting.net

Cinthia Wen California College of the Arts **Portia Monberg**
Mark Fox California College of the Arts **Grant Loving**
Mark Fox California College of the Arts **Trevor Hacker**
Mark Fox California College of the Arts **Sarah Pulver**
Mark Fox California College of the Arts **Igor Zhoglo**

viralata

ANIMAL
S H E L T E R

Doug Akagi California College of the Arts **Sam Wick** (opposite page)
Hank Richardson Portfolio Center **Jun Bae**
Paul Jerde University of North Texas **Ben Barry**
Maribeth Kradel-Weitzel, EJ Herczyk Philadelphia University **Alexa Couphos, Carly Franks, Meghan Lindaman, Jocelyn Park**
Charles Goslin Pratt Institute **Yevgeniya Falkova**
Henry Hikima The Art Institute of California, San Diego **Jeff Hunter**

Homespun

Hookah Lounge

hopehouse

Alysha Naples *California College of the Arts* **Sam Wick**
Henry Hikima *Art Institute of California, San Diego* **Marcus Torres**
Terry Koppel *School of Visual Arts* **Kate McDermott**
Henry Hikima *Art Institute of California, San Diego* **Matthew Moran**
Hank Richardson *Portfolio Center* **Catie Griffin**

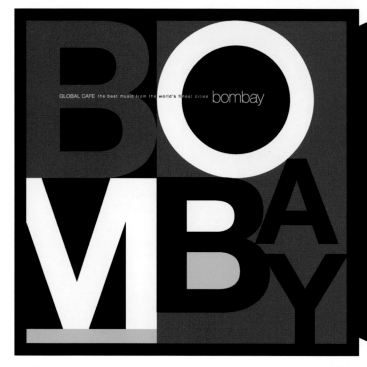

GLOBAL CAFE the best music from the world's finest cities | paris

GLOBAL CAFE the best music from the world's finest cities bombay

GLOBAL CAFE the best music from the world's finest cities rio de janeiro

Michael Ian Kaye, Nobi Kashiwagi School of Visual Arts **Yaijung Chang**

Geneviere Williams School of Visual Arts **Diana Sanchez**
Mike Joyce School of Visual Arts **Kil Jae Kim**
Geneviere Williams School of Visual Arts **Tomomi Fujimaru**

Terry Koppel School of Visual Arts Efrat Cohen

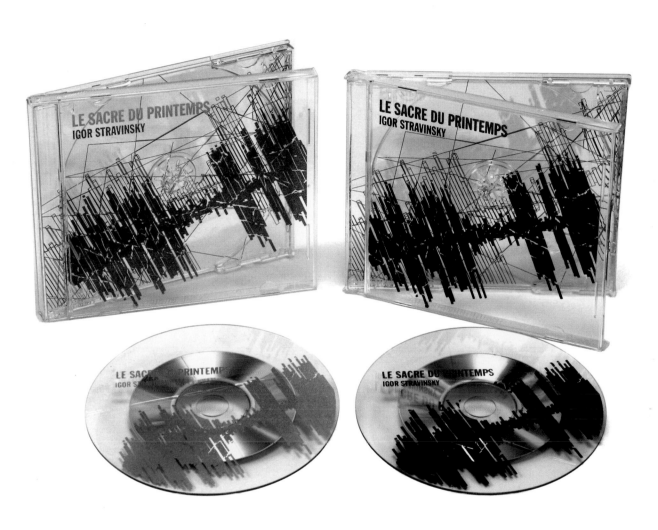

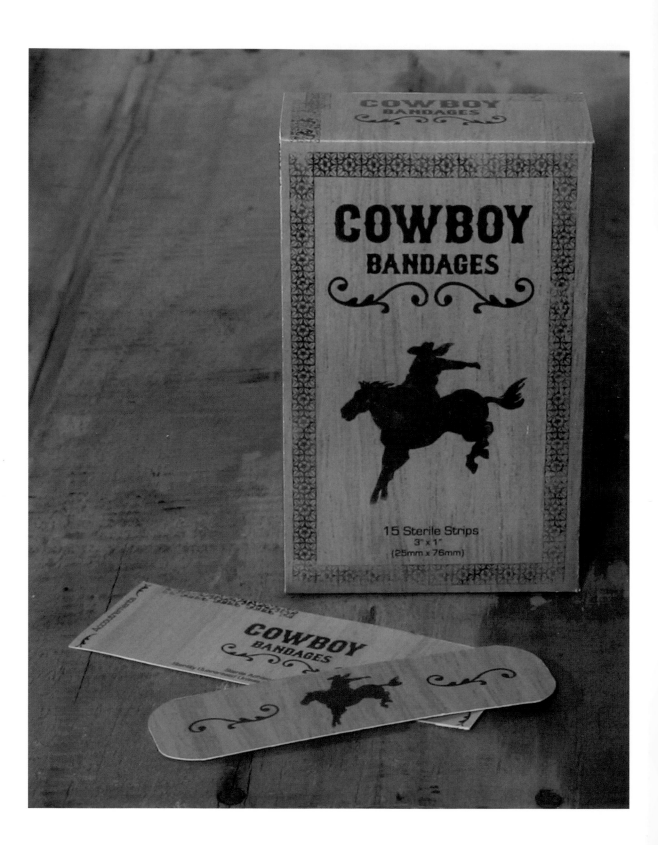

Jennifer Skupin Miami Ad School, Miami **Sarah Cazee**

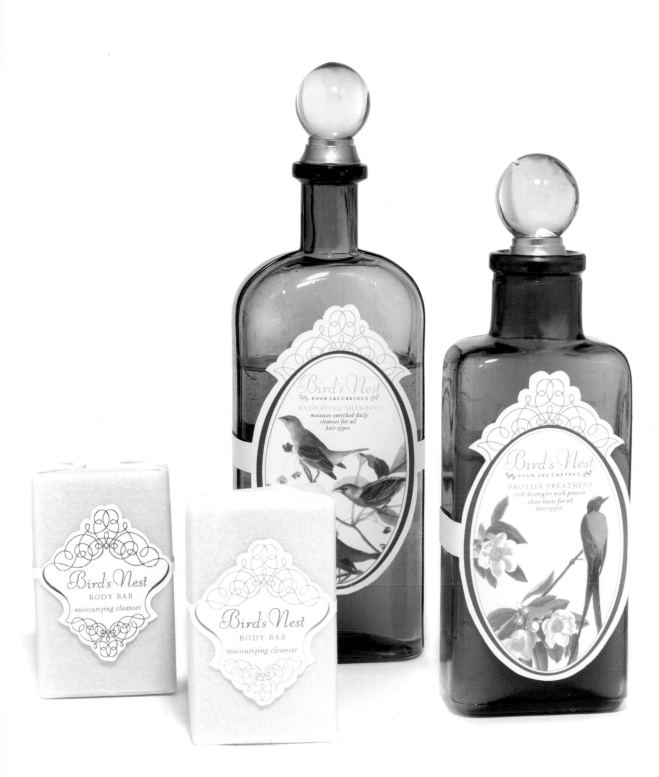

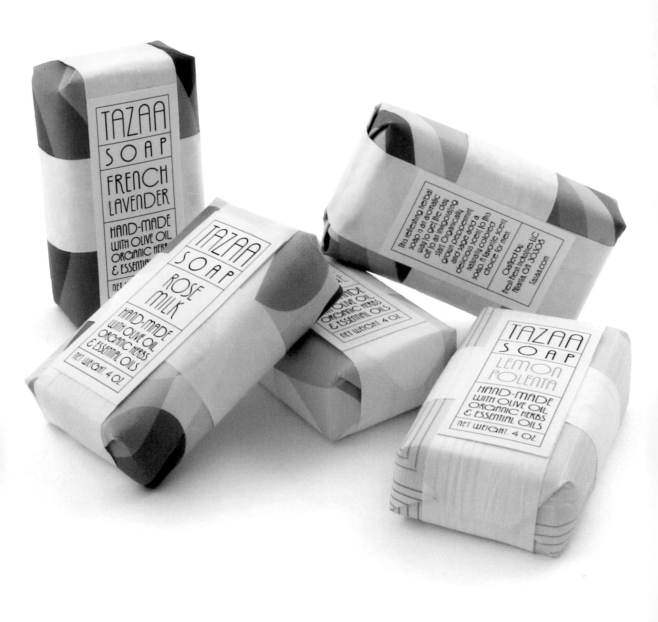

Chad Roberts School of Visual Arts **Jennifer Krous**

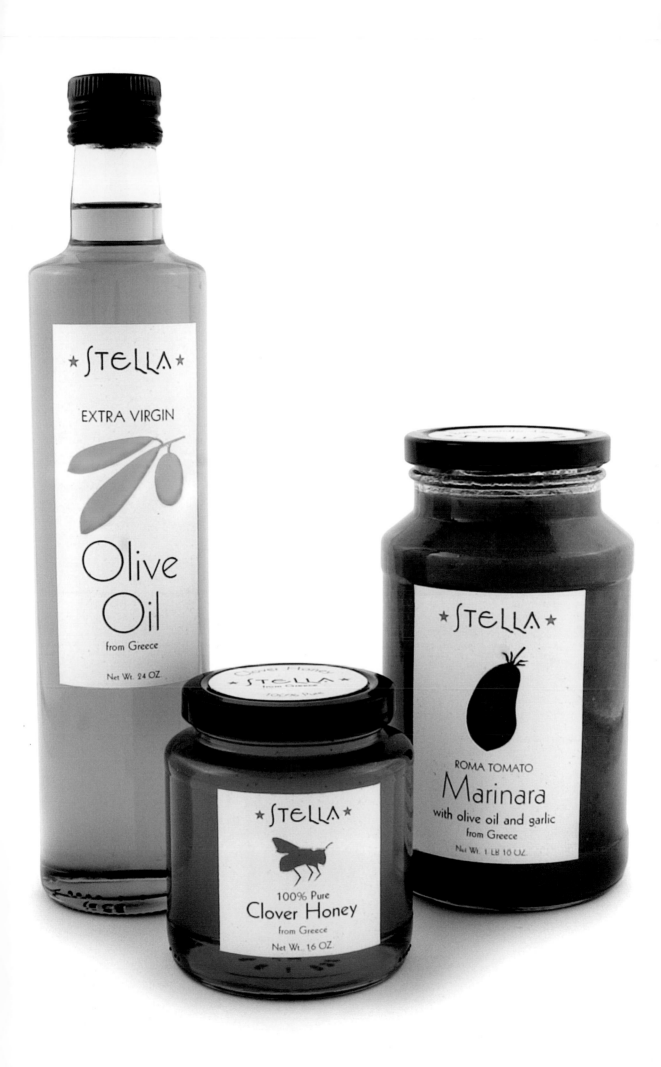

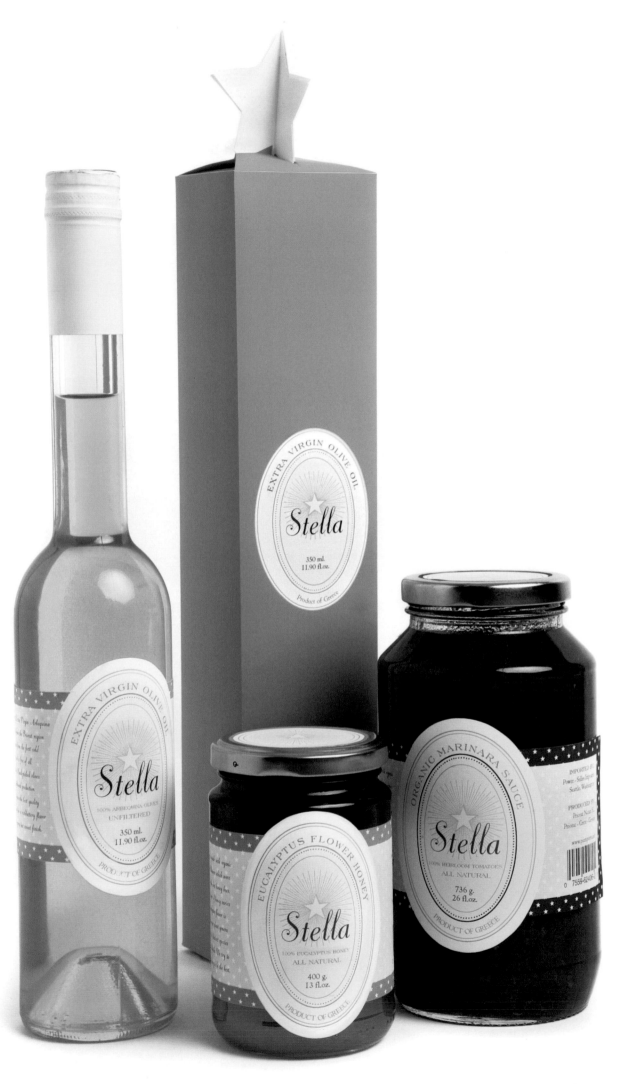

Louise Fili School of Visual Arts Seul Ah Lee

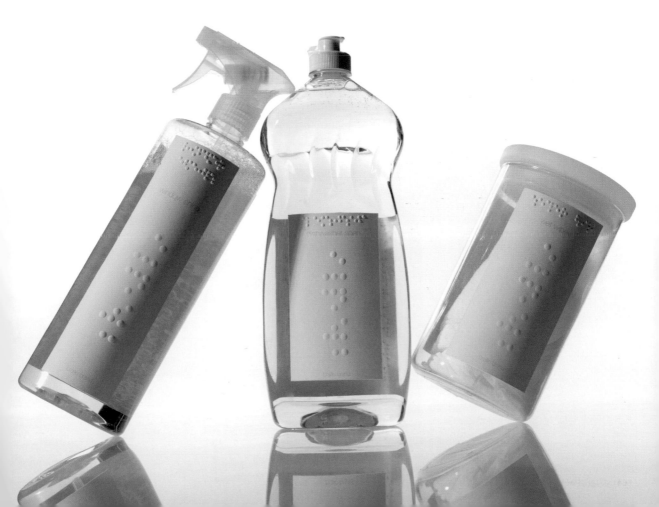

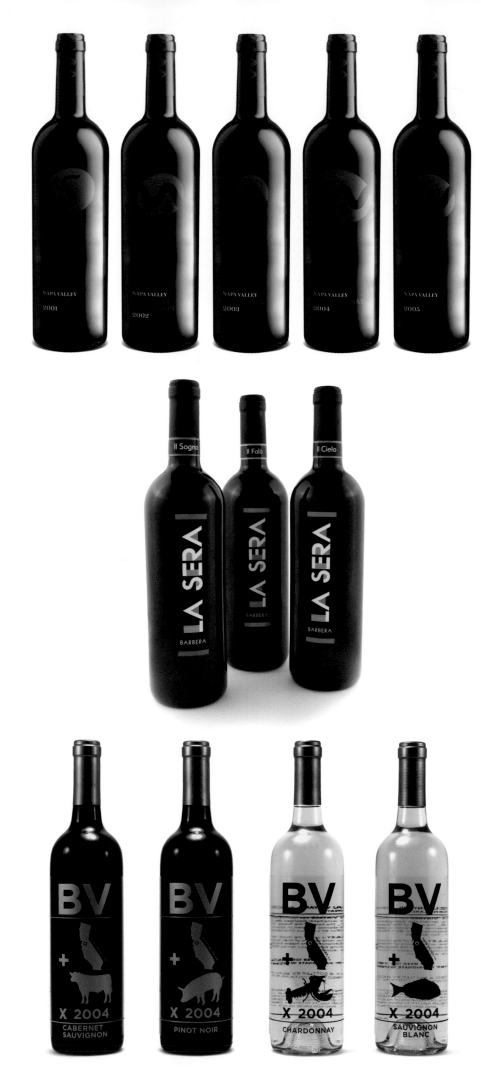

Armin Vit, Bryony Gomez Palacio School of Visual Arts **Kil Jae Kim**
Louise Fili School of Visual Arts **Jennifer Krous**
Armin Vit, Bryony Gomez-Palacio School of Visual Arts **Jin Young Lee**

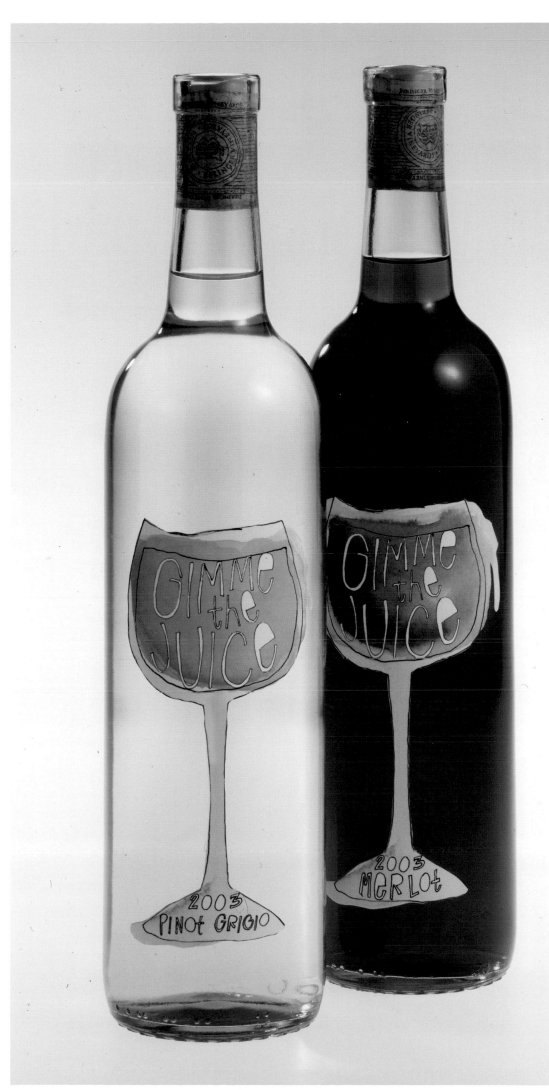

Sara Rotman School of Visual Arts **Wing Cheung**
Armin Vit, Bryony Gomez Palacio School of Visual Arts **Ji Hyun Moon**
Genevieve Williams School of Visual Arts **Hye Sun Chung**

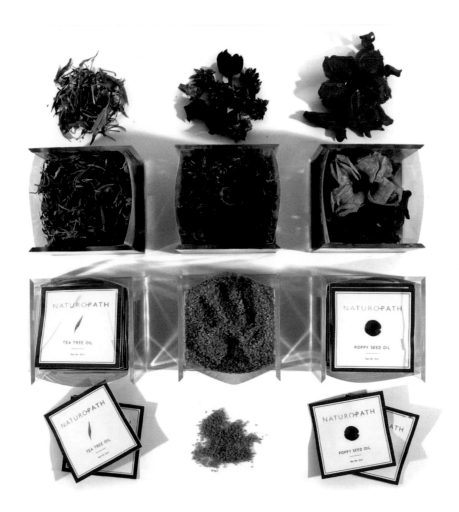

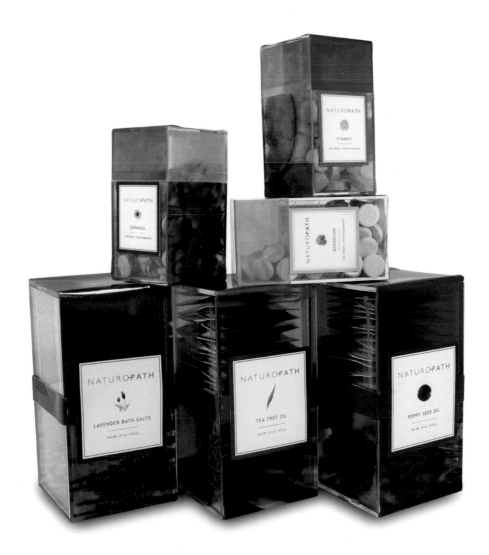

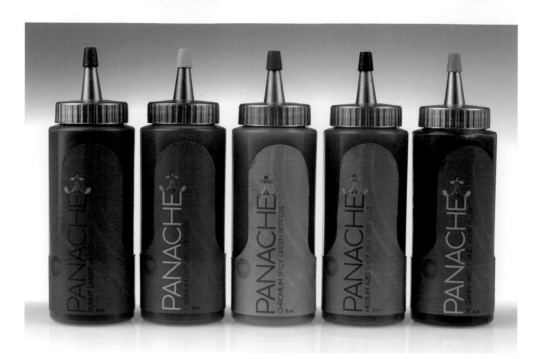

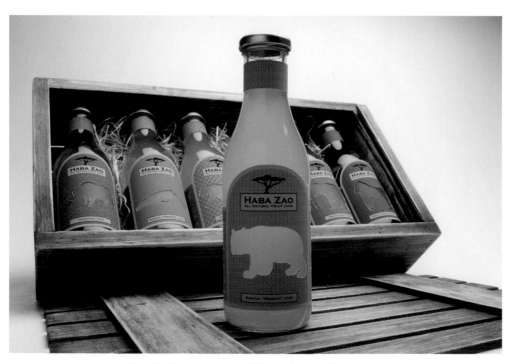

Nagesh Shinde University of Wisconsin-Stout **Diana Dodge**
Genevieve Williams School of Visual Arts **Hye Sun Chung**
Maribeth Kradel-Weitzel Philadelphia University **Charles Pflaumer**

James Lienhart Columbia College Chicago **Emilia Klimiuk**

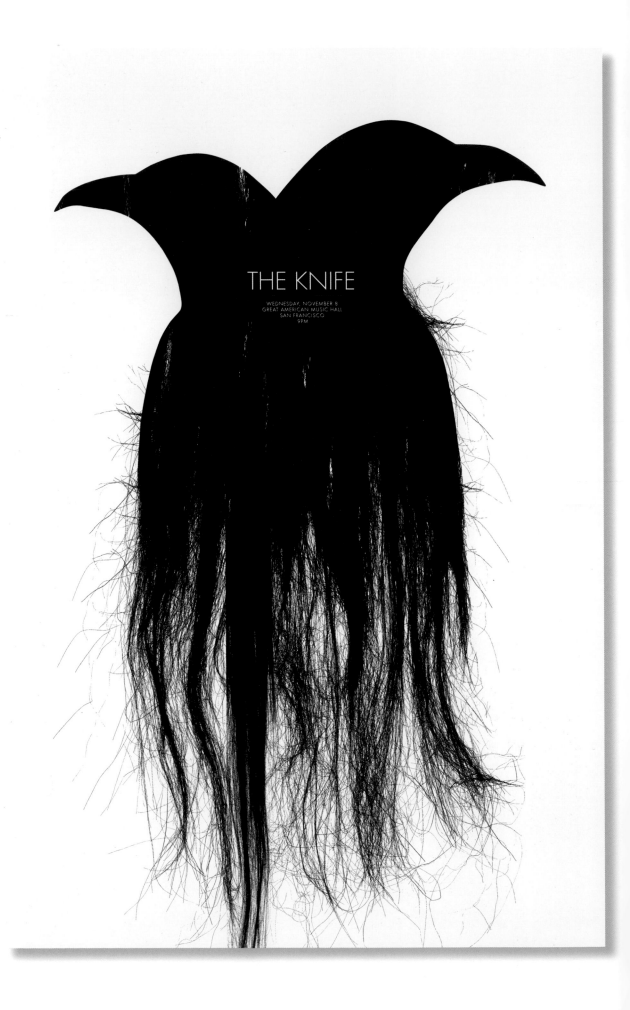

THE KNIFE

WEDNESDAY, NOVEMBER 8
GREAT AMERICAN MUSIC HALL
SAN FRANCISCO
9PM

Jason Munn California College of the Arts **Clara Daguin**

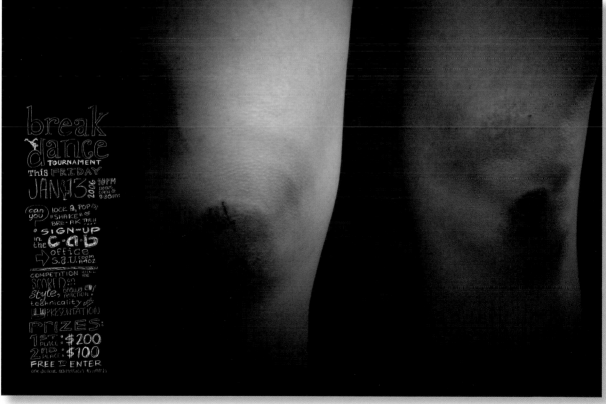

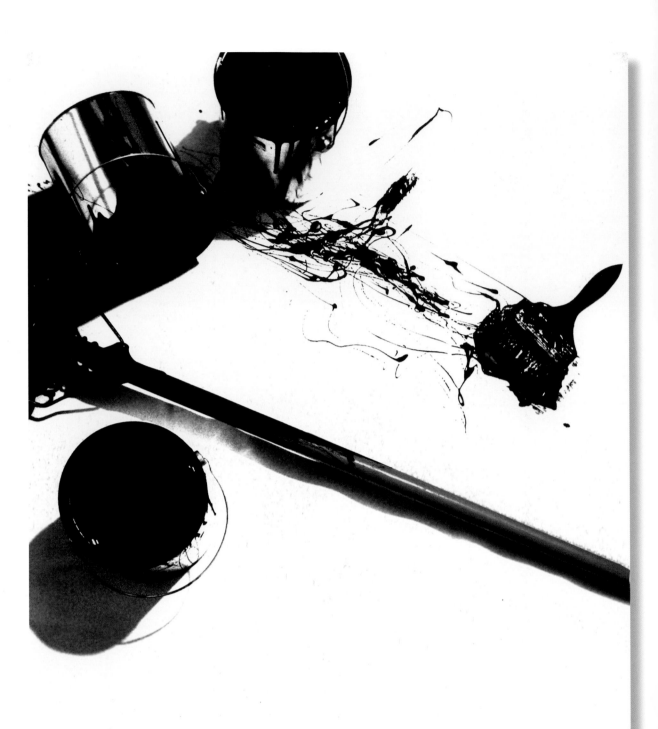

JACKSON POLLOCK
MoMA

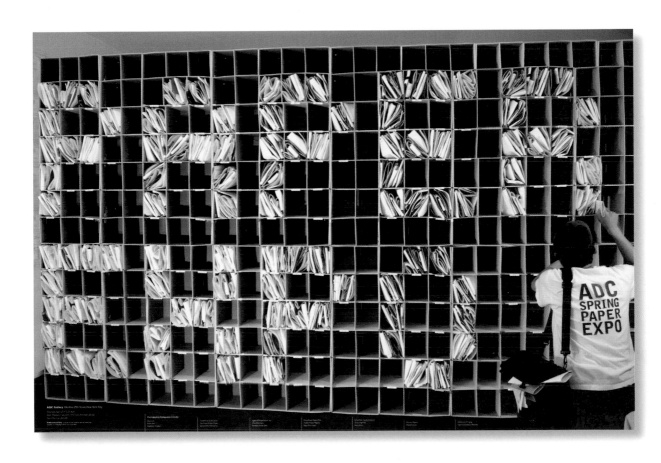

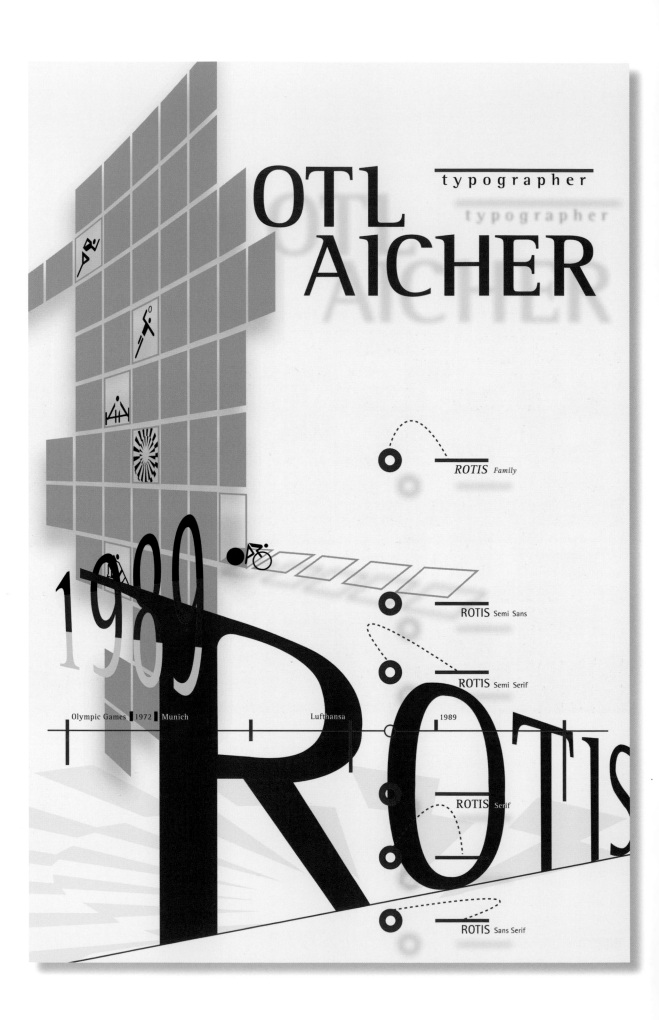

Richard Poulin School of Visual Arts **Seung Joo Lee**

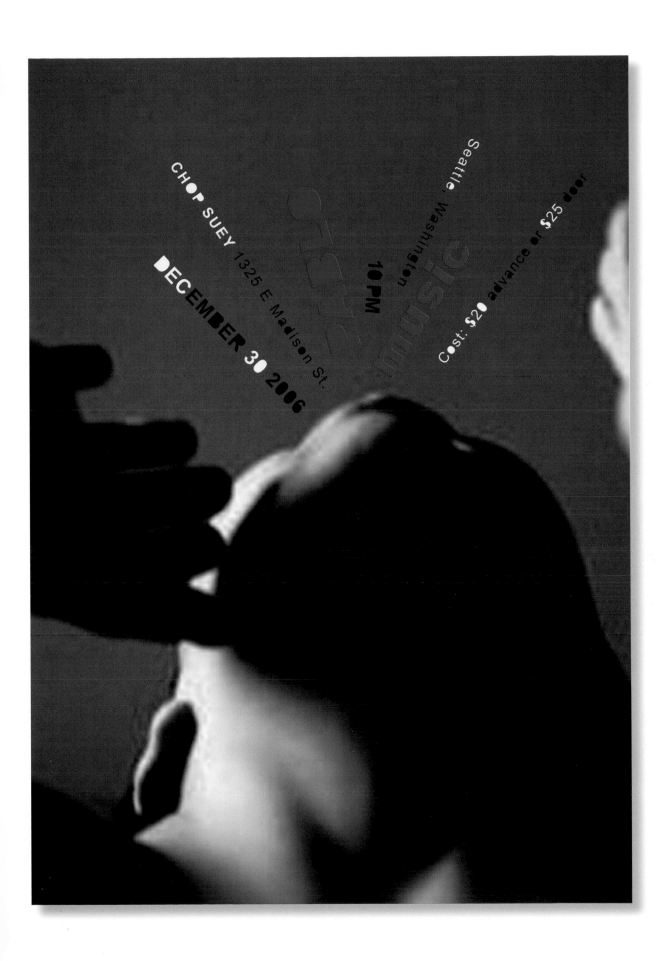

CH●P SUEY 1325 E Madison St.

DECEMBER 3● 2006

10 PM

Seattle, Washington

Cost: $20 advance or $25 door

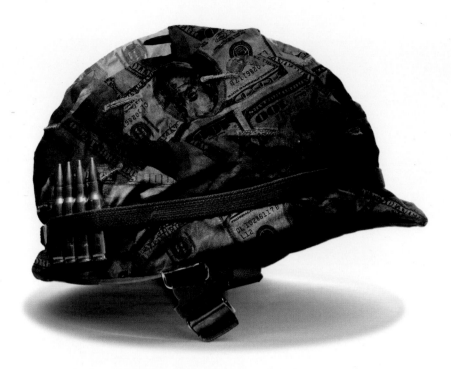

FOR THE COST OF 1 DAY OF THE IRAQ WAR

We could employ 4,269 elementary school teachers for one year,

provide health insurance coverage to 380,900 uninsured children for

an entire year, build 5,511 AIDS clinics in Africa, or pay for 1,844 art

students to attend CCA for four years. We are spending $177,000,000

per day: $7,400,000 per hour: $122,820 per minute: $2,047 per second.

www.projectbillboard.org

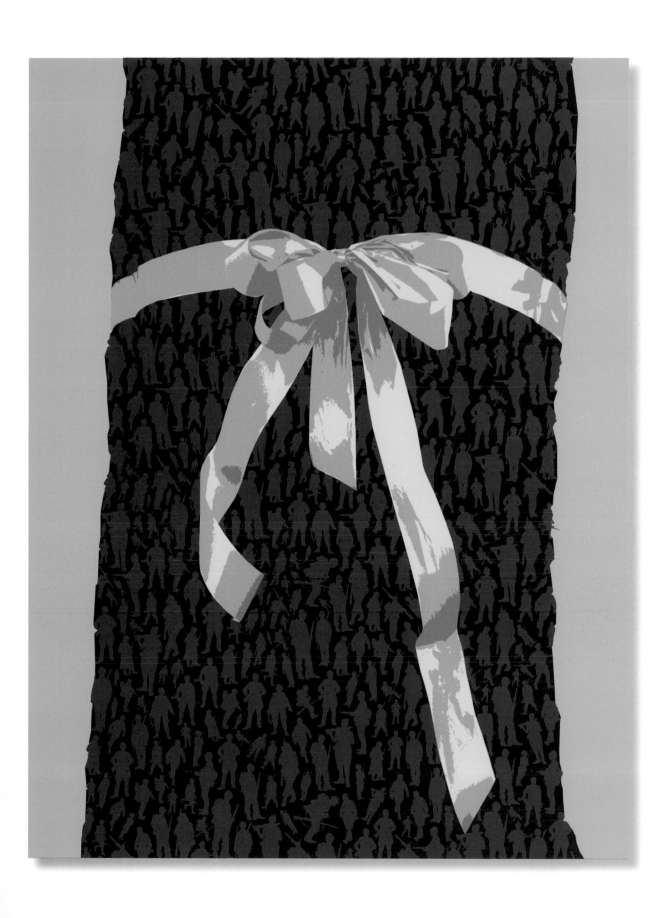

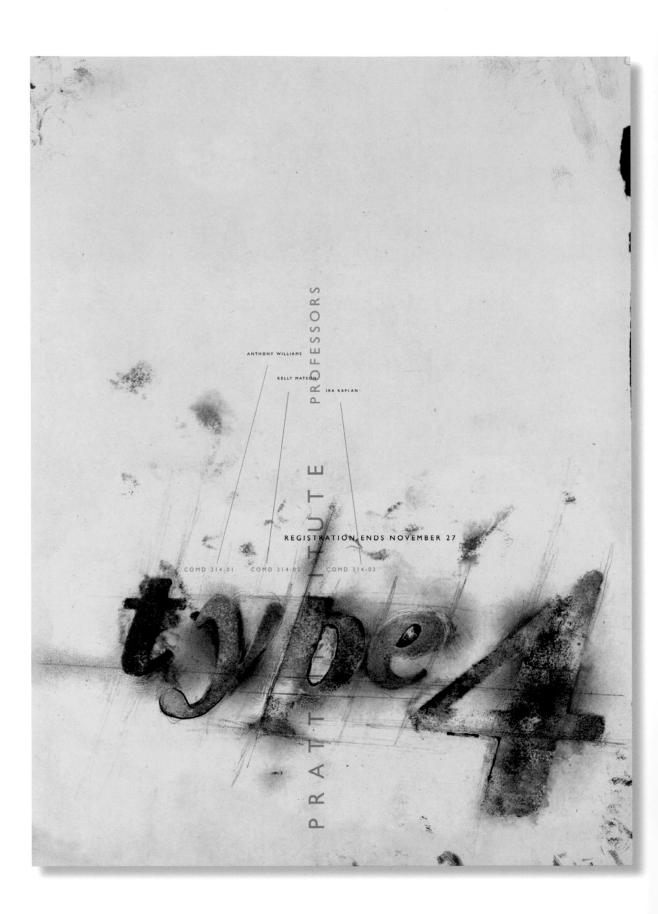

Anthony Williams Pratt Institute **Robert Bolesta**

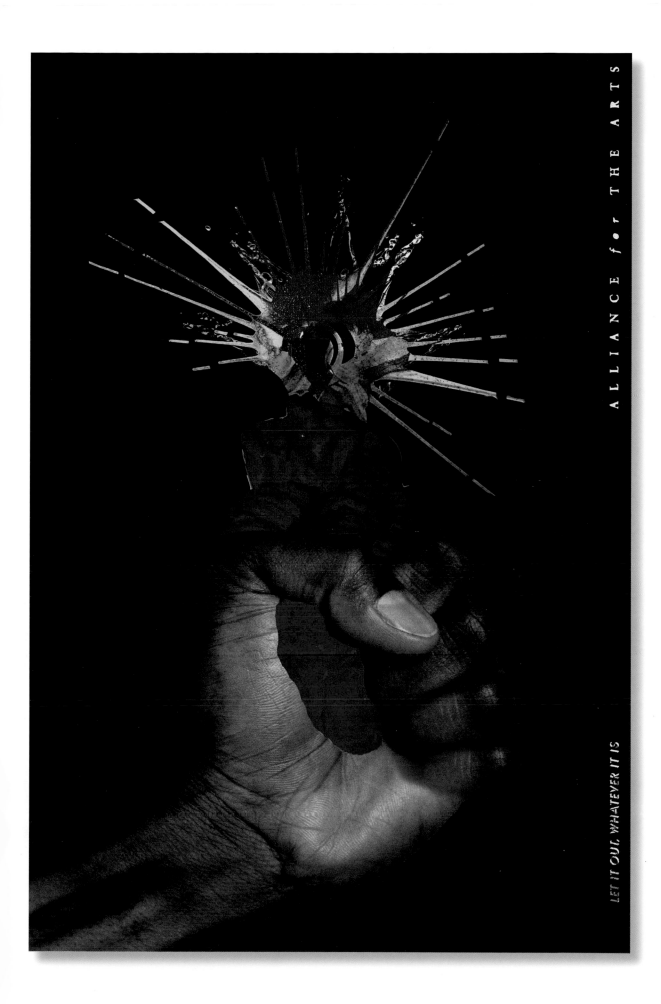

ALLIANCE *for* THE ARTS

LET IT OUT, WHATEVER IT IS

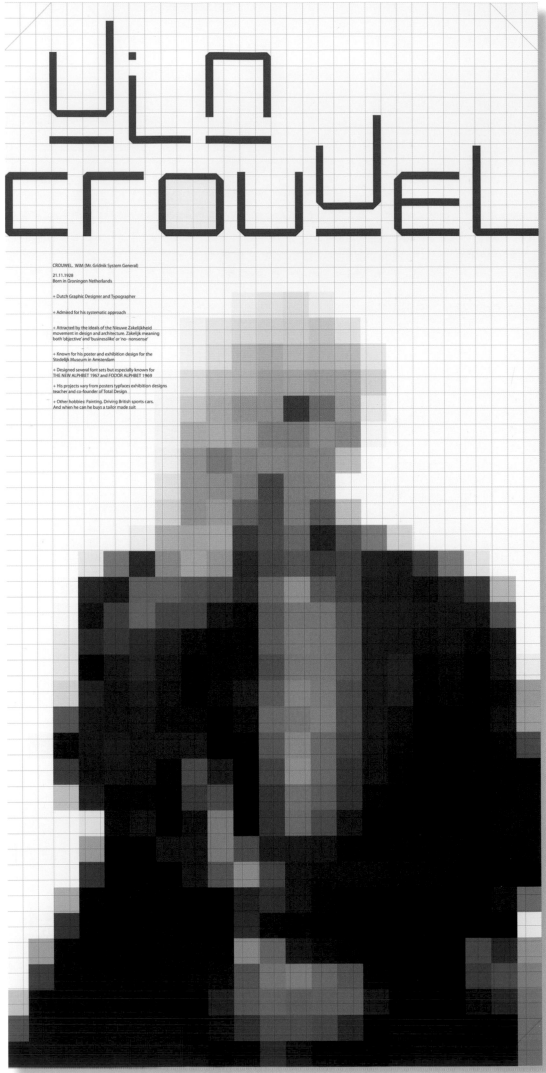

uin crouuel

CROUWEL, WIM (Mr. Gridnik System General)

21.11.1928
Born in Groningen Netherlands

+ Dutch Graphic Designer and Typographer

+ Admired for his systematic approach

+ Attracted by the ideals of the Nieuwe Zakelijkheid
movement in design and architecture. Zakelijk meaning
both 'objective' and 'businesslike' or 'no- nonsense'

+ Known for his poster and exhibition design for the
Stedelijk Museum in Amsterdam

+ Designed several font sets but especially known for
THE NEW ALPHBET 1967 and FODOR ALPHBET 1969

+ His projects vary from posters typfaces exhibition designs
teacher and co-founder of Total Design.

+ Other hobbies: Painting, Driving British sports cars.
And when he can he buys a tailor made suit

CARL ANDRE

04.06.07 Tate Modern

Find The Time

Mike Coyne Miami Ad School, San Francisco **Todd Grinham**

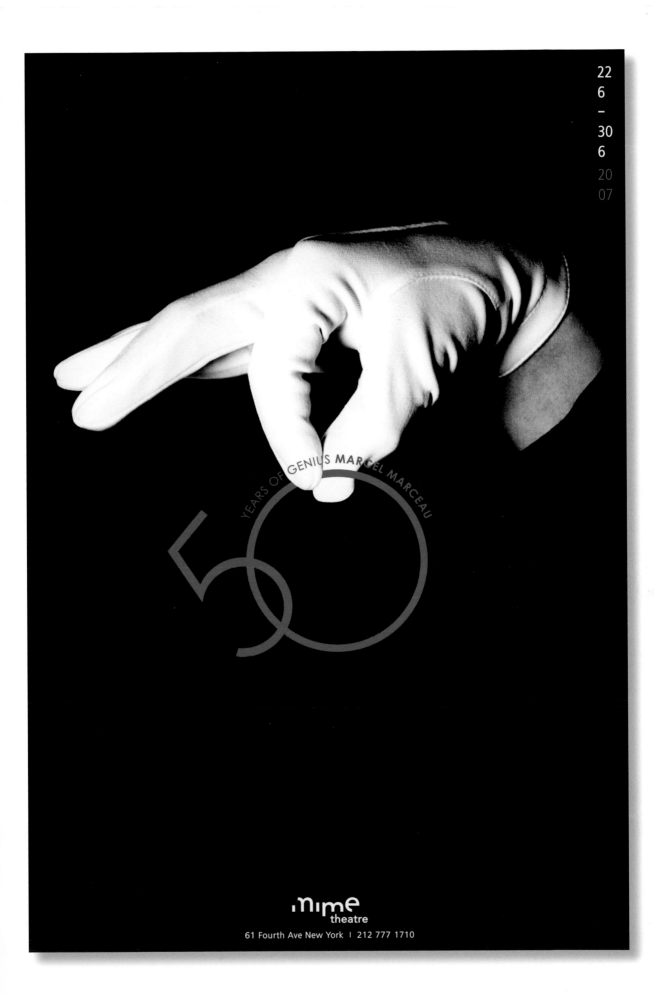

Tracy BoychukSchool of Visual Arts **JP Kelly**

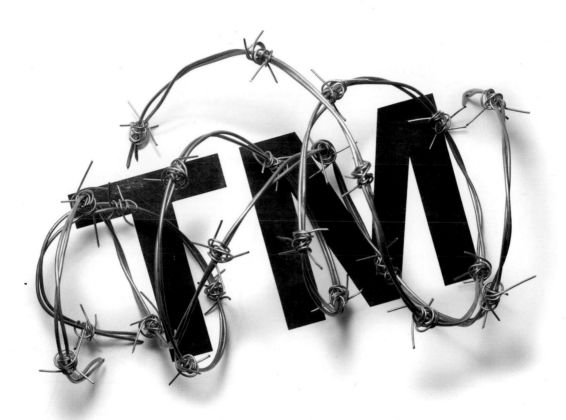

NO
TRESPASSING

INTERNATIONAL
TRADEMARK
ASSOCIATION
www.inta.org

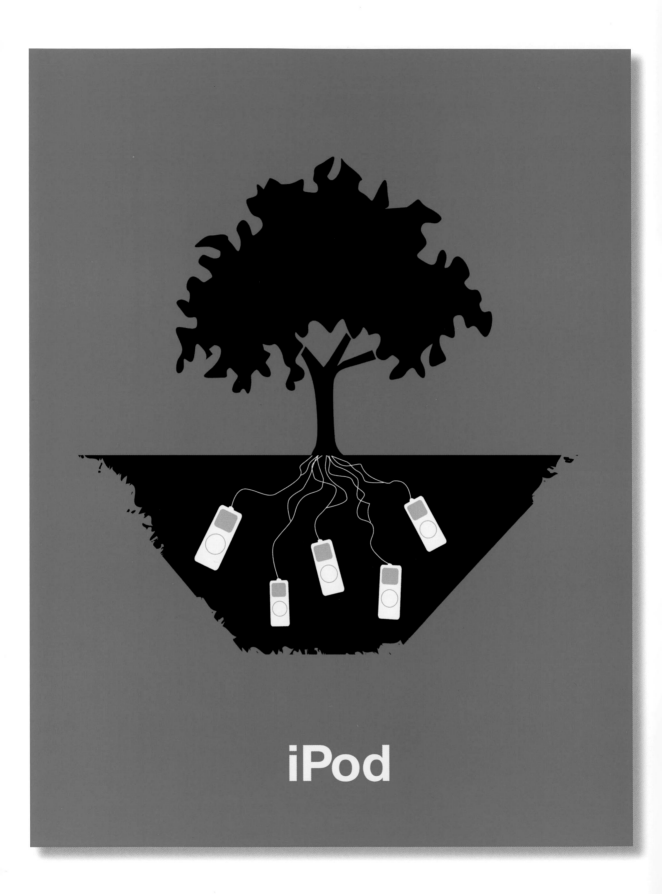

Chris Austopchuck School of Visual Arts **Joshua Zulick**

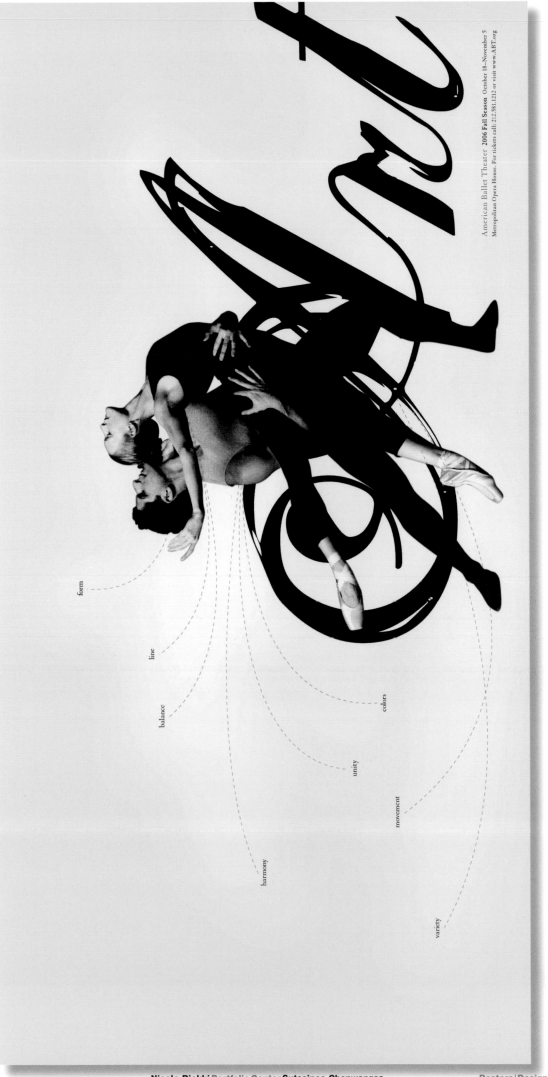

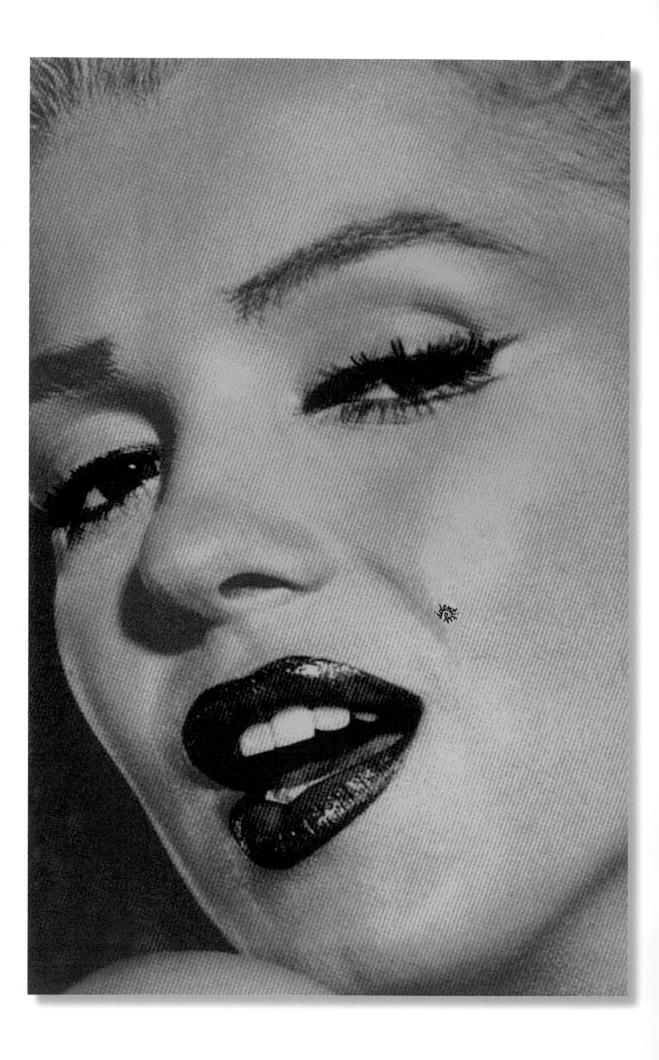

Lanny Sommese Pennsylvania State University **Emily Guman**

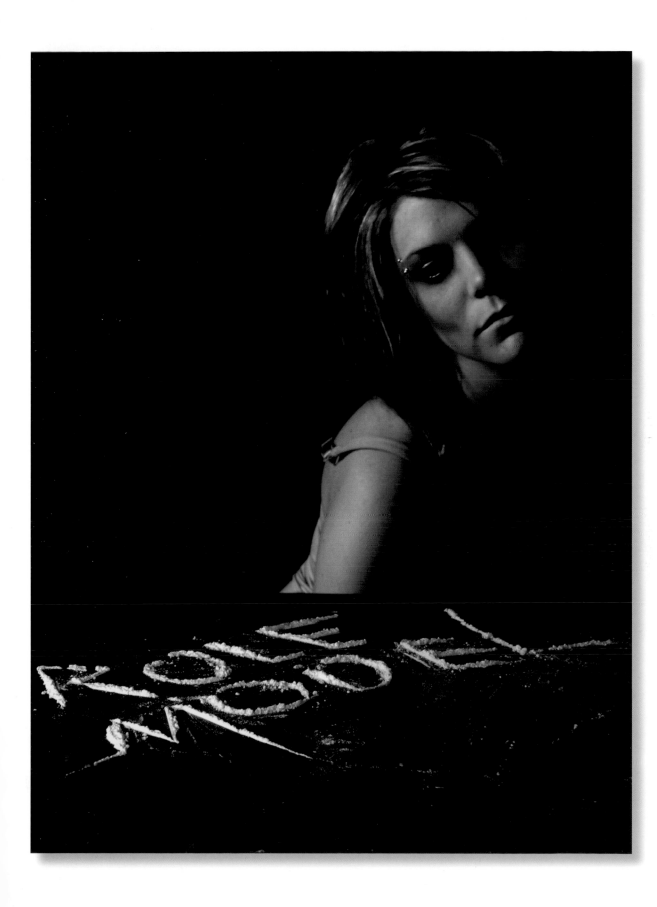

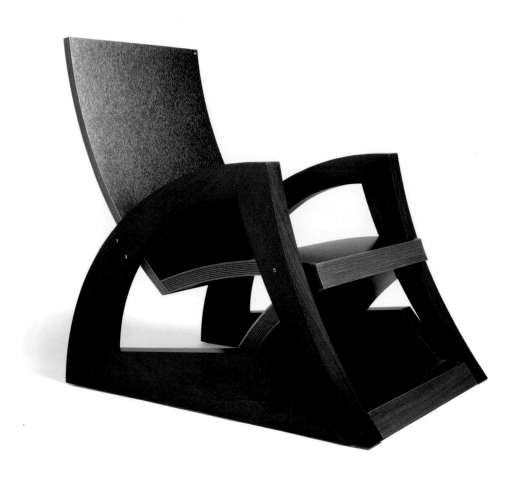

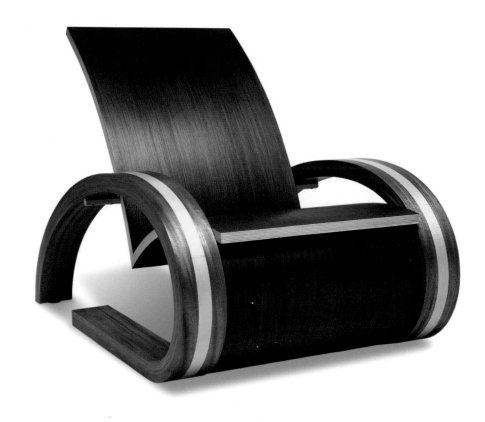

Kevin O'Callaghan School of Visual Arts **Wei Lieh Lee**

Chad Roberts School of Visual Arts **Jesse Kirsch**

Kevin O'Callaghan School of Visual Arts Shelli Silverstein
Chad Roberts School of Visual Arts Jesse Kirsch (middle&bottom)

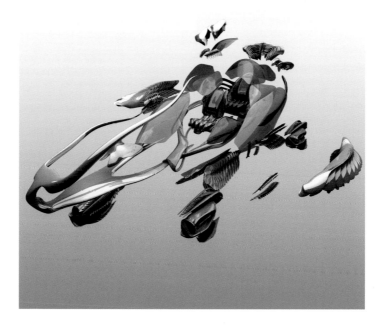

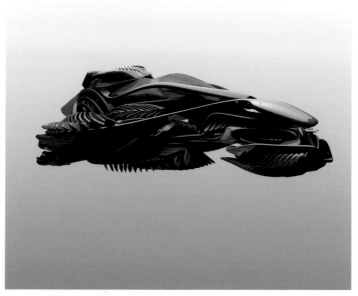

Hernan Diaz Alonso, Josh Taron, Jason Pilarski Art Center College of Design **Wilson Wu** Products | Design**219**

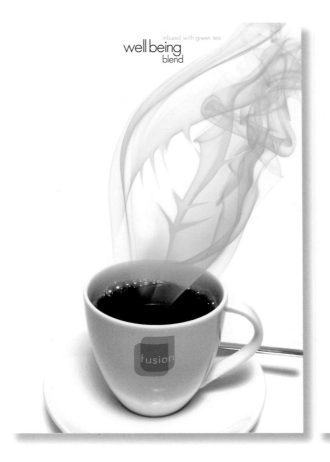

infused with green tea
well being blend

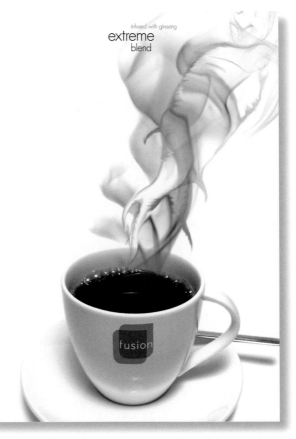

infused with ginseng
extreme blend

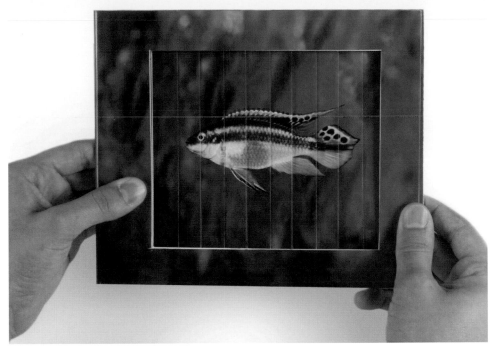

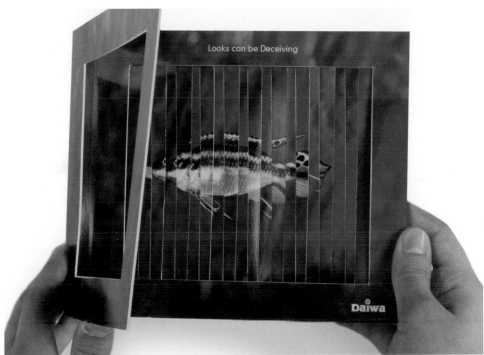

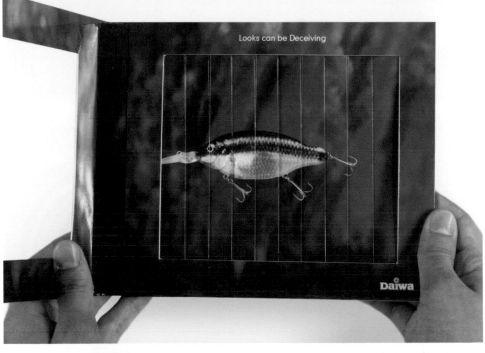

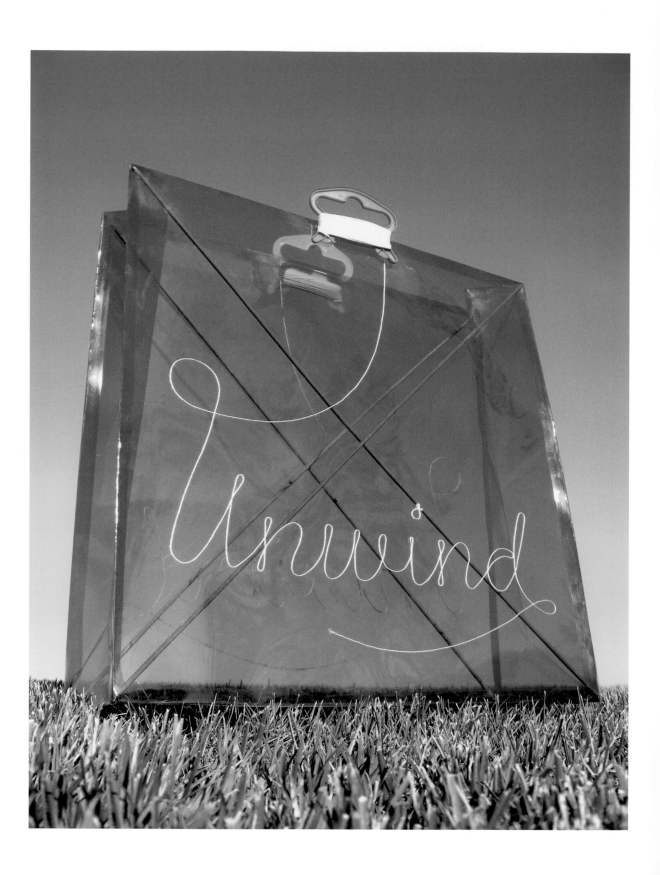

Henry Hikima **The Art Institute of San Diego, California** **Brigid Burke**

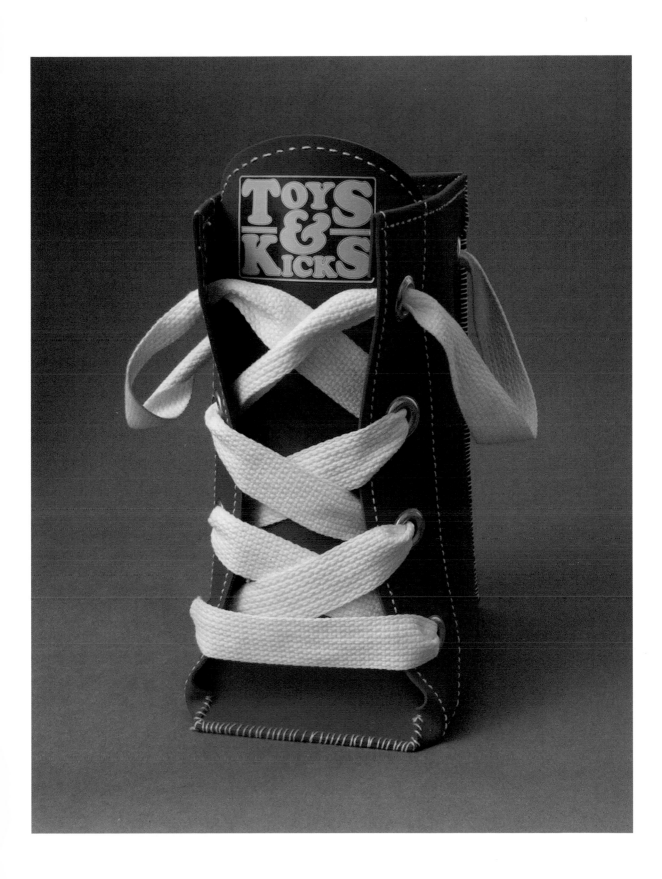

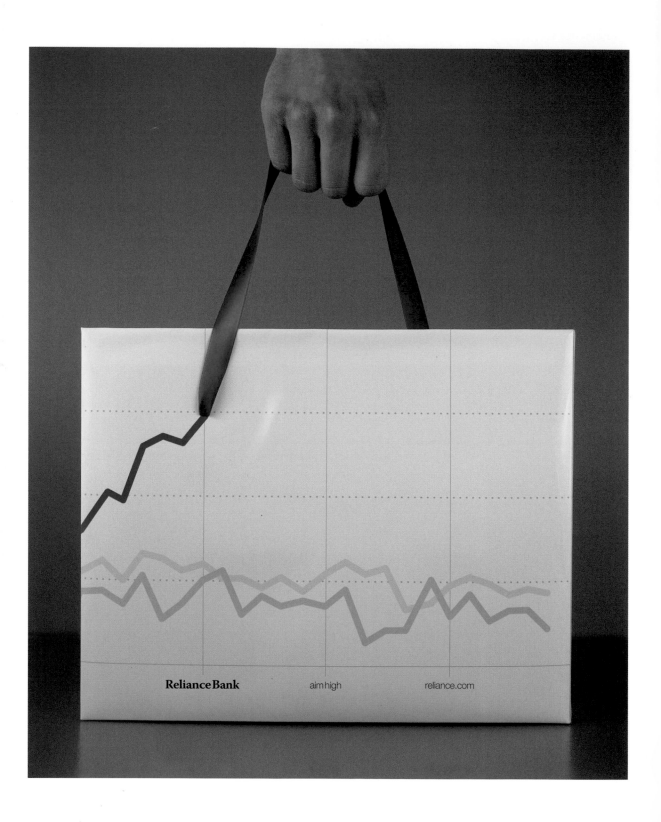

Reliance Bank aim high reliance.com

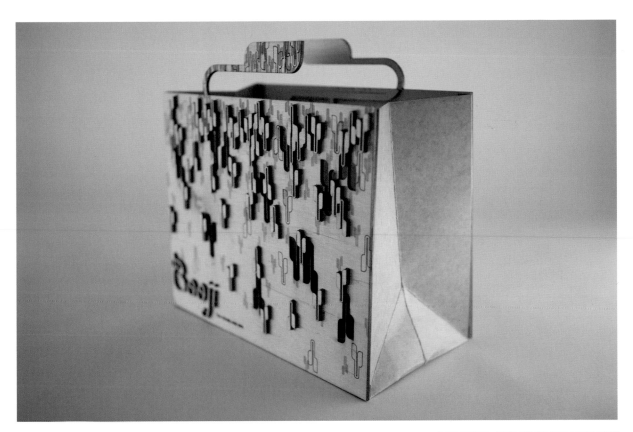

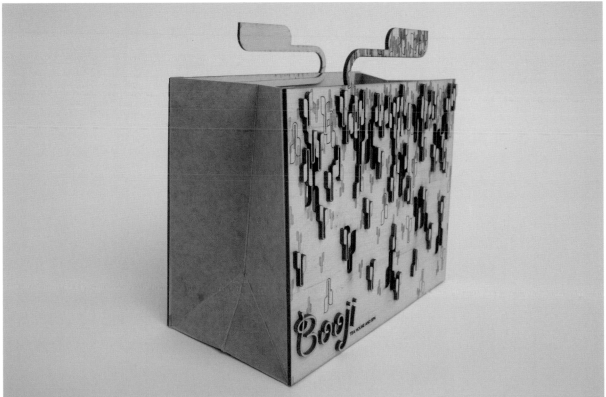

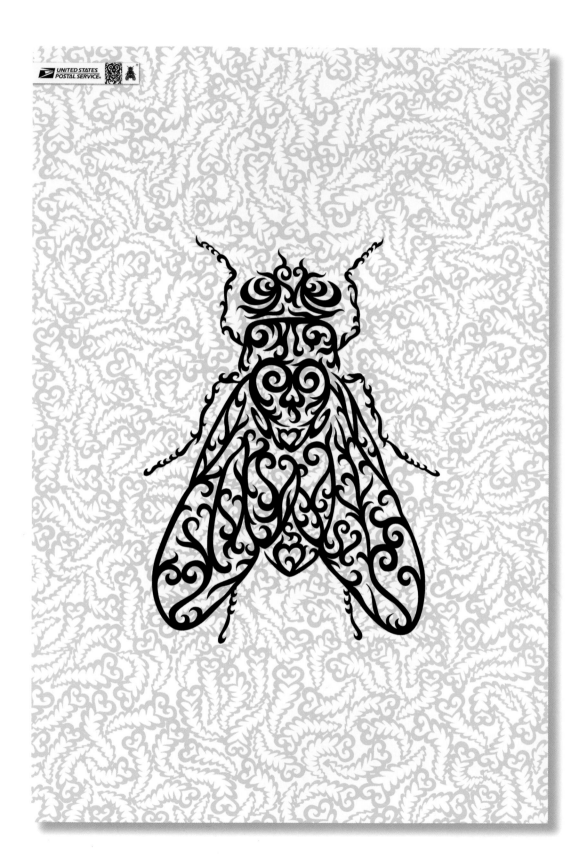

James Victore School of Visual Arts **Wei Lieh Lee** (this spread)

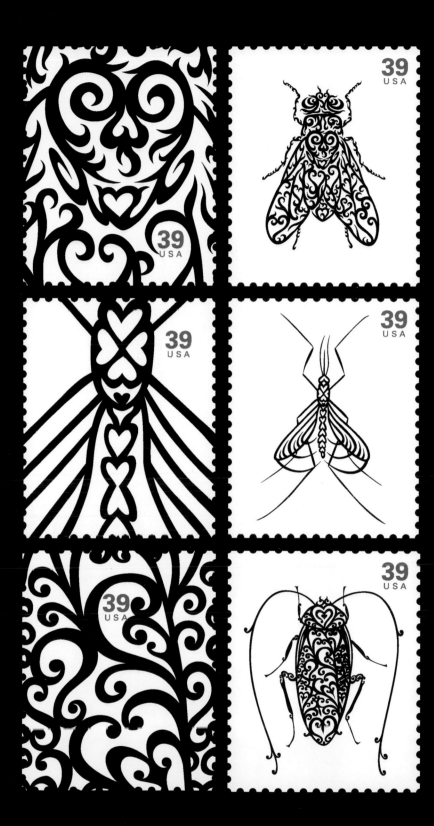

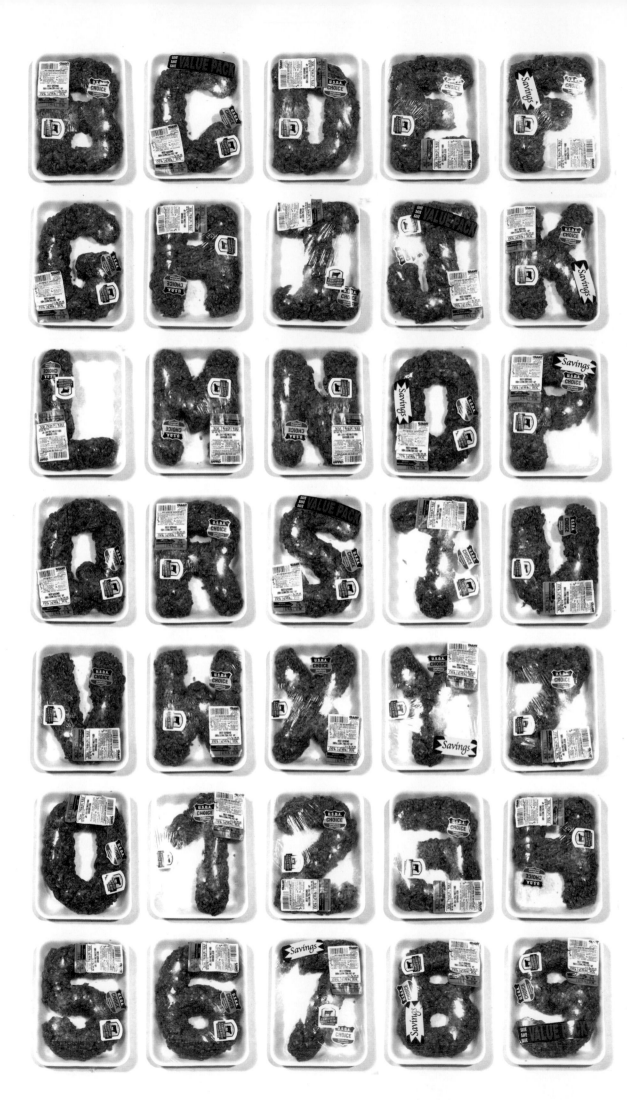

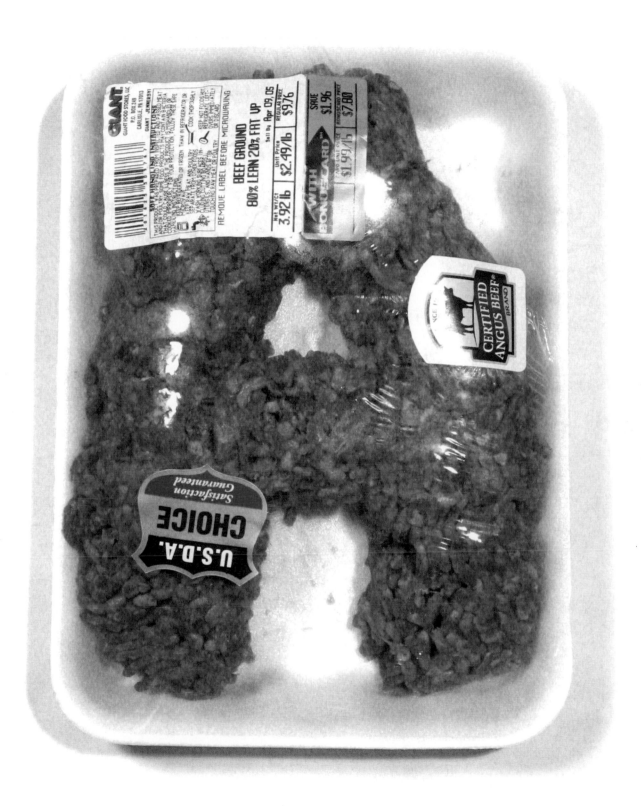

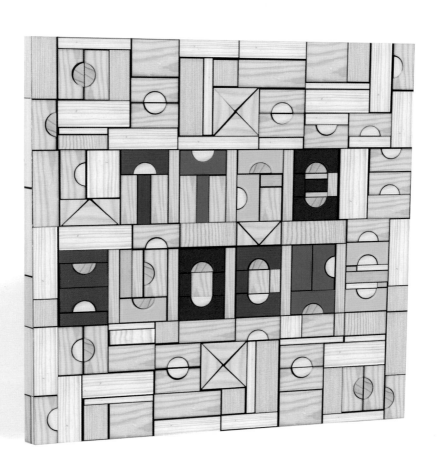

Century Gothic

Monotype Corsiva

OCR A Std

Courier

Monotype Corsiva

FetteFraktur

ITC New Baskerville

Birch Std

Bauhaus

STENCIL STD

04B_21

MESQUITE STD

Bauhaus

N ITC New Baskerville

O ITC New Baskerville

P Century Gothic

Q Adobe Caslon Pro

R Bauhaus

S ITC New Baskerville

T Monotype Corsiva

U Helv-Light

V Helv-Light

ω Σψμβολ

X 04B_21

y Monotype Corsiva

z FetteFraktur

Henrietta Condak School of Visual Arts **Seung Joo Lee**

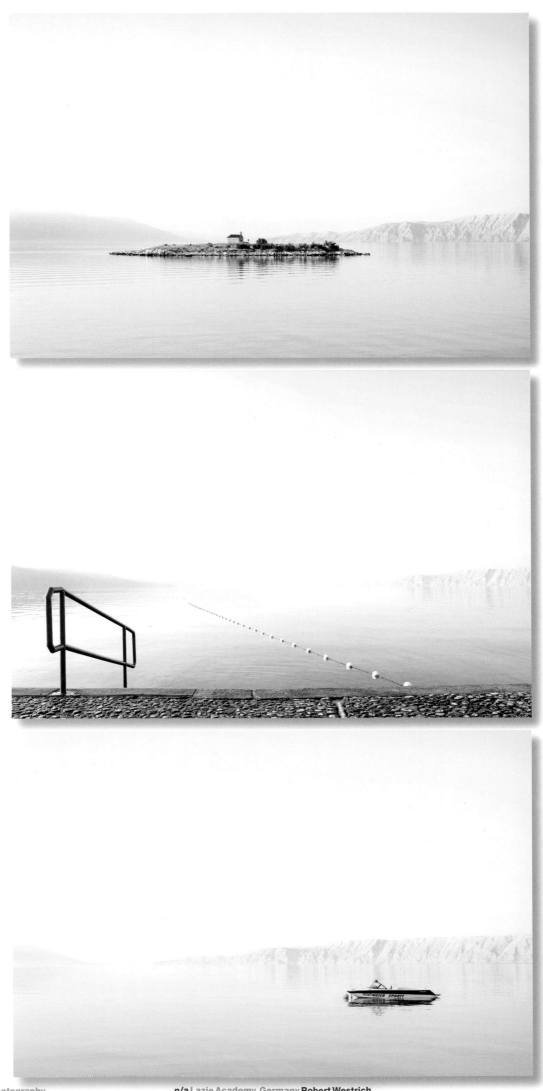

n/a Lazie Academy, Germany Robert Westrich

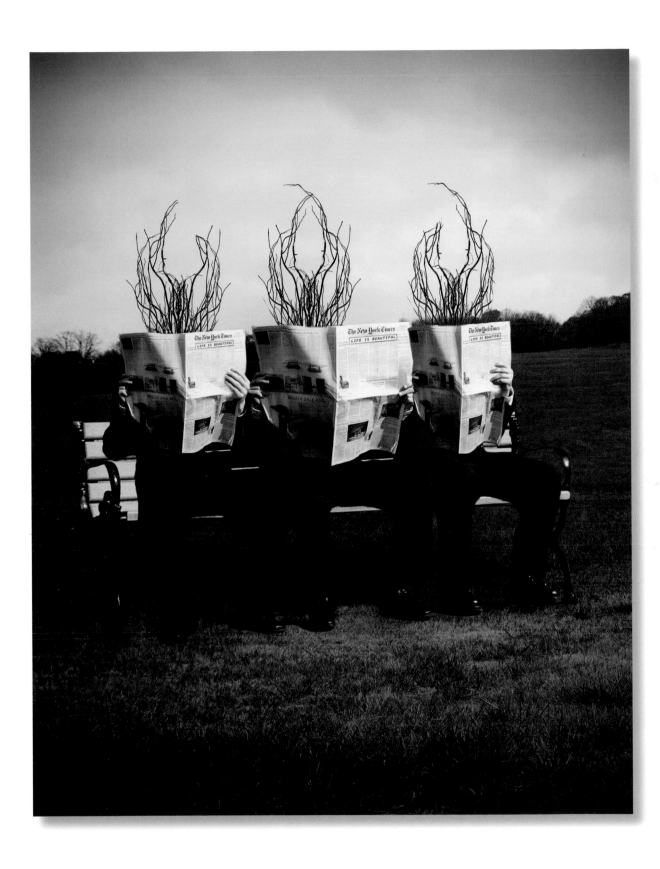

Phil Bekker Art Institute of Atlanta **Dave King**

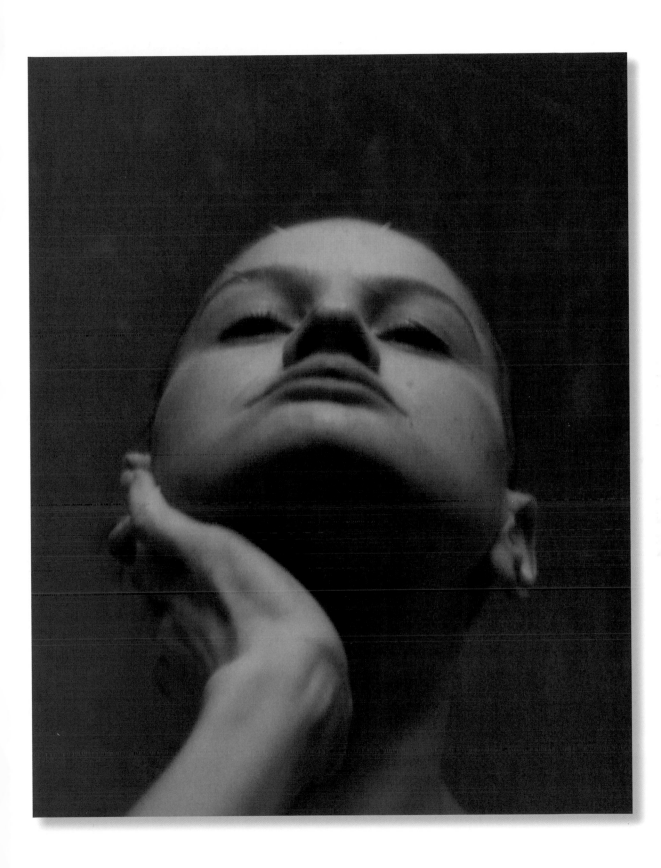

n/a Miami Ad School, San Francisco **Michelle R. Goodwin**

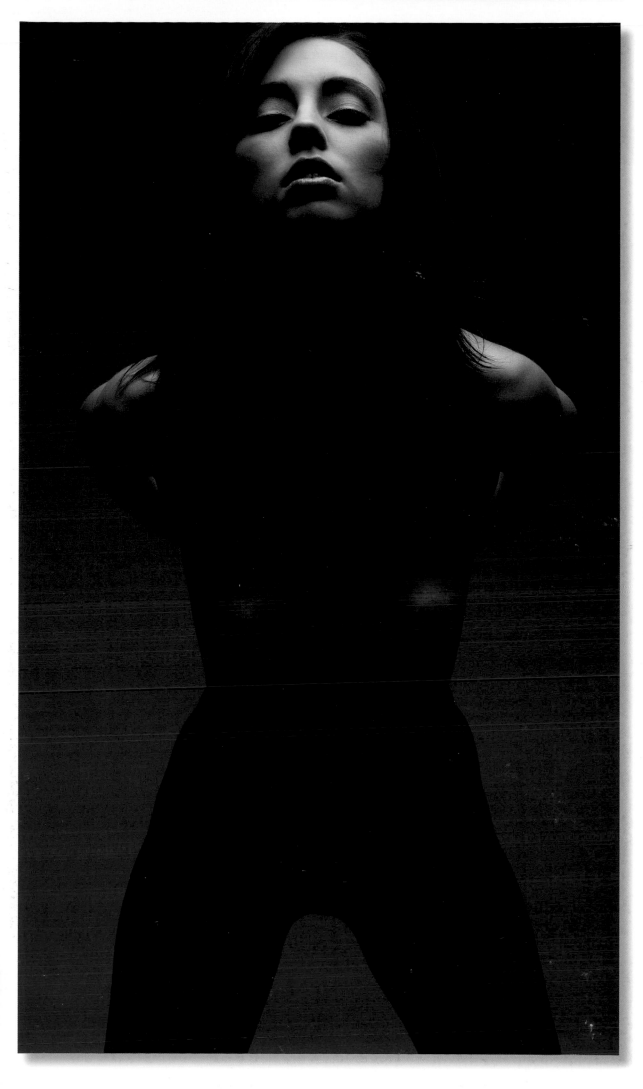

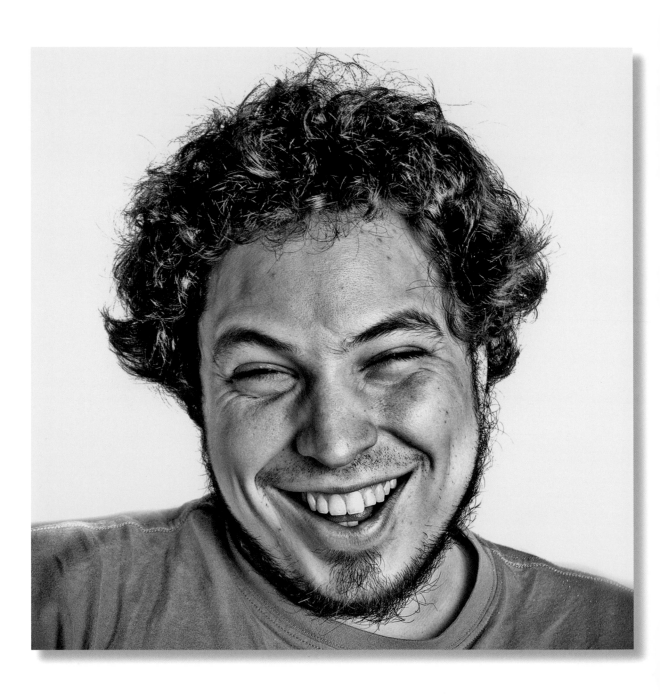

Manolo Garcia Miami Ad School, San Francisco Croix Gagnon

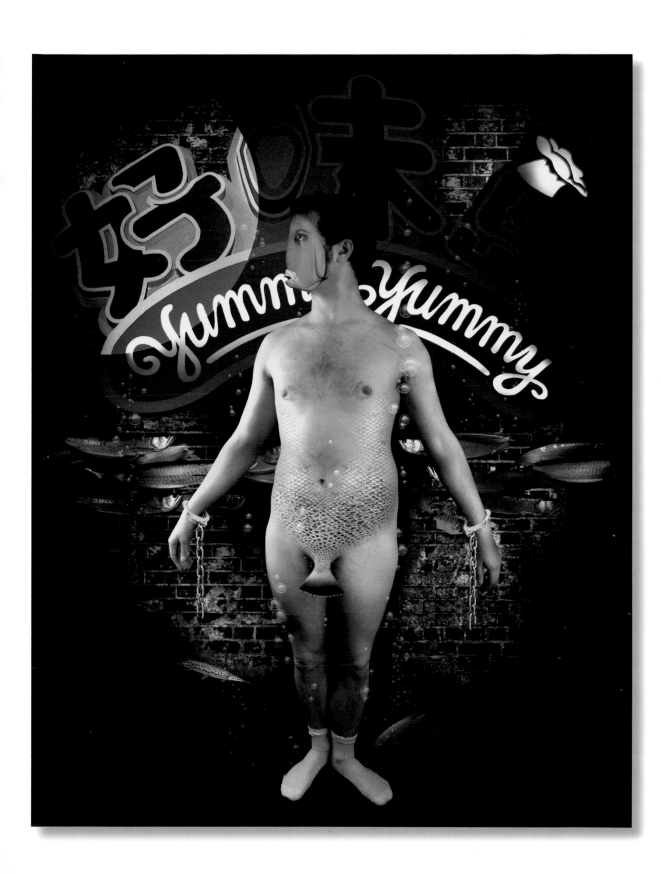

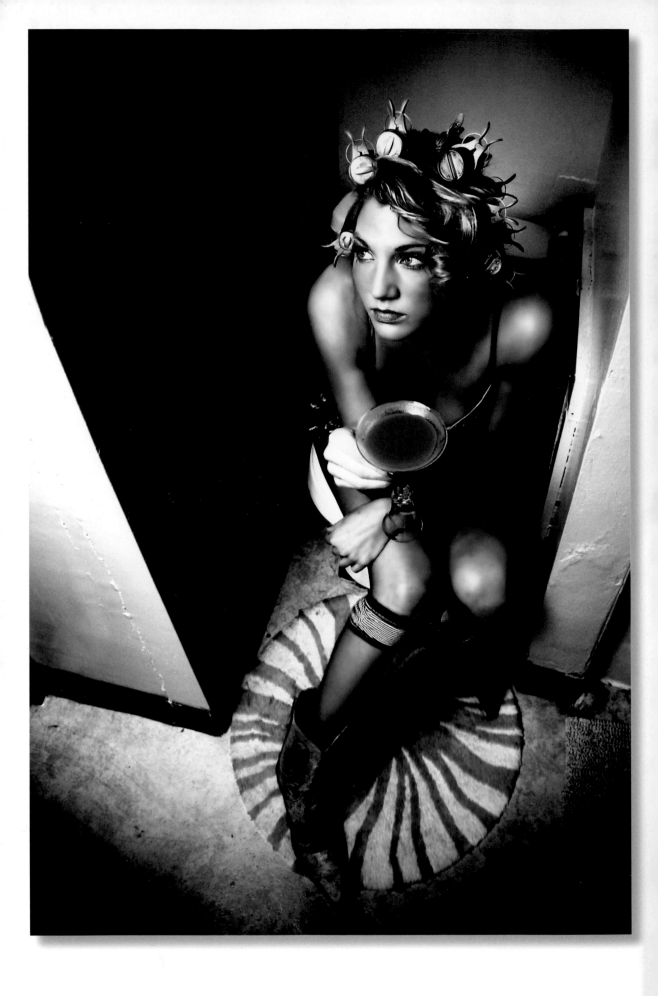

Lanny Sommese Pennsylvania State University **Emily Guman**

Credits

Advertising | AmusementParks
24 Art Director: Steephen Minasvand | Instructor: Jeffrey Metzner | School: SVA | Department: Graphic Design | Department Chair : Richard Wilde

25 Art Director: Jon Barco | Instructor: Lanny Sommese | School: SVA | Department: Graphic Design | Department Chair: Richard Wilde

Advertising | Automotive
26 Art Director: Raymond Lee | Instructor: Sal DeVito | School: SVA | Department: Graphic Design | Department Chair: Richard Wilde

27 Art Director: Lauren Moreau | Instructor: Jeffrey Metzner | School: SVA | Department: Graphic Design | Department Chair: Richard Wilde

28 Art Director: Jordan T. Farkas | Writer: Jordan T. Farkas | Instructor: Sal DeVito | School: SVA | Department: Graphic Design | Department Chair: Richard Wilde

29 Art Director: Frank James Grosberger | Writer: Frank James Grosberger | Instructor: Sal DeVito | School: SVA | Department: Graphic Design | Department Chair: Richard Wilde

30 Art Director: Armands Leitis & Emilia Bergmans | Instructor: Claudia Bach | School: Miami Ad School Europe, Hamburg, Germany | Department: Advertising | Department Chair: Niklas Frings-Rupp

31 (top) Art Director: Andrew Seagrave | Writer: Andrew Seagrave | Instructor: Jack Mariucci | School: SVA | Department: Graphic Design | Department Chair: Richard Wilde

31 (middle) Art Director: Lauren Moreau | Instructor: Jeffrey Metzner | School: SVA | Department: Graphic Design | Department Chair: Richard Wilde

31 (bottom) Art Director: Kianga Williams | Instructor: Jack Mariucci | School: SVA | Department: Graphic Design | Department Chair: Richard Wilde

Advertising | Beverage
32 Art Directors/Writers: Benjamin Rogan, Deniz Yegen | Instructor: Frank Anselmo | School: SVA | Department: MFA Design | Department Chair: Richard Wilde

33 Art Director/Designer/Photographer: Maeden Cruz | Instructor: Henry Hikima | School: Art Institute Of California, San Diego | Department: Advertising | Department Chair: John Judy

Advertising | Billboard
34 (top) Art Directors/Writers: Ji Hyun Lee, Su Won Chang | Instructor: Frank Anselmo | School: SVA | Department: Graphic Design | Department Chair: Richard Wilde

34 (bottom) Art Director/Writer: Ji Hyun Lee | Instructor: Jeffrey Metzner | School: SVA | Department: Graphic Design | Department Chair: Richard Wilde

35 Art Director/Writer: Stephanie Sarnelli | Instructor: Vinny Tulley | School: SVA | Department: Graphic Design | Department Chair: Richard Wilde

36 Art Director: Olivia Rios | Instructor: Ian Mavaroh | School: Miami Ad School, Miami | Department: Art Direction | Department Chair: Jerrod New

37 Art Director/Creative Strategist/Creative Designer/Photographer: David Gonsalves | Model: Erik Bydlo | Instructor: Henry Hikima | School: Art Institute Of California, San Diego | Department: Advertising | Department Chair: John Judy

Advertising | Broadcast
38 Art Directors/Writers: Alexei Beltronel, Jay Marsen | Instructor: Vincent Tulley | School: SVA | Department: Graphic Design | Department Chair: Richard Wilde

39 Art Director/Writer: Jordan T. Farkas | Instructor: Jack Mariucci | School: SVA | Department: Graphic Design | Department Chair: Richard Wilde

Advertising | Camera
40 Art Directors: Siavosh Zabeti, Clemens Ascher, Alexander Kalchev & Fabian Tritsch | Writers: Alexander kalchev, Fabian Tritsch | Instructor: Timm Weber | School: Miami Ad School Europe, Hamburg, Germany | Department: Advertising | Department Chair: Niklas Frings-Rupp

Advertising | Computers
41 Art Directors/Writers: Andrew Seagrave, Jeseok Yi, Francisco Hui | Instructor: Frank Anselmo | School: SVA | Department: MFA Design | Department Chair: Richard Wilde

Advertising | DeliveryService
42 Art Director: Maria Lotuffo | Instructor: Sal DeVito | School: SVA | Department: Graphic Design | Department Chair: Richard Wilde

43 Art Director/Writer: Jeseok Yi | Instructor: Frank Anselmo | School: SVA | Department: MFA Design | Department Chair: Richard Wilde

Advertising | Environment
44 Art Director/Writer: Ashley Montgomery | Instructor: Frank Anselmo | School: SVA | Department: MFA Design | Department Chair: Richard Wilde

45 Art Directors/Writer: Francisco Hui, Jeseok Yi | Instructor: Frank Anselmo | School: SVA | Department: MFA Design | Department Chair: Richard Wilde

46 Art Directors/Writers: Benjamin Rogan, Deniz Yegen | Instructor: Frank Anselmo | School: SVA | Department: MFA Design | Department Chair: Richard Wilde

47 Art Director/Writer: Ashley Montgomery | Instructor: Frank Anselmo | School: SVA | Department: MFA Design | Department Chair: Richard Wilde

48 Art Director/Writer: Ashley Montgomery | Instructor: Frank Anselmo | School: SVA | Department: MFA Design | Department Chair: Richard Wilde

49 Art Director/Writers: Jeseok Yi | Instructor: Frank Anselmo | School: SVA | Department: Graphic Design | Department Chair: Richard Wilde

50 Art Director: Jane Lee | Writer: Jane Lee | Instructor: Frank Anselmo | School: SVA | Department: MFA Design | Department Chair: Richard Wilde

51 Art Directors: Jane Lee, Sue Won Chang | Writers: Jane Lee, Sue Won Chang | Instructor: Frank Anselmo | School: SVA | Department: MFA Design | Department Chair: Richard Wilde

Advertising | Events
52, 53, 54 Creative Strategist: The Pennsylvania State Senior Class of 2007 | Designers: Laura Kottloski, Emily Guman, Melinda Reidenbach | Typographer: Emily Guman, Jonathan Feldman | Photographer: Laura Kottlowski | Photographer's Assistant: Emily Guman, Melinda Reidenbach | Programmer/Web Developer: Nathan Valchar, Jason Hess | Hair: Melinda Reidenbach, Emily Guman | Makeup: Melinda Reidenbach, Emily Guman, Ashley Exton | Model: All members of the Senior Graphic Design Class | Stylists: Laura Kottloski, Emily Guman, Melinda Reidenbach, Ashley Exton | Instructor: Lanny Sommese | Location: Pennsylvania State University | School: Pennsylvania State University | Department: Integrative Arts | Department Chair: Bill Kelly

55 Art Director/Writer: Olesya Tishenko | Instructor: Kim Maley | School: SVA | Department: Graphic Design | Department Chair: Richard Wilde

Advertising | Fashion
56 Art Director/Writer: Raymond Lee | Instructor: Sal DeVito | School: SVA | Department: Graphic Design | Department Chair: Richard Wilde

57, 58 Art Director: Kristin Sommese | Designer/Photographer/Typographer/Artist/Author/Editor/Writer/Hair/Location/Makeup/Print Producer/Set Designer & Props/Stylist: Nadia Udeshi | Model: Kahena Bahri, Ashley Exton | Instructor: Kristin Sommese | School: The Pennsylvania State University | Department: Graphic Design | Department Chair: Kristin Sommese

Advertising | Food
59 Art Director: Jonathan Caravello | Instructor: Sal DeVito | School: SVA | Department: Graphic Design | Department Chair: Richard Wilde

60 Art Director: Stephen Minasvand | Instructor: Jeffrey Metzner | School: SVA | Department: Graphic Design | Department Chair: Richard Wilde

61 Art Director: Andrew Seagrave | Instructor: Jeffrey Metzner | School: SVA | Department: Graphic Design | Department Chair: Richard Wilde

62 Art Director: Ji Hyun Lee | Instructor: Jeffrey Metzner | School: SVA | Department: Graphic Design | Department Chair: Richard Wilde

63 Art Director: Kianga Williams | Writer: Kianga Williams | Instructor: Frank Anselmo | School: SVA | Department: MFA Design | Department Chair: Richard Wilde

Advertising | Products
64 Art Director: Heather Monetti | Instructor: Jeffrey Metzner | School: SVA | Department: Graphic Design | Department Chair: Richard Wilde

65 Art Director: Terris Poole | Instructor: Seymour Leichman | School: Pratt Institute | Department: Communication Design (Graphic Design) | Department Chair: Kathleen Creighton

66 Art Director/Writer: Andrew Seagrave | Instructor: Jeffrey Metzner | School: SVA | Department: Graphic Design | Department Chair: Richard Wilde

67 Art Director: Stephen Minasvand | Instructor: Jeffrey Metzner | School: SVA | Department: Graphic Design | Department Chair: Richard Wilde

68 Art Director: Heather Monetti | Instructor: Jeffrey Metzner | School: SVA | Department: Graphic Design | Department Chair: Richard Wilde

69 Art Director: Kianga Williams | Instructor: Sal DeVito | School: SVA | Department: Graphic Design | Department Chair: Richard Wilde

70 Art Director/Writer: Raymond Lee | Instructor: Jack Mariucci | School: SVA | Department: Graphic Design | Department Chair: Richard Wilde

71 Art Director/Designer: Ken Yamaguchi | Instructor: Jack Mariucci | School: SVA | Department: Graphic Design | Department Chair: Richard Wilde

72 Art Directors: Siavosh Zabeti & Dirk Gelijsteen | Writer: Dirk Gelijsteem | Instructor: Menno Kluin & Icaro Doria | School: Miami Ad School Europe, Hamburg, Germany | Department: Advertising | Department Chair: Niklas Frings-Rupp

73 Art Director: Wongi Ryu | Instructor: Jack Nariucci | School: SVA | Department: Graphic Design | Department Chair: Richard Wilde

74 Art Director: Aline Forastieri | Instructor: Bill Meek | School: Texas State University | Department: Art and Design | Department Chair: Erik Nielsen

75 Art Director/Writer: Jeseok Yi | Instructor: Jack Mariucci | School: SVA | Department: Graphic Design | Department Chair: Richard Wilde

76, 77 Art Directors: Juri Zaech, Felix Hoffman, Kanak Mehra | Writer: Kanak Mehra | Instructor: Joanna Swistowski | School: Miami Ad School Europe, Hamburg, Germany | Department: Advertising | Department Chair: Niklas Frings-Rupp

78 Art Director: Justin Pedone | Instructor: Sal DeVito | School: SVA | Department: Graphic Design | Department Chair: Richard Wilde

79 Art Directors: Croix Gagnon & Siavosh Zabeti | Writer: Croix Gagnon | Instructor: Adam Kerj | School: Miami Ad School Europe, Hamburg, Germany | Department: Advertising | Department Chair: Niklas Frings-Rupp

80 Art Directo/Writer: Jordan T. Farkas | Instructor: Vincent Tulley | School: SVA | Department: Graphic Design | Department Chair: Richard Wilde

81 Art Director: Kianga Williams | Instructor: Jack Mariucci | School: SVA | Department: Graphic Design | Department Chair: Richard Wilde

82 Art Director: Benjamin Rogan | Writer: Benjamin Rogan | Instructor: Vincent Tulley | School: SVA | Department: Graphic Design | Department Chair: Richard Wilde

83 Art Director: Kristin Sommese | Designer/Photographer/Typographer/Artist/Author/Writer: Ben Brucker | Model: Linda Mattioni | Set Designer & Props/Makeup/Stylist: Ben Brucker | Instructor: Kristin Sommese | School: Pennsylvania State | Department: Integrative Arts | Department Chair: Bill Kelly

84 Art Director/Writer: Stephanie Sarnelli | Instructor: Vincent Tulley | School: SVA | Department: Graphic Design | Department Chair: Richard Wilde

85 Art Director: Aline Forastieri | Instructor: Bill Meek | School: Texas State University | Department: Art and Design | Department Chair: Erik Nielsen

Advertising | ProfessionalService
86 Art Director/Writer: Andrew Seagrave | Instructor: Jack Mariucci | School: SVA | Department: Graphic Design | Department Chair: Richard Wilde

87 Art Directors/Writers: Alexei Beltronel, Jay Marsen | Instructor: Jack Mariucci | School: SVA | Department: Graphic Design | Department Chair: Richard Wilde

88, 89 Art Director: Croix Gagnon | Writer: Ian Hart | Instructor: Jim Bosiljevac | Client: State Farm Insurance | School: Miami Ad School, San Francisco | Department: Advertising | Department Chair: Denise Esterkyn

Credits

90 Art Director: Ken Yamaguchi | Designer: Ken Yamaguchi | Instructor: Jack Mariucci | School: SVA | Department: Graphic Design | Department Chair: Richard Wilde

91 Art Director: Kianga Williams | Instructor: Jack Mariucci | School: SVA | Department: Graphic Design | Department Chair: Richard Wilde

Advertising | PublicService
92 Art Director: Jeseok Yi | Writer: Jeseok Yi | Instructor: Frank Anselmo | School: SVA | Department: MFA Design | Department Chair: Richard Wilde

93 Art Director/Writer: Andrew Seagrave | Instructor: Frank Anselmo | School: SVA | Department: Graphic Design | Department Chair: Richard Wilde

94 Art Director/Creative Director: David Gonsalves, Henry Hikima | Creative Strategist/Designer/Photographer/Model: David Gonsalves | Instructor: Henry Hikima | School: Art Institute Of California, San Diego | Department: Graphic Design | Department Chair: John Judy

95 Art Director/Creative Strategist/Photographer/Writer: David Gonsalves | Creative Directors: David Gonsalves, Henry Hikima | Instructor: Henry Hikima | School: Art Institute Of California, San Diego | Department: Graphic Design | Department Chair: John Judy

96 Art Director: Kianga Williams | Instructor: Jack Mariucci | School: SVA | Department: Graphic Design | Department Chair: Richard Wilde

97 Art Director: Kianga Williams | Instructor: Jack Mariucci | School: SVA | Department: Graphic Design | Department Chair: Richard Wilde

Advertising | Retail
98 Art Director/Writer: Suewon Chang | Instructor: Vincent Tulley | School: SVA | Department: Graphic Design | Department Chair: Richard Wilde

99 Art Directors: Alexei Beltronel, Jay Marsen | Instructor: Frank Anselmo | School: SVA | Department: MFA Design | Department Chair: Richard Wilde

100 Art Director: Rhea Hanges | Writer: Todd Lewin | Instructors: Salvador Veloso, Marco Vega | School: Miami Ad School | Department: Advertising | Department Chair: Ron Seichrist

101 Art Director/Writer: Andrew Seagrave | Instructor: Frank Anselmo | School: SVA | Department: MFA Design | Department Chair: Richard Wilde

102, 103 Art Director: Olivia Rios | Instructor: Alejandro Barreras | School: Miami Ad School, Miami | Department: Art Direction | Department Chair: Jerrod New

Advertising | SocialCommentary
104 Art Director/Writer: Jeseok Yi | Instructor: Frank Anselmo | School: SVA | Department: MFA Design | Department Chair: Richard Wilde

Design | Books
106, 107 Art Director: Eun Jung Cho | Instructor: Carin Goldberg | School: SVA | Department: Graphic Design | Department Chair: Richard Wilde

108 Art Director: Sam Gray | Instructor: Adrian Pulfer | School: Brigham Young University | Department: Graphic Design | Department Chair: Adrian Pulfer

109 Art Director: Jung Meen Lee | Instructor: Ji Lee | School: SVA | Department: Graphic Design | Department Chair: Richard Wilde

110, 111 Art Director/Designer: Kyung Mo Kang | Instructor: Mike Joyce | School: SVA | Department: Graphic Design | Department Chair: Richard Wilde

112, 113 Art Director/Designer/Photographer: Emily Clark | Writers: Walt Whitman, Manual Yang, Paul Muldoon, Emily Dickinson | Instructor: Quentin Currie | School: Savannah College of Art & Design-School of Communication Arts | Department: Graphic Design | Department Chair: Professor Quentin Currie

114 (top) Art Director/Designer/Photographer: Timothy Moraitis | Writers: Anastasia Loukaitou-Sideris, Robert Gottlieb | Instructor: Brad Bartlett | School: Art Center College of Design | Department: Graphic Design | Department Chair: Nik Hafermaas

114 (bottom) Art Director: Ryan Hayes | Instructor: Frank Baseman | School: Philadelphia University | Department: Graphic Design Communications | Department Chair: Dennis Kuronen

115 (top) Art Director: Nate Salciccioli | Author: David Large | Instructor: Charles Brock | School: Seattle Pacific University

115 (bottom) Art Director: Nate Salciccioli | Author: Margaret Drabble | Instructor: Wes Youssi | School: Seattle Pacific University

116 (top) Art Director: Christina Kim | Instructor: Chris Austopchuck | School: SVA | Department: Graphic Design | Department Chair: Richard Wilde

116 (middle) Art Director: Dana Goor | Instructor: Carin Goldberg | School: SVA | Department: Graphic Design | Department Chair: Richard Wilde

116 (bottom) Art Director: Seulgi Ho | Instructor: John Fulbrook | School: SVA | Department: Graphic Design | Department Chair: Richard Wilde

117 Art Director: Melissa Flicker | Instructor: Arnold Holland | School: California State University, Fullerton | Department: College of Natural Sciences and Mathematics | Project Chair: Rochelle Woods/Assistant Dean

Design | Branding
118, 119, 120 Art Director: Yon Joo Choi | Instructor: Michael Ian Kaye | School: SVA | Department: Graphic Design | Department Chair: Richard Wilde

121 Art Director: Stephanie Monroe | Instructor: Louise Fili | School: SVA | Department: Graphic Design | Department Chair: Richard Wilde

122 Art Director: Jennifer Krous | Instructor: Chad Roberts | School: SVA | Department: Graphic Design | Department Chair: Richard Wilde

123 Art Director: Hirotaka Yamada | Instructor: Chris Austopchuck | School: SVA | Department: Graphic Design | Department Chair: Richard Wilde

124 Art Director: Jungmin Byun | Instructor: Roswitha Rodrigues | School: SVA | Department: Graphic Design | Department Chair: Richard Wilde

125 Art Director: Megan Bailey | Instructor: David Copestakes | School: Pennsylvania State University | Department: Graphic Design | Department Chair: Paul Chidester (Visual Arts Chair)

126 Art Director: Ji Eun Ku | Instructor: Michael Ian Kaye | School: SVA | Department: Graphic Design | Department Chair: Richard Wilde

127 Art Director: Jin Young Lee | Instructor: Armin Vit, Bryony Gomez Palacio | School: SVA | Department: Graphic Design | Department Chair: Richard Wilde

Design | Brochures
128, 129 Art Director: Shawn Prokes | Designer: Shawn Prokes | Artist: Shawn Prokes | Instructor: Lilli Maya | School: Illinois State University, School of Fine Art | Department: Graphic Design | Department Chair: Peter Bushel

Design | Calendar
130 Art Director: Jonathan Feldman | Instructor: Kristin Sommese | School: Pennsylvania State University | Department: Integrative Arts | Department Chair: William Kelly

131 Art Director: Paul Sahner | Instructor: Henrietta Condak | School: SVA | Department: Graphic Design | Department Chair: Richard Wilde

Design | CreativeExploration
132 Art Director: Se Jin Kim | Instructor: Kevin O'Callaghan | School: SVA | Department: Graphic Design | Department Chair: Richard Wilde

133 Art Director: Fumio Osawa | Photographer: Fumio Osawa | Instructor: Kevin O'Callaghan | School: SVA | Department: Graphic Design | Department Chair: Richard Wilde

134 Art Director: Myung Ha Chang | Instructor: Kevin O'Callaghan | School: SVA | Department: Graphic Design | Department Chair: Richard Wilde

134 Art Director: Donnie Miller | Instructor: Kevin O'Callaghan | School: SVA | Department: Graphic Design | Department Chair: Richard Wilde

135 Art Director: Anastasia Pudin | Instructor: Kevin O'Callaghan | School: SVA | Department: Graphic Design | Department Chair: Richard Wilde

136 Art Director: Wei Lieh Lee | Designer: Wei Lieh Lee | Photographer: Myko | Instructor: Kevin O'Callaghan | School: SVA | Department: Graphic Design | Department Chair: Richard Wilde

137 Art Director: Se Jin Kim | Instructor: Kevin O'Callaghan | School: SVA | Department: Graphic Design | Department Chair: Richard Wilde

138 Art Director: Marcello Alves | Instructor: Kevin O'Callaghan | School: SVA | Department: Graphic Design | Department Chair: Richard Wilde

Design | Currency
139 Art Director: Andrew Bontorno | Instructors: Brent Barson, Adrian Pulfer | School: Brigham Young University | Department: Graphic Design | Department Chair: Adrian Pulfer

Design | DVDs
140, 141 Art Director: HaeJin Lee | Instructor: Richard Poulin | School: SVA | Department: Graphic Design | Department Chair: Richard Wilde

Design | Editorial
142, 143 Art Director: Byron Regej | Instructor: Robert Best | School: SVA | Department: Graphic Design | Department Chair: Richard Wilde

144, 145 Art Director/Designer: Wei Lieh Lee | Instructor: Michael Ian Kaye | School: SVA | Department: Graphic Design | Department Chair: Richard Wilde

146 Art Director: Sarah Berends | Instructor: Richard Poulin | School: SVA | Department: Graphic Design | Department Chair: Richard Wilde

147 Art Director: Yon Joo Choi | Instructor: Michael Ian Kaye | School: SVA | Department: Graphic Design | Department Chair: Richard Wilde

148 Art Director: Andrew Bontorno | Instructor: Adrian Pulfer | School: Brigham Young University | Department: Graphic Design | Department Chair: Adrian Pulfer

149 Art Director: Kate McDermott | Instructor: Terry Koppel | School: SVA | Department: Graphic Design | Department Chair: Richard Wilde

150 Art Director/Designer/Photographer/Typographer/Artist: Greg Comstock | Models: cover – Justin Musil; cosplay article – Sheila Soroushian, Cristina Cuevas | Instructor: Theron Moore | School: California State University, Fullerton | Department: Visual Arts | Department Chair: Larry Johnson

151 Art Director/Editor/Photographer/Print Producer/Illustrator: Chuhang Guo | Instuctor: Theron Moore | School: California State University, Fullerton | Department: Visual Arts | Department Chair: Larry Johnson

152, 153 Art Director: Regina Kushnir | Instructor: Carin Goldberg | School: SVA | Department: Graphic Design | Department Chair: Richard Wilde

154, 155 Art Director: Maria Lotuffo | Instructor: John Fulbrook | School: SVA | Department: Graphic Design | Department Chair: Richard Wilde

156, 157 Art Director: Yaijung Chang | Instructors: Michael Ian Kaye, Nobi Kashiwagi | School: SVA | Department: Graphic Design | Department Chair: Richard Wilde

Design | Exhibitions
158 Art Director: Masood Ahmed | Instructor: Kevin O'Callaghan | School: SVA | Department: MFA Design | Department Chair: Steven Heller, Lita Talarico

Design | Games
159 Art Director: Byron Regej | Instructor: Chris Austopchuck | School: SVA | Department: Graphic Design | Department Chair: Richard Wilde

Design | Illustrations
160 Art Director: Phoebe Sonder | Instructor: Veronica Lawlor | School: Pratt Institute | Department: Illustration | Department Chair: Kathleen Creighton

161 Art Director: Matthew Smith | Instructor: Jim Burke | School: Pratt Institute | Department: Illustration | Department Chair: Kathleen Creighton

162 Designer: Sheena Hisiro | Instructor: Veronica Lawlor | School: Pratt Institute | Department: Communications Design | Department Chair: Kathleen Creighton

163 Art Director: Kim Scafuro | Instructor: Uong | School: Pratt Institute | Department: Illustration | Department Chair: Kathleen Creighton

164 Art Director: Rachel Morris | Instructor: Rudy Gutierrez | School: Pratt Institute | Department: Communications Design | Department Chair: Kathleen Creighton

165 Illustrator: Rachel Dunagan | Instructor: Leslie Haines | School: Watkins College of Art & Design | Department: Graphic Design | Department Chair: Leslie Haines

Credits

Design | Letterhead
166, 167 Designer: Meggan Cook | Instructor: Chris Austopchuck | School: SVA | Department: Graphic Design | Department Chair: Richard Wilde

Design | Logos
168 (top) Designer/Illustrator: Portia Monberg | Instructor: Cinthia Wen | School: California College of the Arts | Department: Graphic Design | Department Chair: Mark Fox

168 (second) Designer/Illustrator: Grant Loving | Instructor: Mark Fox | School: California College of the Arts | Department: Graphic Design | Department Chair: Mark Fox

168 (midddle) Designer/Illustrator: Trevor Hacker | Instructor: Mark Fox | School: California College of the Arts | Department: Graphic Design | Department Chair: Mark Fox

168 (fourth) Designer/Illustrator: Sarah Pulver | Instructor: Mark Fox | School: California College of the Arts | Department: Graphic Design | Department Chair: Mark Fox

168 (bottom) Designer/Illustrator: Igor Zhoglo | Instructor: Mark Fox | School: California College of the Arts | Department: Graphic Design | Department Chair: Mark Fox

169 Designer: Wen Yaw Lee | Instructor: Michael Gerbino | School: Pratt Institute | Department: Communications Design | Department Chair: Kathleen Creighton

170 Designer: Sam Wick | Creative Director: Doug Akagi | School: California College of the Arts | Department: Graphic Design | Department Chair: Mark Fox

171 (top) Designer: Jun Bae | Instructor: Hank Richardson | School: Portfolio Center | Department: Graphic Design | Department Chair: Hank Richardson

171 (second) Designer: Ben Barry | Instructor: Paul Jerde | School: University of North Texas | Department: School of Visual Arts | Department Chair: Eric Ligon

171 (middle) Designer: Alexa Couphos, Carly Franks, Meghan Lindaman, Jocelyn Park | Art Director: Maribeth Kradel-Weitzel, EJ Herczyk | School: Philadelphia University | Department: Graphic Design Communications | Department Chair: Dennis Kuronen

171 (fourth) Designer: Yevgeniya Falkova | Instructor: Charles Goslin | School: Pratt Institute | Department: Communications Design (Graphic Design) | Department Chair: Kathleen Creighton

171 (bottom) Designer: Jeff Hunter | Instructor: Henry Hikima | School: The Art Institute of California, San Diego | Department: Graphic Design | Department Chair: John Judy

172 (top) Designer: Sam Wick | Creative Director: Alysha Naples | School: California College of the Arts | Department: Graphic Design | Department Chair: Mark Fox

172 (second) Designer/Illustrator: Marcus Torres | Design Director: Henry Hikima | School: Art Institute Of California, San Diego | Department: Graphic Design | Department Chair: John Judy

172 (middle) Designer: Kate McDermott | Design Director: Terry Koppel | School: SVA | Department: Graphic Design | Department Chair: Richard Wilde

172 (fourth) Designer: Matthew Moran | Creative Director: Henry Hikima | School: Art Institute Of California, San Diego | Department: Graphic Design | Department Chair: John Judy

172 (bottom) Designer/Illustrator: Catie Griffin | Instructor: Hank Richardson | School: Portfolio Center | Department: Graphic Design | Department Chair: Hank Richardson

173 Designer: Jin Young Lee | Instructors: Armin Vit, Bryony Gomez-Palacio | School: SVA | Department: Graphic Design | Department Chair: Richard Wilde

Design | MusicCDs
174 Art Director: Jee Lee | Creative Director: Mike Joyce | School: SVA | Department: Graphic Design | Department Chair: Richard Wilde

175 Art Director: Jin Young Lee | Creative Director: LuAnn Graffeo | School: SVA | Department: Graphic Design | Department Chair: Richard Wilde

176 Designer: Yaijung Chang | Instructor: Michael Ian Kaye, Nobi Kashiwagi | School: SVA | Department: Graphic Design | Department Chair: Richard Wilde

177 (top) Art Director: Diana Sanchez | Creative Director: Genevieve Williams | School: SVA | Department: Graphic Design | Department Chair: Richard Wilde

177 (middle) Art Director: Kil Jae Kim | Creative Director: Mike Joyce | School: SVA | Department: Graphic Design | Department Chair: Richard Wilde

177 (bottom) Art Director: Tomomi Fujimaru | Instructor: Genevieve Williams | School: SVA | Department: Graphic Design | Department Chair: Richard Wilde

178 Art Director: Efrat Cohen | Creative Director: Terry Koppel | School: SVA | Department: Graphic Design | Department Chair: Richard Wilde

179 Art Director: Jin Young Lee | Creative Directors: Hjalti Karlsson, Jan Wilker | School: SVA | Department: Graphic Design | Department Chair: Richard Wilde

Design | Packaging
180 Designer: Sarah Cazee | Design Directors: Jennifer Skupin, Kessels Kramer | School: Miami Ad School | Department: Graphic Design | Department Chair: Jose Diaz

181 Designer: Ariana Delibero | Instructor/Design Director: Genevieve Williams | School: SVA | Department: Graphic Design | Department Chair: Richard Wilde

182 Art Director: Jennifer Krous | Creative Director: Chad Roberts | Photographer: Theresa Stebe | School: SVA | Department: Graphic Design | Department Chair: Richard Wilde

183 Art Director: Jennifer Krous | Creative Director: Louise Fili | Photographer: Theresa Stebe | School: SVA | Department: Graphic Design | Department Chair: Richard Wilde

184 Art Director: Seul Ah Lee | Creative Director: Louise Fili | School: SVA | Department: Graphic Design | Department Chair: Richard Wilde

185 Designer: Meggan Cook | Instructor/Design Director: Christ Austopchuck | School: SVA | Department: Graphic Design | Department Chair: Richard Wilde

186 (top) Art Director: Kil Jae Kim | Creative Directors: Armin Vit, Bryony Gomez Palacio | School: SVA | Department: Graphic Design | Department Chair: Richard Wilde

186 (middle) Art Director: Jennifer Krous | Creative Director: Louise Fili | Photographer: Theresa Stebe | School: SVA | Department: Graphic Design | Department Chair: Richard Wilde

186 (bottom) Designer: Jin Young Lee | Instructors: Armin Vit, Bryony Gomez Palacio | School: SVA | Department: Graphic Design | Department Chair: Richard Wilde

187 Art Director: Caroline Petruzzi | Creative Director: Genevieve Williams | School: SVA | Department: Graphic Design | Department Chair: Richard Wilde

188 (top) Art Director: Wing Cheung | Creative Director: Sara Rotman | School: SVA | Department: Graphic Design | Department Chair: Richard Wilde

188 (middle) Art Director: Ji Hyun Moon | Creative Director: Armin Vit, Bryony Gomez Palacio | School: SVA | Department: Graphic Design | Department Chair: Richard Wilde

188 (bottom) Designer: Hye Sun Chung | Instructor: Genevieve Williams | School: SVA | Department: Graphic Design | Department Chair: Richard Wilde

189 Art Director/Designer: Kyung Mo Kang | Instructor: Mike Joyce | School: SVA | Department: Graphic Design | Department Chair: Richard Wilde

190 (top) Designer: Diana Dodge | Instructor: Nagesh Shinde | School: University of Wisconsin-Stout | Department: Art and Design | Department Chair: Ron Verdon

190 (middle) Designer: Hye Sun Chung | Instructor/Design Director: Genevieve Williams | School: SVA | Department: Graphic Design | Department Chair: Richard Wilde

190 (bottom) Designer: Charles Pflaumer | Art Director: Maribeth Kradel-Weitzel | School: Philadelphia University | Department: Graphic Design Communications | Department Chair: Dennis Kuronen

191 Art Director: Jee Whan Yeo | Creative Director: Armin Vit, Bryony Gomez Palacio | School: SVA | Department: Graphic Design | Department Chair: Richard Wilde

192 Designer: Emilia Klimiuk | Instructor/Account Director: James Lienhart | School: Columbia College, Chicago | Department: Art and Design | Department Chair: Sabina Ott

193 Art Director: Jin Young Lee | Creative Director: Genevieve Willams, Armin Vit, Bryony Gomez Palacio | School: SVA | Department: Graphic Design | Department Chair: Richard Wilde

193 Art Director: Jin Young Lee | Creative Director: Genevieve Williams | School: SVA | Department: Graphic Design | Department Chair: Richard Wilde

Design | Posters
194 Designer/Illustrator: Clara Daguin | Instructor: Jason Munn | School: California College of the Arts | Department: Graphic Design | Department Chair: Mark Fox

195 Designer/Creative Director: Jessica Campbell | Instructor: Chris Lyons | School: Rochester Institute of Technology | Department: College of Imaging Arts and Sciences, School of Design | Department Chair: Patti J. Lachance

196 Art Directpr: Wongi Ryu | Creative Director: Genevieve Williams | School: SVA | Department: Graphic Design | Department Chair: Richard Wilde

197 Art Director: Jee Lee | Creative Director: Mike Joyce | School: SVA | Department: Graphic Design | Department Chair: Richard Wilde

198 Art Director: Seung Joo Lee | Creative Director: Richard Poulin | School: SVA | Department: Graphic Design | Department Chair: Richard Wilde

199 Designer: Kate McDermott | Design Director: Terry Koppel | School: SVA | Department: Graphic Design | Department Chair: Richard Wilde

200 Designer/Photographer/Writer: Austin Hamby | Instructor: Mark Fox | School: California College of the Arts | Department: Graphic Design | Department Chair: Mark Fox

201 Designer/Illustrator/Art Director/Creative Director/Design Director: Ronald J. Cala II | Instructor: Joe Scorsone | School: Tyler School of Art, Temple University | Dept: Graphic and Interactive Design | Department Chair: Stephanie Knopp

202 Designer: Robert Bolesta | Instructor: Anthony Williams | School: Pratt Institute | Department: Communications Design | Chairperson: Kathleen Creighton

203 Art Director/Designer: Ken Yamaguchi | Instructor: Stacy Drummond | School: SVA | Department: Graphic Design | Department Chair: Richard Wilde

204 Designer: Mao Kudo | Instructor/Account Director: Richard Poulin | School: SVA | Department: Graphic Design Department Chair: Richard Wilde

205 Art Director: Caroline Tak | Creative Director: Chris Austopchuck | School: SVA | Department: Graphic Design | Department Chair: Richard Wilde

206 Art Director: Todd Grinham | Instructor: Mike Coyne | School: Miami Ad School, San Francisco | Department: Art Direction | Department Chair: Denise Esterkyn (Director)

207 Designer: Yoon Seuk Shim | Professor: Arch Garland | School: Pratt Institute | Department: Communications Design | Department Chair: Kathleen Creighton

208 Designer/Illustrator: JP Kelly | Instructor: Mark Fox | School: California College of the Arts | Department: Graphic Design | Department Chair: Mark Fox

209 Designer: Yoon Seuk Shim | Professor: Michael Gerbino | School: Pratt Institute | Department: Communications Design | Department Chair: Kathleen Creighton

210 Art Director: Joshua Zulick | Creative Director: Chris Austopchuck | School: SVA | Department: Graphic Design | Department Chair: Richard Wilde

211 Design Director: Sutasinee Chanwangsa | Instructor: Hank Richardson | School: Portfolio Center | Department: Graphic Design | Department Chair: Hank Richardson

212 Designer/Typographer: Emily Guman | Art Director: Lanny Sommese | School: Pennsylvania State University | Department: Integrative Arts | Department Chair: Bill Kelly

213 Designer: Brian Suter | Art Director: Kristen Sommese | School: Pennsylvania State University | Department: Integrative Arts | Department Chair: William Kelly

Design | Products
214 Designer: Alvin Diec | Instructor: Hank Richardson | School: Portfolio Center | Department: Design | Department Chair: Hank Richardson

214 Designer: Michael Seitz | Instructor: Hank Richardson | School: Portfolio Center | Department: Graphic Design | Department Chair: Hank Richardson

215 Art Director/Designer: Wei Lieh Lee | Design Director/Instructor: Kevin O'Callaghan | Photographer: MYKO | School: SVA | Department: Graphic Design | Department Chair: Richard Wilde

216 Designer: Jesse Kirsch | Instructor/Design Director: Cad Roberts | School: SVA | Department: Graphic Design | Department Chair: Richard Wilde

217 (top) Designer: Shelli Silverstein | Design Director: Kevin O'Callaghan | School: SVA | Department: Graphic Design | Department Chair: Richard Wilde

217 (middle) Designer: Jesse Kirsch | Instructor/Design Director: Chad Roberts | School: SVA | Department: Graphic Design | Department Chair: Richard Wilde

217 (bottom) Designer: Jesse Kirsch | Instructor/Design Director: Chad Roberts | School: SVA | Department: Graphic Design Department Chair: Richard Wilde

218 Art Director: Meilee Seung | Instructor: Ji Lee | School: SVA | Department: Graphic Design | Department Chair: Richard Wilde

219 Designer: Wilson Wu | Instructors: Hernan Diaz Alonso, Josh Taron, Jason Pilarski | School: Art Center College of Design | Department: Enviromental Design | Department Chair: David Mocarski

Design | Promotion
220 Designer: Yoon Seuk Shim | Instructor: Michael Gerbino | School: Pratt Institute | Department: Communications Design | Department Chair: Kathleen Creighton

221 Designer/Art Director/Artist/Creative Director/Design Director/Photograper/Print Producer/Typographer: Kyle Klemetsrud | Instructor: Henry Hikima | School: The Art Institute of San Diego | Department: Graphic Design | Department Chair: John Judy

Design | ShoppingBags
222 Designer: Brigid Burke | Instructor: Henry Hikima | School: Art Institute of California, San Diego | Department: Advertising | Department Chair: John Judy

223 Designer/Artist: Juan Garcia | Art Director: Theron Moore | School: California State University, Fullerton | Department: Art | Department Chair: Larry Johnson

224 Designer: Jonathan Feldman | Instructor: Fang Chen | School: Pennsylvania State University | Department: Integrative Arts | Department Chair: William Kelly

225 Designer: Charles H. Wang | Art Director: Theron Moore | Photographer: Daniel Johung | School: California State University, Fullerton | Department: Department of Visual Arts | Department Chair: Larry Johnson

Design | Stamps
226. 227 Art Director/Designer/Illustrator: Wei Lieh Lee | Instructor/Design Director: James Victore | School: SVA | Department: Graphic Design | Department Chair: Richard Wilde

Design | Typography
228, 229 Designer: Robert Bolesta | Instructor: Anthony Williams | School: Pratt Institute | Department: Communications Design | Chairperson: Kathleen Creighton

230, 231 Designer: Jung Meen Lee | Design Directors: Henrietta Condak, Ji Lee | School: SVA | Department: Graphic Design | Department Chair: Richard Wilde

232, 233 Designer: Daeil Kim | Instructors: G. Dan Covert, Andre Andreev | School: Pratt Institute | Department: Communications Design | Department Chair: Kathleen Creighton

234 Art Director: Seung Joo Lee | Creative Director: Henrietta Condak | School: SVA | Department: Graphic Design | Department Chair: Richard Wilde

Photography
235 Photographer: Robert Westrich | School: Lazie Academy, Germany | Art Title: Sundaymorning

Description: This free work arose as a self advertising in the summer of 2006 in Croatia.

236 Photographer: Jessica Triggs | Instructor: Phil Bekker | School: Art Institute of Atlanta | Department: Photographic Imaging | Department Chair: Linda Wood

237 Photographer: Marisa Bedard | Instructor: Phil Bekker | School: Art Institute of Atlanta | Department: Photographic Imaging | Department Chair: Linda Wood

238 Designer/Photographer/Set & Design Props/Stylist/Art Director/Makeup/Hair: Emily Guman | Model: Brooke Banker | Instructor: Lanny Sommese | School: Pennsylvania State University | Department: Integrative Arts | Department Chair: Bill Kelly

239 Photographer: Dave King | Instructor: Phil Bekker | School: Art Institute of Atlanta | Department: Photographic Imaging | Department Chair: Linda Wood

240, 241 Art Director: Michelle R. Goodwin | School: Miami Ad School, San Francisco | Department: Art Direction | Department Chair: Denise Esterkyn

242 Photographer: Richard Meade | Instructor: Phil Bekker | School: Art Institute of Atlanta | Department: Photographic Imaging | Department Chair: Linda Wood

243 Title: Carlos | Art Director: Croix Gagnon | Instructor: Manolo Garcia | School: Miami Ad School, San Francisco | Department: Photography | Department Chair: Denise Esterkyn

244 Account Director/Art Director/Artist/Hair/Illustrator/Makeup/Model/Photographer/Print Producer/Set Designer & Props/Stylist: Jason Mathews Gottlieb | Instructor: Bruce McKaig | School: Corcoran College of Art + Design | Title: Hao Wei Dao (Good Flavor Island) | Department: Design/Digital Media | Department Chair: Kem Sawyer

SchoolDirectory

Art Center College of Design www.artcenter.edu
Hillside:1700 Lida St., Pasadena, CA 91103 | Tel 626 396 2200
South: 950 S. Raymond Ave., Pasadena, CA 91105 | Tel 626 396 2319

Art Institute of Atlanta www.ArtInstitutes.edu
6600 Peachtree Dnwdy Rd., #100, Atlanta, GA 30328 | Tel 770 394 8300

Brigham Young University www.byu.edu
A-41 ASB, Brigham Young University, Provo, UT 846026 | Tel 801 422 4636

California College of the Arts www.cca.edu
San Francisco: 1111 8th St., San Francisco, CA 94107-2247 | Tel 415 703 9500
Oakland: 5212 Broadway, Oakland, CA 94618-1426 | Tel 510 594 3600

California State University, Fullerton www.fullerton.edu
P.O. Box 34080, Fullerton, CA 92834-9480 | Tel 714 278 2011

Columbia College www.colum.edu
600 S. Michigan Ave., Chicago, IL 60605 | Tel 312 663 1600

Corcoran College of Art + Design www.corcoran.org
Downtown: 500 17th St. NW, Washington, DC 20006-4804 | Tel 202 639 1801
Georgetown: 1801 35th St. NW, Washington, DC 20007 | Tel 202 298 2541

Illinois State University, College of Fine Arts www.cfa.ilstu.edu
Campus Box 5600, Center for Visual Arts 116
Tel 309 438 8321 | Fax 309 438 8318

Lazi Academy www.lazi-akademie.de
Schlösslesweg 48-50, 73732 Esslingen, Germany | Tel +49 (0)711 93 78 38 0

Merz Akademie www.merz-akademie.de
Academy of Art and Design, Teckstr. 58, 70190 Stuttgart, Germany
Tel +49 (0)711 268 66 0 | Fax +49 (0)711 268 66 21

Miami Ad School www.miamiadschool.com
955 Alton Rd., Miami Beach, FL 33139 | Tel 305 538 3193

Miami Ad School, Europe www.miamiadschool.com
Finkeanu 35, 22081, Hamburg, Germany | Tel +49 40 41347 0 | Fax +49 40 41346767

Miami Ad School, San Francisco www.miamiadschool.com
415 Jackson St. # B, San Francisco, CA 94111 | Tel 415 837 0966

Pennnsylvania State University www.psu.edu
201 Shields Building, Box 3000, University Park, PA 16804-3000
Tel 814 0865 5471 | Fax 814 863 7590

Philadelphia University www.philau.edu
School House Lane & Henry Ave., Philadelphia, PA 19144-5497
Tel 215 951 2700

Portfolio Center www.portfoliocenter.com
125 Bennett St., Atlanta, GA 30309 | Tel 404 351 5055 | Fax 404 355 8838

Pratt Institute www.pratt.edu
Brooklyn: 200 Willoughby Ave., Brooklyn, NY 11205
Manhattan: 144 West 14th St., New York, NY 10011 | Tel 718 636 3600

Rochester Institute of Technology www.rit.edu
One Lomb Memorial Drive, Rochester, NY 14623-5603 | Tel 585 475 2411

Savannah College of Arts & Design www.scad.edu
342 Bull St., Savannah, GA 31401 | Tel 912 525 5000

School of Visual Arts www.schoolofvisualarts.edu
209 East 23rd St., New York, NY 10010-3994
Tel 212 592 2000 | Fax 212 725 3587

Seattle Pacific University www.spu.edu
3307 3rd Ave. W, Seattle, WA 98119 | Tel 206 281 2000

Texas State University www.txstate.edu
601 University Drive, San Marcos, TX 78666 | Tel 512 245 2111

The Art Institute of California, San Diego www.artinstitutes.edu
7650 Mission Valley Rd., San Diego, CA 92108 | Tel 858 598 1216

Tyler School of Art, Temple University www.temple.edu/tyler
7725 Penrose Ave., Elkins Park, PA 19027 | Tel 215 782 2828

University of North Texas www.unt.edu
P.O. Box 311277 Denton, TX 76203 | Tel 940 565 2000

University of Wisconsin-Stout www.uwstout.edu
712 South Broadway St., Menomonie, WI 54751 | Tel 715 232 1122

Watkins College of Art & Design www.watkins.edu
2298 MetroCenter Blvd., Nashville, TN 37228
Tel 615 383 4848 | Fax 615 383 4849

AwardWinningStudents

Alves, Marcello 138
Ahmed, Masood 158
Ascher, Clemens 40
Barco, Jon 25
Bae, Jun 171
Barry, Ben 171
Bailey, Megan 125
Beltronel, Alexei 38, 87, 99
Berends, Sarah 146
Bergmans, Emilia 30
Bolesta, Robert 202, 228, 229
Bontorno, Andrew 139, 148
Burke, Brigid 222
Byun, Jungmin 124
Caravello, Jonathan 59
Campbell, Jessica 195
Cala II, Ronald J. 201
Cazee, Sarah 180
Chang, Su Won 34, 51, 98
Chang, Myung Ha 134
Chang, Yaijung 156, 157, 176
Chanwangsa Sutasinee 211
Cheung, Wing 188
Chung, Hye Sun 188, 190
Cho, Eun Jung 106, 107
Choi, Yon Joo 118, 119, 120, 147
Clark, Emily 112, 113
Comstock, Greg 150
Cook, Meggan 166, 167, 185
Couphos, Alexa 171
Cohen, Efrat 178
Cruz, Maeden 33
Daguin, Clara 194
Delibero, Ariana 181
Diec, Alvin 214
Dodge, Diana 190
Dunagan, Rachel 165
Falkova, Yevgeniya 171
Farkas, Jordan T. 28,39,80
Feldman, Jonathan 130, 224

Flicker, Melissa 117
Forastieri, Aline 74, 85
Franks, Carly 171
Fujimaru, Tomomi 177
Gagnon, Croix 79, 88, 89, 242
Garcia, Juan 223
Gelijsteen, Dirk 72
Gonsalves, David 37, 94, 95
Goor, Dana 116
Goodwin, Michelle R. 239, 240
Gottlieb, Jason Mathews 243
Grosberger, Frank James 29
Gray, Sam 108
Griffin, Catie 172
Grinham, Todd 206
Guman, Emily 4, 52, 53, 54, 212, 244
Guo, Chuhang 151
Hacker, Trevor 168
Hamby, Austin 200
Hayes, Ryan 114
Hisiro, Sheena 162
Ho, Seulgi 116
Hoffman, Felix 76, 77
Hui, Francisco 41, 45
Hunter, Jeff 171
Ivannikova, Raisa 24
Kang, Kyung Mo 110, 111, 189
Kalchev, Alexander 40
Kelly, JP / 208
Kim, Christina 116
Kim, Daeil 232, 233
Kim, Se Jin 132, 137
Kim, Kil Jae 177, 186
King, Dave 238
Klimiuk, Emilia 192
Kirsch, Jesse 216, 217
Klemetsrud, Kyle 221
Kottloski, Laura 52, 53, 54
Krous, Jennifer 122, 182, 186
Ku, Ji Eun 126

Kudo, Mao 204
Kushnir, Regina 152, 153
Lee, Raymond 26, 56, 70
Leitis, Armands 30
Lee, HaeJin 140, 141
Lee, Jee 174, 197
Lee, Ji Hyun 34, 62
Lee, Jin Young
................. 127, 173, 175, 179, 186, 193
Lee, Jane 50, 51
Lee, Jung Meen 109, 230, 231
Lee, Seul Ah 184
Lee, Seung Joo 198, 234
Lee, Wei Lieh
............. 136, 144, 145, 215, 226, 227
Lee, Wen Yaw 169
Lindaman, Meghan 171
Loving, Grant 168
Lotuffo, Maria 42, 154, 155
Marsen, Jay 38, 87, 99
McDermott, Kate 149, 172, 199
Meade, Richard 241
Mehra, Kanak 76, 77
Miller, Donnie 134
Minasvand, Steephen 2, 60, 67
Moreau, Lauren 27, 31
Montgomery, Ashley 44, 47, 48
Monetti, Heather 64, 68
Moraitis, Timothy 114
Monroe, Stephanie 121
Morris, Rachel 164
Monberg, Portia 168
Moran, Matthew 172
Moon, Ji Hyun 188
Park, Jocelyn 171
Pedone, Justin 78
Petruzzi, Caroline 187
Pflaumer, Charles 190
Poole, Terris 65
Prokes, Shawn 128, 129

Pudin, Anastasia 135
Pulver, Sarah 168
Regej, Byron 142, 143, 159
Reidenbach, Melinda 52, 53, 54
Rios, Olivia 36, 102, 103
Rogan, Benjamin 32, 46, 82
Ryu, Wongi 73, 196
Salciccioli, Nate 115
Sahner, Paul 131
Sanchez, Diana 177
Scafuro, Kim 163
Sarnelli, Stephanie 35, 84
Seagrave, Andrew
............... 31, 41, 61, 66, 86, 93, 101
Seung, Meilee 218
Seitz, Michael 214
Silverstein, Shelli 217
Shim, Yoon Seuk 207, 209, 220
Sommese, Kristin 57, 58, 83
Sonder, Phoebe 160
Suter, Brian 213
Tak, Caroline 205
Tishenko, Olesya 55
Torres, Marcus 172
Triggs, Jessica 237
Tritsch, Fabian 40
Wang, Charles H. 225
Westrich, Robert 236
Williams, Kianga .. 31,63,69,81,91,96,97
Wick, Sam 170, 172
Wu, Wilson 219
Yamaguchi, Ken 71, 90, 203
Yamada, Hirotaka 123
Yegen, Deniz 32, 46
Yeo, Jee Whan 191
Yi, Jeseok 41, 43, 45, 49, 75, 92, 104
Zabeti, Siavosh 40, 72, 79
Zaech, Juri 76, 77
Zhoglo, Igor 168
Zulick, Joshua 210

AwardWinningSchools

Art Center College of Design .. 114, 219
Art Institute of Atlanta
.................... 236, 237, 238, 241
Art Institute of California, San Diego
.......... 33, 37, 94, 95, 171, 172, 221, 222
Brigham Young University 139, 148
California State University, Fullerton
................ 117, 150, 151, 223, 225
California College of the Arts
................ 168, 170, 172, 194, 200
Columbia College Chicago 192
Corcoran College of Art + Design .. 243
Illinois State University, College of

Fine Arts 128, 129
Lazie Academy 236
Miami Ad School
......... 30, 36, 40, 72, 76, 77, 79, 88, 89,
100, 102, 103, 180, 206, 239, 240, 242
Pennsylvania State University
................. 4, 52, 53, 54,
57, 58, 83, 125, 130, 212, 213, 224, 244
Philadelphia University .. 114, 171, 190
Portfolio Center 171, 172, 211, 214
Pratt Institute
...... 160, 161, 162, 163, 164, 169, 171,
202, 207, 209, 220, 228, 229, 232, 233

Texas State University 74, 85
Tyler School of Art, Temple University
..................................... 201
University of North Texas 171
School of Visual Arts 2, 24, 25,
26, 27, 28, 29, 31, 32, 34, 35, 38, 39, 41,
42, 43, 44, 45, 46, 47, 48, 49, 50, 51, 55,
56, 59, 60, 61, 62, 63, 64, 66, 67, 68, 69,
70, 71, 73, 75, 78, 80, 81, 82, 84, 86, 87,
90, 91, 92, 93, 96, 97, 98, 99, 101, 104,
106, 107, 109, 110, 111, 116, 118, 119,
120, 121, 122, 123, 124, 126, 127, 131,
132, 133, 134, 135, 136, 137, 138, 140,

141, 142, 143, 144, 145, 146, 147, 149,
152, 153, 154, 155, 156, 157, 158, 159,
166, 167, 172,173, 174, 175, 176, 177,
178, 179, 181, 182, 183, 184, 185, 186,
187, 188, 189, 190, 191, 193, 196, 197,
198, 199, 203, 204, 205, , 208, 210, 215,
216, 217, 218, 226, 227, 230, 231, 234
Savannah College of Art & Design
..................................... 112, 113
Seattle Pacific University 115
Watkins College of Art & Design ... 165
University of Wisconsin – Stout ... 190
Rochester Institute of Technology . 195

AwardWinningInstructors

Doug Akagi 170
Andre Andreev 232, 233
Frank Anselmo
............. 32, 34, 41, 43, 44, 45, 46, 47,
48, 49, 50, 51, 63, 92, 93, 99, 101, 104
Chris Austopchuck
... 116, 123, 159, 166, 167, 185, 205, 210
Claudia Bach 30
Alejandro Barreras 102, 103
Brent Barson 139
Frank Baseman 114
Phil Bekker 237, 238, 241
Robert Best 142, 143
Jim Bosiljevac 88, 89
Charles Brock 115
Jim Burke 161
Fang Chen 224
Henrietta Condak ... 131, 230, 231, 234
David Copestakes 125
G. Dan Covert 232, 233
Mike Coyne 206
Quentin Currie 112, 113
Sal DeVito 26, 28, 29, 42, 56, 59, 69, 78
Icaro Doria 72

Stacy Drummond 203
Louise Fili 121, 183, 184, 186
Mark Fox 168, 200
John Fulbrook 116, 154, 155
Manolo Garcia 242
Arch Garland 207
Michael Gerbino 169, 219, 230
Carin Goldberg .. 106, 107, 116, 152, 153
Charles Goslin 171
LuAnn Graffeo 175
Rudy Gutierrez 164
Leslie Haines 165
EJ Herczyk 171
Henry Hikima
........ 33, 37, 94, 95, 171, 172, 221, 222
Arnold Holland 117
Paul Jerde 171
MikeJoyce .. 110, 111, 174, 177, 189, 197
Hjalti Karlsson 179
Michael Ian Kaye 118,
119, 120, 126, 144, 145, 147, 156, 157, 176
Adam Kerj 79
Menno Kluin 72
Terry Koppel 149, 172, 178, 199

Maribeth Krael-Weitzel 171
Kessels Kramer 180
Veronica Lawlor 160, 162
Ji Lee 109, 218, 230, 231
Seymour Leichman 65
James Lienhart 192
Chris Lyons 195
Ian Mavaroh 36
Lilli Maya 128, 129
Bruce McKaig 243
Kim Maley 55
Jack Mariucci 31, 39, 70,
71, 73, 75, 81, 86, 87, 90, 91, 96, 97
Bill Meek 74, 85
Jeffrey Metzner 2, 24,
25, 27, 31, 34, 60, 61, 62, 64, 66, 67, 68
Theron Moore 150, 151, 223, 225
Jason Munn 194
Alysha Naples 172
Kevin O'Callaghan 132, 133,
134, 135, 136, 137, 138, 158, 215, 217
Bryony Gomez Palacio
....... 127, 173, 186, 188, 191, 193
Richard Poulin .. 140, 141, 146, 198, 204

Adrian Pulfer 139, 148
Hank Richardson 171, 172, 214
Chad Roberts 122, 182, 216
Roswitha Rodrigues 124
Sara Rotman 188
Joe Scorsone 201
Nagesh Shinde 190
Jennifer Skupin 180
Kristin Sommese ... 57, 58, 83, 130, 213
Lanny Sommese .. 4, 52, 53, 54, 212, 244
Joanna Swistowski 76, 77
Vincent Tulley 35, 38, 80, 82, 84, 98
Uong ... 163
MarcoVvega 100
Salvador Veloso 100
James Victore 226, 227
Armin Vit 127, 173, 186, 188, 191, 193
Tim Weber 40
Cinthia Wen 168
Anthony Williams 202, 228, 229
Genevieve Williams
....... 177, 181, 187, 188, 190, 193, 196
Jan Wilker 179
Wes Youssi 115

PlatinumWinningInstructors

Frank Anselmo, School of Visual Arts
......... 32, 34, 41, 43, 44, 45 46, 47,
48, 49, 50, 51 63, 92, 93, 99, 101, 104

Jack Mariucci, School of Visual Arts
................................. 31, 39,
70, 71, 73, 75, 81, 86, 87, 90, 91, 96, 97

Jeffrey Metzner, School of Visual Arts
................................. 2, 24,
25, 27, 31 34 60, 61 62, 64, 66, 67, 68

Kevin O'Callaghan, School of Visual
Arts 132, 133
134, 135, 136, 137, 138, 158, 215, 217

DepartmentChairs

Peter Bushel 128, 129
Paul Chidester 125
Kathleen Creighton
... 65, 160, 161, 162, 163, 164, 169, 171,
202, 207, 209, 220, 228, 229, 232, 233
Jose Diaz 180
Denise Esterkyn
............. 88, 89, 206, 240, 241, 243
Mark Fox .. 168, 170, 172, 194, 200, 208
Niklas Frings-Rupp
........................ 30, 40, 72, 76, 77, 79
Nik Hafermaas 114
Leslie Haines 165

Larry Johnson 150, 151 223, 225
John Judy
........ 33, 37, 94, 95, 171, 172, 221, 222
Bill Kelly 4, 52, 53, 54, 83, 212, 238
Willam Kelly 130, 213, 224
Stephanie Knopp 201
Dennis Kuronen 114, 171
Patti J. Lachance 195
Eric Ligon 171
David Mocarski 219
Jerrod New 36, 102, 103
Erik Nielsen 74, 85
Sabina Ott 192

Adrian Pulfer 139, 148
Hank Richardson ... 171, 172, 211, 214
Ken Sawyer 244
Ron Seichrist 100
Kristin Sommese 57, 58
Ron Verdon 190
Richard Wilde 2, 24 25,
26, 27, 28, 29, 31, 32, 34, 35, 38, 39,
41, 42, 43, 44, 45, 46, 47, 48, 49, 50,
51, 55, 56, 59, 60, 61, 62, 63, 64, 66,
67 68, 69, 70, 71, 73, 75, 78, 80, 81, 82,
84, 86, 87, 90, 91, 92, 93, 96, 97, 98, 99,
101, 104, 106, 107, 109, 110, 111, 116,

118, 119, 120, 121, 122, 123, 124, 126,
127, 131, 132, 133, 134, 135, 136, 137,
138 140, 141, 142, 143, 144, 145, 146
147, 149, 152, 153, 154, 155, 156 157,
159, 166, 167, 172, 173, 174, 175, 176,
177, 178, 179, 181, 182, 183, 184, 185,
186, 187, 188, 189, 190, 191, 193, 196,
197, 198, 199, 203, 204, 205, 210, 215,
216, 217, 218, 226, 227, 230, 231, 234
Linda Wood 236, 237, 239, 242
Rochelle Woods/Assistant Dean .. 117

GraphisTitles

DesignAnnual2008

Spring 2007
Hardcover: 256 pages
300 plus color illustrations

Trim: 8.5 x 11.75"
ISBN:1-932026-43-6
US $70

GraphisDesignAnnual2008 is the definitive Design exhibition, featuring the year's most outstanding work in a variety of disciplines. Featured categories include Books, Brochures, Branding, Interactive, Letterhead, Signage, Stamps, Typography and more! All winners have earned the new Graphis Gold and/or Platinum Awards for excellence. Extensive credits for each piece and case studies on Platinum winners complete the book.

PhotographyAnnual2008

Winter 2007
Hardcover: 240 pages
200 plus color illustrations

Trim: 8.5 x 11.75"
ISBN: 1-932026-45-2
US $70

GraphisPhotographyAnnual2008 is a beautiful collection of the year's best photographs. Shot by some of the world's most respected artists, these stunning images are organized by category for easy referencing. Each has earned a Graphis Gold and/or Platinum award for excellence. This year's *Annual* features interviews with internationally renown Photographers **Parish Kohanim**, **Henry Leutwyler** and **Hugh Kretschmer**.

AdvertisingAnnual2008

Fall 2007
Hardcover: 256 pages
300 plus color illustrations

Trim: 8.5 x 11.75"
ISBN:1-932026-44-4
US $70

GraphisAdvertisingAnnual2008 showcases over 300 single ads and campaigns, from trade categories as varied as Automotive, Film, Financial Services, Music, Software and Travel. All have earned the new Graphis Gold Award for excellence, and outstanding entries have earned the Graphis Platinum Award. This year's edition also includes case studies of a few Platinum-winning Advertisements. This is a must-have for anyone in the industry.

PosterAnnual2007

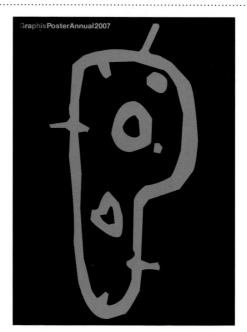

Summer 2007
Hardcover: 256 pages
200 plus color illustrations

Trim: 8.5 x 11.75"
ISBN: 1-932026-40-1
US $70

GraphisPosterAnnual2007 features the finest Poster designs of the last year, selected from thousands of international entries. These award winning Posters, produced for a variety of corporate and social causes, illustrate the power and potential of this forceful visual medium. This year's edition includes interviews with Japanese Designer **Shin Matsunaga**, **Marksteen Adamson** of Britain's ASHA and Swiss Poster Curator **Felix Studinka**.

GraphisTitles

NewTalentAnnual2005

Fall 2005
Hardcover: 256 pages
500 plus color illustrations
Trim: 7 x 11 13/16"
ISBN: 1-931241-44-9
US $70

NewTalentDesignAnnual2005 is the only international annual of creative and visually stunning student work. Graphis provides a platform where students on the verge of entering the professional arena may obtain the recognition — and exposure — that they deserve. Showcased in full color, the winning work celebrates fresh and imaginative solutions in varied disciplines of Advertising, Design and Photography. Detailed indices and credits complete the collection.

NewTalentAnnual2006

Fall 2006
Hardcover: 240 pages
300 plus color illustrations
Trim: 7 x 11 13/16"
ISBN: 1-932026-23-1
US $70

NewTalentDesignAnnual2006 is the only forum to feature the best, internationally produced student work of the last and this year. It provides young professionals a rare opportunity for exposure and recognition. *New Talent Annual* also serves as an unmatched resource for Design and Advertising firms seeking the brightest and the best. In classic Graphis quality, the selected work demonstrates fresh and innovative examples of effective Advertising, Branding, Illustration, Product Design and much more.